Inspired by China

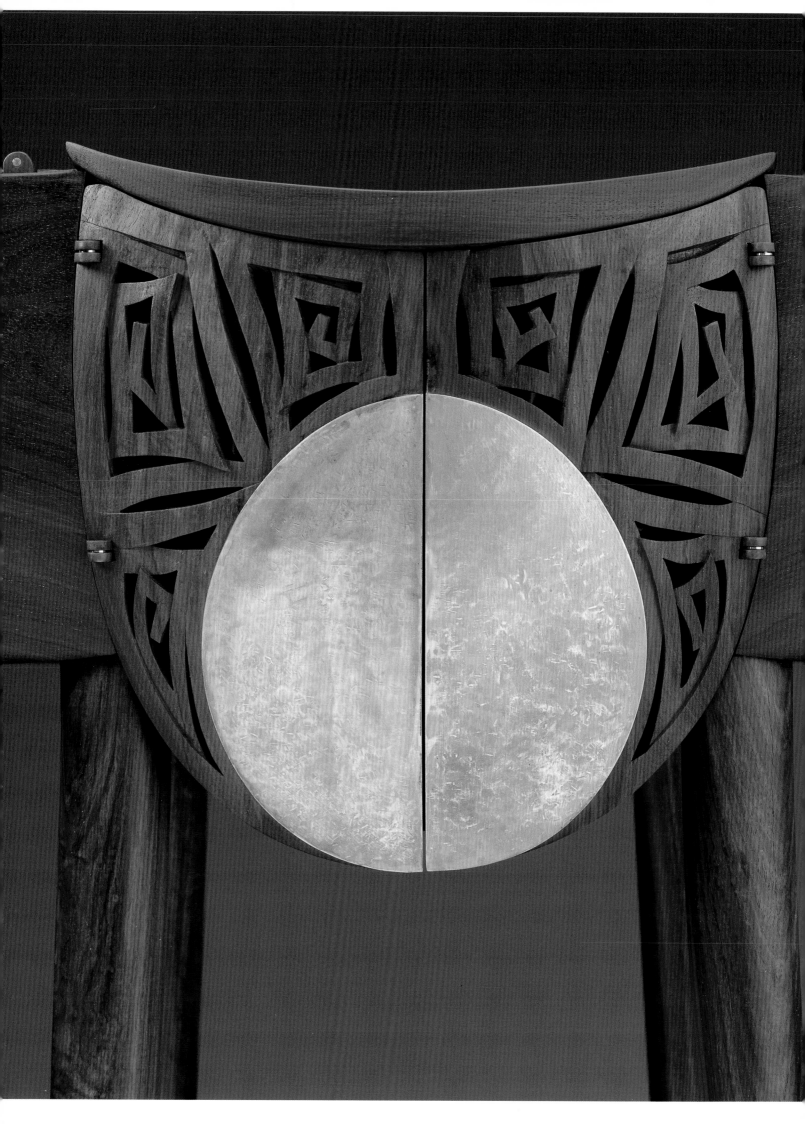

PEABODY ESSEX MUSEUM SALEM, MASSACHUSETTS

Nancy Berliner

Edward S. Cooke, Jr.

Inspired by CHINA

Contemporary

Furnituremakers

Explore

Chinese Traditions

Published in conjunction with the exhibition *Inspired by China: Contemporary Furnituremakers Explore Chinese Traditions*, organized by the Peabody Essex Museum, Salem, Massachusetts, October 28, 2006–March 4, 2007. Exhibition tour: Museum of Art, Fort Lauderdale, Florida, November 30, 2007–March 31, 2008.

Library of Congress Control Number: 2006903024
ISBN (paper): 0-87577-205-6
ISBN (cloth): 0-87577-207-2
www.pem.org

Distributed by University of Washington Press
PO Box 50096
Seattle, WA 98145-5096
www.washington.edu/uwpress

Front cover left to right: Incense Stand with cabriole legs and foliated hexagonal outline, 17th century (Plate 63); Gord Peteran, *Inception Stand* (Plate 64)

Back cover top to bottom: Shao Fan, *Round Stool* (detail of Plate 52); Michael Hurwitz, *The Chinese Piece* (detail of Plate 31); Square Table, 18th century (detail of Plate 45)

Frontispiece: Brian Newell, *Cicada Cabinet* (detail of Plate 33)

Designed by Jeff Wincapaw
Edited by Brian Hotchkiss, Vern Associates
Proofread by Melissa Duffes
Color separations by iocolor, Seattle
Produced by Marquand Books, Inc., Seattle
 www.marquand.com
Printed and bound in China by C&C Offset Printing Co., Ltd.

Contents

Foreword

When we think about the future of the world, we always have in mind its being where it would be if it continued to move as we see it moving now. We do not realize that it moves not in a straight line . . . and that its direction changes constantly.

— Ludwig Wittgenstein[1]

In organizing *Inspired by China: Contemporary Studio Furnituremakers Explore Chinese Traditions* —as an immersive workshop, exhibition, and publication—the Peabody Essex Museum embarked on a multifaceted project based on the concept of cross-cultural exchange as a transformative experience. Twenty-two studio furnituremakers from the United States, Canada, and China have participated, taking as their inspirational partners outstanding historical Chinese furniture and two curatorial collaborators steeped in their respective specialties yet united in their commitment to this study in creativity.

Inspiration, that animating experience of influence, is a highly charged word, combining a sense of cause and effect with an aura of intangibility and mystery. Although often linked to intuition and emotion, inspiration is also an agent for change, discovery, and experimentation, processes generally considered intrinsic to creativity. Originality of thought and the ability to make meaningful new forms are ageless aspects of human existence, yet the word *creativity,* as a powerful, positive abstraction, is a relative newcomer to Western modern discourse. Coined in 1875 by literary historian Adolfus William Ward, it was not commonly found in English-language dictionaries until after World War II. Today, as we readily describe as creative a range of activities—from painting to problem solving—we embrace creativity as an interdisciplinary phenomenon that we assume exists in most circumstances worldwide. Indeed, as Robert Paul Weiner argues in *Creativity & Beyond: Cultures, Values, and Change,* "Making the *new* is our culture's agenda," not just in America but on a global scale because of the seemingly infinite access to ideas.[2]

The potential for exchange that this implies is at this project's heart. Yet exchange is hardly a new event in the mutual fascination that has existed between the West and Asia, for at least six centuries, in diplomatic, religious, artistic, commercial, and technological spheres. Creativity and innovation are frequently driven by a desire to reinterpret and transform traditions and to explore connections between disparate experiences. Relevant to *Inspired by China* is the fact that the aesthetics of Chinese decorative art have been an important source for new directions in European and American furniture, from the Chippendale style of the mid-eighteenth century through the Aesthetic style of the late nineteenth century to modernist design during the 1930s and 1940s. Despite these manifestations of influence and appreciation, the Western perspective on Chinese furniture has been fairly limited, focusing in the nineteenth century on late Qing styles and during the 1930s and 1940s on unadorned Ming styles. Equally significant for our endeavor is that Chinese furniture reflects assimilation and adaptation of forms and functions from Western and other Asian cultures. By way of example, we take sitting in a chair so for granted that it is difficult to imagine the dramatic changes in lifestyle and aesthetics that the introduction of the chair effected in China from the Tang dynasty (618–907) onward.

In bringing together historical Chinese furniture and contemporary studio furniture-makers, Nancy Berliner, the museum's curator of Chinese art, and Edward S. Cooke, Jr., the Charles F. Montgomery Professor of American Decorative Arts at Yale University, have explored a confluence provided by developments in their respective fields. The past twenty years have witnessed increased research and collecting associated with Chinese furniture, revealing numerous distinct styles of vernacular furniture, ornate Ming furniture, and a range of types and materials. Nancy Berliner's *Friends of the House: Furniture from China's Towns and Villages,* for the Peabody Essex Museum in 1995, and *Beyond the Screen: Chinese Furniture of the 16th and 17th Centuries,* for the Museum of Fine Arts, Boston, in 1996, have contributed to expanding understanding of the breadth of Chinese furniture. During the same period, studio furniture

in North America has blossomed, moving independent production into a new notion of furniture that fuses art, design, and craft. Ned Cooke's publications for the Museum of Fine Arts, Boston—*New American Furniture: The Second Generation of Studio Furnituremakers*, in 1989, and *The Maker's Hand: American Studio Furniture, 1940–1990*, in 2003—have been seminal interpretations of this fusion.

The intersection of discoveries in historic Chinese furniture and experimentation by contemporary studio furnituremakers has presented an opportunity that the Peabody Essex Museum is exceptionally positioned to explore. Dating to the early nineteenth century, our holdings in Chinese, Asian export, and American decorative art are among the country's first efforts to acquire works that reflect America's journey across the country and into the world abroad. From the museum's founding mission in 1799—to provide the public with an international array of "wonders"—has evolved our commitment to providing experiences that connect art and culture (historical and contemporary) to engage the mind, enrich the spirit, and stimulate the senses.

Nancy Berliner and Ned Cooke have organized a complex project through a true partnership as well as in collaboration with many people. Several private collectors have generously shared their magnificent holdings in Chinese furniture, a resource without which this project would not have been possible. The 22 contemporary studio furnituremakers deserve our appreciation for their enthusiastic commitment to the project's concept, while we celebrate them individually for the exceptional furniture each has made.

To Deputy Director and COO Josh Basseches we extend gratitude for his role in leading *Inspired by China* to fruition. Priscilla Danforth, the project's manager, coordinated a multitude of personalities, activities, and details with thoughtful rigor. Bruce MacLaren, associate curator of Chinese art, provided important support for the workshop and the publication. Registrar Claudine Scoville and her staff marshaled the challenges of far-flung loans and an exhibition tour. Christy Sorensen, Vas Prabhu, and their staff have produced lively new media and avenues of interpretation in the exhibition and online.

The publication has benefited from Ronald Abramson's generous support. Brian Hotchkiss of Vern Associates, Newburyport, Massachusetts, deserves kudos for his excellent editing and coordination of this groundbreaking book. Jeff Wincapaw, its designer at Marquand Books, Seattle, has shaped an enticing volume, and photographer Dean Powell brings us closer to the furniture in telling detail. David Seibert and Kurt Weidman of Museum Design Associates, Cambridge, Massachusetts, have worked tirelessly with the curators to provide our visitors with a compelling installation design that reinforces the project's basis in inspiration.

We are pleased that the Museum of Art/Fort Lauderdale is the exhibition's second venue and thank Director Irvin Lippman and Chief Curator Annegreth Nill for embracing the project.

To Fred Johnson, Peg Dorsey, Tara Cederholm, Kate Hanson, Michael Melanson, and Martha Small, translators Zhou Yiyan and Laura Hsieh, the Chinese artisans Ning Degen and Hu Laiyou, Christopher Machin at the U.S. Consulate General Shanghai, Michael Clausen at the U.S. Embassy Beijing, Wang Shukai, photographer Barbara Kennedy, interns Anna Reynolds, Jasmine Shin-Jye Deng, and Jessica Eng, and the Hawthorne Hotel, Salem, we extend warmest thanks for their varied professional services and support.

In presenting *Inspired by China*, we believe that the creative potential of cross-cultural exchange stands revealed, for the historic examples and the contemporary work that they have inspired extend the perception of furniture as artistic and cultural expressions.

Dan L. Monroe, Executive Director and CEO, and
Lynda Roscoe Hartigan, Chief Curator

Notes

1. As cited in Richard E. Nisbett, *The Geography of Thought: How Asians and Westerners Think Differently ... and Why* (New York: Free Press, 2003), 102.

2. Robert Paul Weiner, *Creativity & Beyond: Cultures, Values, and Change* (Albany: State University of New York Press, 2000), 98.

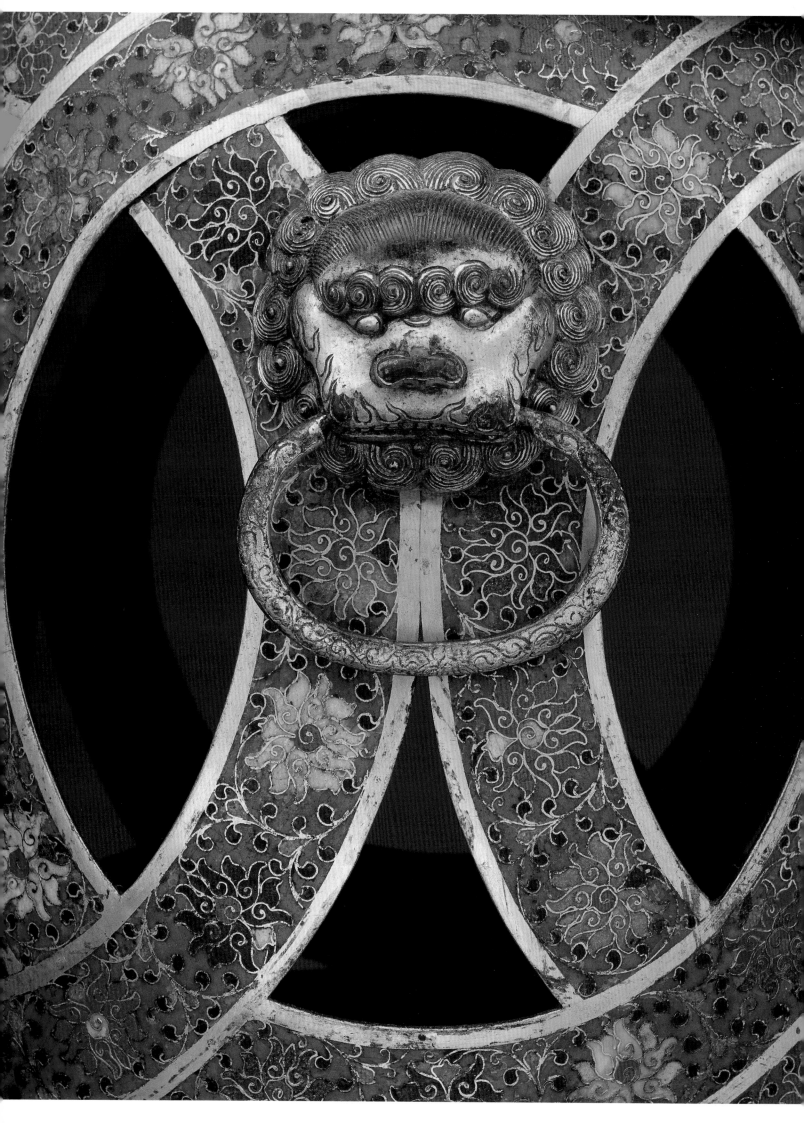

Nancy Berliner and Edward S. Cooke, Jr.

Introducing Inspired by China

With globalization a complex issue among politicians, economists, academics, and cultural leaders, the time seems ripe for a more nuanced and focused exploration of cross-cultural exchange in the contemporary world. *Inspired by China* brings together a wide range of historical Chinese objects and contemporary furnituremakers from diverse cultures to explore the possibilities surrounding the creation and use of furniture in the context of cross-cultural influences. In such a circumstance, the opportunities for learning become limitless. While many people have some general sense of the beautiful joinery and exquisite workmanship found in Chinese furniture, few have a full understanding of the range of styles, the variety of forms, or the function or meanings of these forms. In short, Chinese furniture history has been very much in its nascent stage in the West, largely due to limited direct contact and firsthand knowledge. To bring new insights to surviving examples and to promote a more open-ended discourse about the past and the present, we invited leading furnituremakers from China and North America to the Peabody Essex Museum to look at and talk together about historical Chinese furniture and to share their experiences with one another. This interaction provided an international connection for contemporary practitioners and resulted in works that have furthered possibilities for furniture and creativity in China and North America.

In light of contemporary museological practice, the Peabody Essex Museum's interest in explicating the relationship of collection, inspiration, and fabrication has motivated the organization of *Inspired by China* as an exhibition and publication. The two-hundred-year history of direct interaction between China and Salem (manifested most recently in the relocation of the Yin Yu Tang house to the Peabody Essex Museum), the historical and contemporary furniture legacy in the Salem–Boston area, and the recent Sino-American reengagement have combined to produce an ideal opportunity. Capitalizing on the internationalization of the art and design world, which is characterized by an unprecedented flow of objects and furnituremakers, we sought to bring together North American and Chinese studio furnituremakers to explore an ecumenical range of historical Chinese furniture including elaborate lacquerwork, classical Ming hardwood examples, and vernacular expressions. Rather than construct a virtual exercise in which a curator chooses certain existing examples that reveal the borrowing of motifs, forms, or concepts, we felt it essential that we bring creators and objects together in an educational workshop before asking the

Xiudun stool (detail of Plate 49)

9

furnituremakers to respond with new objects. In this endeavor, the historic Chinese furniture became the foundation for object-based creative inquiry and forged lively exchanges among different participants. The final exhibition of the inspirational and new work features a wide range of materials that provide the visitor with multiple perspectives.

The root-wood stools, the stone stools, the trompe l'oeil pieces ... those were a surprise. The vision has been broadened by coming here. I didn't know the range of variation; I was more focused on just one aspect of Chinese, where now the range is much larger. And that also, in a way, has changed or challenged my preconceptions. I was thinking of them in [terms of] pure refinement, and then realizing there's a much broader range to their vocabulary that they're drawing from. It means that even on the refined pieces you have to look at them again, that there are probably subtleties going on that I didn't even pick up.

—Tom Hucker

For this project we selected studio furnituremakers, a specific set of artists linked by education in the craft outside of traditional apprenticeships; an interest in connecting concept, materials, and technique; a small studio in which they work; and a consistent engagement with furniture as a cultural product. They eagerly embrace furniture as a creative parameter and comfortably describe themselves as "studio furnituremakers" to signify their particular niche. In North America, where studio furniture has blossomed since the 1950s as a vibrant field with a strong professional identity, few studio furnituremakers had enjoyed firsthand experience with Chinese forms, materials, and techniques. In China, studio furniture is less developed, but an increasing number of sculptors, designers, and furniture connoisseurs are demonstrating an interest in broader notions of furnituremaking. Few of these Chinese artists had any knowledge of the studio furniture community in North America and its wide variety of approaches. Bringing the two groups of artists together with a common focus on historic material thus provided an opportunity for creative and professional interaction.

I'm attracted to the everyday use of furniture that's attractive and made out of interesting wood. That's always where I come back to when I look at Chinese furniture. I mean, there are the big fancy [pieces] ... but there's this elm stuff here that interests me just as much.

—Hank Gilpin

In drawing up an invitational list for the workshop, the curators sought advice from many colleagues in the field, carefully weighed a large list of potential participants, discussed the merits of different approaches, and made difficult choices to keep the project at a manageable size. Because each participant would be making something new, we opted for mature artists who had strong track records in producing work of consistent strength. In thinking about the varieties of materials, uses, and meanings of the historic Chinese furniture, we tried to identify practitioners with affinities to different aspects of Chinese furniture. In considering materials, we thought that Clifton Monteith's extraordinary use of willow and lacquer (Plate 18), Bonnie Bishoff and Mark Syron's original development of polymer clay veneers (Plate 27), and Richard Prisco's postindustrial use of wood and steel (Plate 35) would offer rich commentary on Chinese materials. To shed light on the consummate attention to the intricate and refined, but hidden, joinery found in historical work, we invited such furnituremakers as Michael Puryear, who often works with an anthropological perspective (Plate 38);

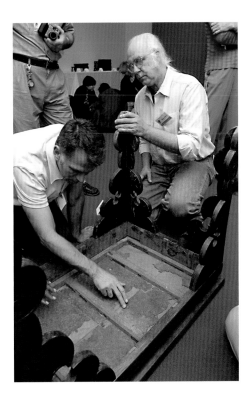

Hank Gilpin and Richard Prisco study the lacquered underside of the top of the altar table in Plate 5. Lacquer was used not only for a decorative finish but also to provide a protective finish in areas that are not ordinarily visible. The lacquer protects the table's underside from damage that could be caused by moisture rising off the ground.

You know, my idea of Chinese art in general that has been drilled into us culturally is jade, ivory, and ceramics.... I hope I don't ruffle any feathers here, but I find it relatively fussy. But I do admire it.

—Garry Knox Bennett

Hank Gilpin, whose direct hardwood joinery resonates deeply with the Chinese work (Plate 7); and Joe Tracy, whose work reveals an interest in quiet joinery framing natural accents such as popple stones or burls (Plate 19). Another group we sought to involve were those who develop objects with an eye toward cultural meaning. We felt that Tom Hucker's study of the tea ceremony and Italian design would result in a nuanced response (Plate 16), that John Dunnigan's deep knowledge of furniture history and the changing meanings of objects would offer instructive insights (Plates 34 and 60), and that Ai Weiwei's (Plate 68) and Shao Fan's (Plates 4 and 52) interest in deconstructing furniture and reusing historically charged timbers would express a reverence for the ancient traditions of China.

Such an active linking of creator and collections has a rich tradition in the past quarter-century. Since the early 1970s, there has been a noticeable change regarding the role of museum collections in regard to the practice of art and design. No longer are collections unquestioned repositories of canonical models to copy or respectfully study, as in the old South Kensington model of the late nineteenth century. Instead, artists began to make institutional critiques part of the artistic process as they questioned the authority of collection displays, and museums began to question their own exhibition strategies due to the writings of scholars such as James Clifford. Artists including Daniel Buren, Fred Wilson, and Yinka Shonibare have served as curators, "mining" museum collections, interjecting their own work in atypical hangings, or providing labels that draw attention to the collections with new perspectives. Such

Clifton Monteith, who works primarily with willow wood, examines a bamboo chair. He is joined by Hu Laiyou, a furnituremaker from rural Anhui Province, who made this chair, and a translator. As with making objects from willow wood, fabricating furniture with bamboo entails heating and then bending the material, and cannot rely on complex joinery.

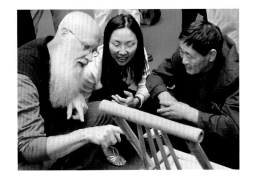

new assemblages shifted the orientation of the visitor and challenged traditional, received histories of objects.

In contrast to the artist-as-curator model, a second approach emerged in which the institution served as curator. Some museums, ranging from large ones such as the National Gallery in London, to focused institutions such as the Isabella Stewart Gardner Museum in Boston, to small regional museums such as the Museum für sas Fürstentum in Lüneburg, Germany, brought in resident artists or groups of artists to learn from and be inspired by institutional collections in order to make something new and bring new vitality to a static collection.

That dynamic is an intangible. . . . No one can put that into play on purpose. I mean you can bring certain people together but you can't predict what will happen when they're together, and not only can you not predict what happens when they're together but you can't predict what travels between them in their heads, and when they go home, and how that affects what you're asking us to do. I honestly believe that. I mean, the way he [Garry Knox Bennett] works, I'm intrigued by it, you know it makes me think, what could I do if I worked with that mindset for a while. I might not have thought of that if I hadn't spent the night pounding down a few, and no one could've planned that, and who knows how that's going to impact whatever I make.

—Hank Gilpin

Yet a third model of critique positions the artist as museum educator, whereby museums develop collection-based themes and then bring in artists to respond to these themes. For example, curators at the Museum of Fine Arts, Boston, invited a group of studio furnituremakers to look together at the collection of historic American furniture, then make new work in response to what they saw and learned. Rather than leading to a linear, hierarchical sort of influence from art object to artist/designer, the new interventions have highlighted a more dynamic, ongoing relationship that focuses upon the curatorial and creative process. Such an engagement brings a collection to life.

In June 2005, the Peabody Essex Museum hosted 22 furnituremakers from the United States, Canada, and China for a three-day interactive symposium on Chinese furniture. This immersion was defined as a participatory workshop and consisted of informal curatorial presentations, demonstrations of techniques, and plenty of opportunity to examine and talk about furniture. The workshop reenacted, with a more formal agenda, the rhythms of cultural exchange that have occurred for centuries and across mountains, oceans, and deserts, among artists, artisans, and all purveyors of culture and technology. The invited participants—among the most prominent and respected furnituremakers in the field—came with the expectation that following this workshop they would return to their studios to create something inspired by their experience.

Many aspects of Chinese furniture were inspirational—not the least of which was the joinery: ultimately simple and neat looking from the outside, while incredibly complex and completely hidden on the inside.

—Judy McKie

For the American participants, the gathering was an opportunity to experience firsthand, and in-hand, the legendarily precise workmanship of Chinese furniture, prized and revered among woodworkers, and to study a wide diversity of furniture

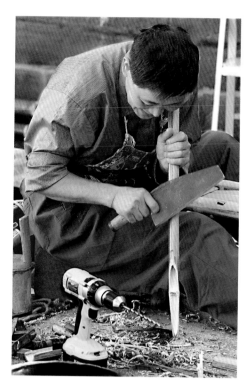

A highlight of the workshop was a demonstration by Hu Laiyou of his bamboo chair–making technique. Seated on a rock in the sunny forecourt of Yin Yu Tang, a glass jar of tea by his side and a cleaver in hand, Hu picked up his bamboo lengths—brought from his village in China, where he had freshly cut them—and began to hack them precisely into the necessary sizes. To bend the rigid, two- or two-and-a-half-inch-diameter stalk, Hu gathered together the bits of discarded bamboo shavings and placed them in an earthenware pot from the Yin Yu Tang interior. He lit the scraps, and, once a good flame had risen, he placed the stool's leg into the fire. The resins of the fresh bamboo rose to the surface, bubbled, and glistened, and at just the right moment, Hu withdrew it from the heat, positioned it against the seat of the chair, and with a swift movement, bent it to the desired angle. Not unmindful of the open flame, he quickly took a large gulp of his tea and sprayed the fire, extinguishing it in the traditional and common Chinese technique, which prompted a round of applause from the American audience.

We hear about it [China] all the time in American culture in terms of a certain nervousness about economics and manufacturing, but we rarely think about it in dynamics and the exchange culturally, and creatively. And I think that socially, in a larger context than this exhibition, this is a very important bridge to make between the two cultures. That's a wonderful thing to be involved in.

—Tom Hucker

from China. Spread out in a large gallery that was open only to workshop participants were more than 40 pieces of Chinese furniture, from low stools to high tables, from humble village softwood chairs to finely carved tropical hardwood tables hailing from the homes of China's privileged as well as furnishings fabricated from bamboo and stone. Unlike in most museum settings, the furnituremakers were invited to handle (carefully), turn over, and in some cases dismantle the furniture to better understand the construction, forms, textures, and nuances of Chinese furniture. Entering the vast gallery, some of the North American furnituremakers gravitated immediately toward a pile of wooden components with a sign PLEASE PUT ME TOGETHER. Four of them attempted to create a four-legged chair from the twenty-odd shaped members. Some excited progress was made among those willing to attack the challenge, but eventually a stalemate was reached. Hu Laiyou then approached his frustrated yet determined and fixated colleagues. "Let me show you how to do it," he said, laughing at their inability to understand the explicit order in which the pieces had to be assembled. Supplementing these examples of furniture selected from both the Peabody Essex Museum and private collections were extensive library holdings in Chinese art and culture from the museum's collection. Scheduled opportunities to visit the standing exhibitions of Chinese furniture, architecture, and art at the Peabody Essex Museum and the Museum of Fine Arts, Boston, provided yet another layer of immersion in Chinese material culture. In short, the participants were exposed to an incomparable variety of resources relevant to the project.

The Chinese furnituremakers traveled half-way around the globe to reencounter a full representation of their own culture's history and to come in contact with the perspectives, ideas, techniques, and works of their American counterparts, whom they

had never met. They were awed by the creative energy and variety they saw. Joining these studio furnituremakers, all involved in the world of contemporary international art markets and galleries, were two traditional Chinese furnituremakers from the rural reaches of Anhui Province. Ning Degen works with the traditional techniques of complex mortise-and-tenon joinery to fasten together wooden components of chairs, tables, and cabinets. Hu Laiyou is a bamboo furnituremaker. By splitting, heating with fire, and twisting the ubiquitous bamboo of southern China, he is able to manipulate the material into comfortable and durable furniture of a type that has served Chinese people for centuries.

A gathering of international colleagues organized for the purpose of learning inevitably leads to more than a pure study session, and can quickly become an event of social engagement. In the small world of contemporary furnituremaking, where the artists often spend hours, if not months, working alone with their tools, a gathering such as this workshop becomes an opportunity to catch up, share ideas, and relax with a group engaged in similar pursuits. The workshop began with an introductory dinner, where language proved an initial barrier. Old friends from opposite sides of the North American continent drifted to some tables, while the Chinese gathered at their own table. By the end of the three days, however, conversations, facilitated by translators when necessary, were sparking and addresses and emails were being exchanged. Since the workshop, emails and visits continue and will continue among the newly acquainted friends.

During the months following the workshop, the furnituremakers confronted the challenge of making sense of their intense experience in Salem, articulating designs, and meeting a completion deadline. Emails, letters, and telephone calls poured in to the staff at the museum. Some, including Garry Knox Bennett (Plates 2, 43, and 46) and Shao Fan, jumped right into work, while others such as Brian Newell (Plate 33) and Gord Peteran (Plate 64) mulled over their ideas—in their studios and their emails—for months.

One of the Chinese guys and I both tried to put a chair together, and he was slapping my hands out of the way because I wasn't doing it right, and then we'd laugh at each other.

—Tom Hucker

As expected, each participant digested and absorbed different aspects of the Chinese furniture, usually responding from his or her related experiences. Certain aspects of Chinese traditions resonated more with the contemporary practitioners than others. The lattice that captured the interest of Thomas Chippendale in the mid-eighteenth century continues to captivate current makers, but perhaps for different reasons. The dynamic cracked-ice pattern, so paramount in Chinese seventeenth-, eighteenth-, and nineteenth-century design, and yet never fully explored by American or European artists or designers, evoked delight for many of these furnituremakers, who drew on it for both decorative and structural inspiration. The organic, natural aesthetics of Chinese traditions that so enthused late-seventeenth-century European garden designers inspired several contemporary furnituremakers to look anew at materials or surfaces. Others were troubled by a fundamental tension between the reverence for technical skill in Ming China and the seeming disregard for craft evidenced by contemporary plastic goods made in China. Meanwhile, some of the Chinese furnituremakers displayed in their works a keen interest in Western conceptual and even deconstructionist approaches to their furniture.

I started as an apprentice with a fifth-generation German cabinetmaker in Philadelphia—Leonard Hilgner. I remember one day, I was feeling somewhat frustrated and cocky and I said, "Leonard, show me something that will just blow my mind." And he brought out one of the double-lapped Chinese joints, and we started talking about Chinese furniture and that was my first introduction to Chinese furniture, and it's been one of my favorite types of furniture ever since.

—Tom Hucker

Unexpectedly, for some, the event not only informed the form or style of a specific piece created for the exhibition, but also prompted new courses and directions in their thinking and their lives. Brian Newell, who has lived in Japan for seven years, became intrigued with Chinese culture. Upon returning to Japan, he quickly decided to explore China. After a few emails to his new Chinese furnituremaker friends in Beijing, Brian traveled to Beijing and is now contemplating moving there. Brian's trip to China also served as a catalyst for Shao Fan in Beijing. American furnituremakers today make most of their furniture by themselves, using woodworking machinery, hand tools, and occasional assistants. In Beijing the sophisticated studio furnituremakers traditionally create their works in a manner similar to that of their predecessors, the literati. They design the piece and then work closely with a traditional furnituremaker who undertakes the majority of the skilled tasks, from sawing the wood to joining, to polishing. When Brian began describing his shop, full of large machine tools, to his Chinese colleagues, Shao Fan became intrigued and is now determined to begin purchasing machines and tools in order to take on more of the work himself.

The workshop and the resulting *Inspired by China* exhibition are an important step in a new cross-cultural exchange between America and China. The older Silk Road has given way to a new technological highway, characterized by jet travel, email, jpeg files, and homepages, which has facilitated blending traditional and innovative perspectives on furniture. We trust that this endeavor is only the first of a sustained period of interaction, one that will not homogenize the furniture of the world but highlight the regional traditions and spawn new hybrids. In short, examinations of traditions will fuel innovation but not be subsumed by it.

We are indebted to the steadfast and invaluable assistance of Bruce MacLaren, Associate Curator of Chinese Art, and the infallible (and unflappable) organizational work of our project manager, Priscilla Danforth, in this uniquely and complexly constructed exhibition project. Tara Cederholm, Kate Hanson, Michael Melanson, Martha Small, and Libby Caterino all generously contributed to the realization of the workshop and the exhibition. Lynda Hartigan provided insightful comments on earlier drafts of the publication. We are also extremely grateful to Brian Hotchkiss of Vern Associates for his encouraging support and his acute and wise editing of this book. Christine Mehring and Jennifer Gross happily talked about the types of artist interventions in the museum. Ned Johnson's effervescent enthusiasm for furniture and innovation has been blessedly contagious and an invaluable contribution to this project. We also want to acknowledge our deep appreciation for the support of this endeavor by Bill Mellins and Carol Warner. Finally, and most importantly, we wish to thank the furnituremakers, who willingly and enthusiastically accepted the challenge to be inspired.

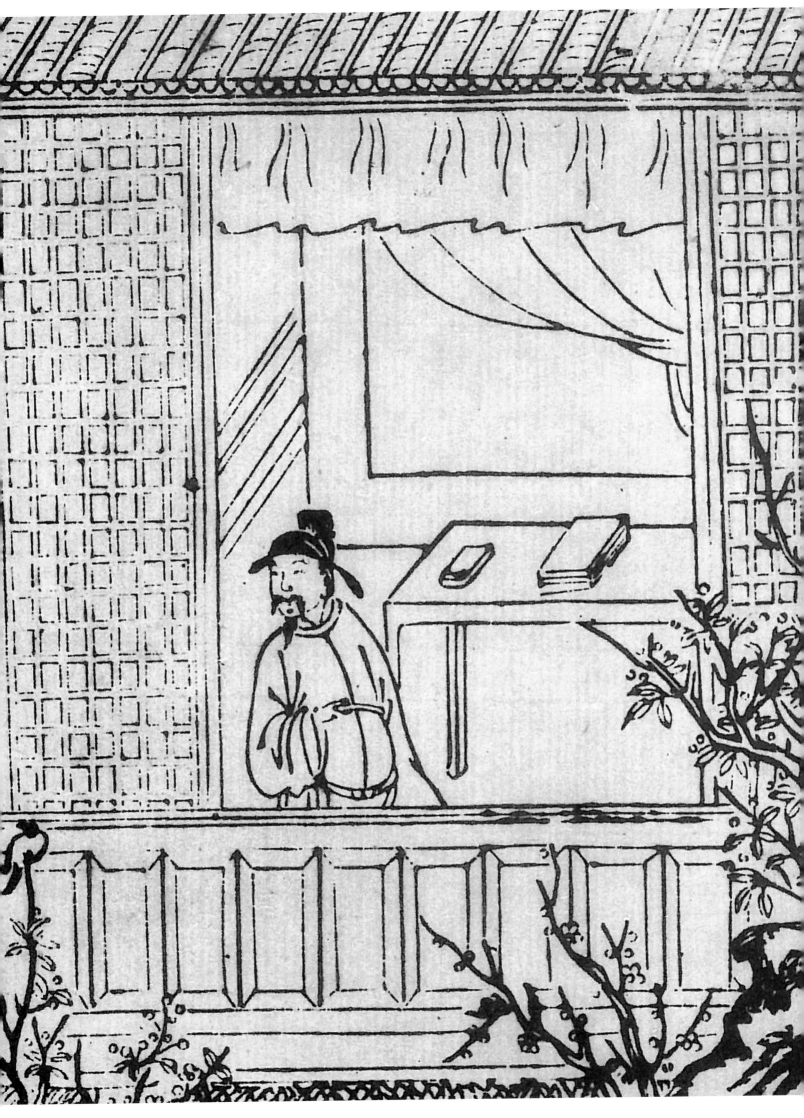

Nancy Berliner

Considering Influences from Afar
The Impact of Foreign Cultures on Chinese Furniture

You have to keep changing, and changing, and changing. That's the only way you can keep things new and fresh.

—Brian Newell

Wheels move and times turn round.

—Kangxi emperor (1654–1722)

Imagine the classical image of a Ming gentleman sitting by a waist-high window on a hardwood chair. At his waist-level hardwood desk, brush in hand, he writes calligraphy on a bright white sheet of paper. His favorite antiquities, including a blue-and-white brush-washing dish, are scattered across the desk's surface. The calligraphy, the brush, the paper, and the porcelain were all developed in China. The chair, the table, and even the cobalt of the underglaze-blue design on the porcelain and the window height, however, all resulted from experiences with and adoptions from non-Chinese cultures.

A review of Chinese furniture history over the past four millennia reveals constant modifications, transformations, and fluctuations in forms, designs, materials, and lines. The historic Chinese objects in *Inspired by China* were created during a relatively short time span stretching from the sixteenth through the nineteenth centuries. They represent only one period of Chinese furnishings following over three thousand years of cultural developments. Tracing through those three thousand years of rhythmic transformations, it becomes apparent that much furniture, as well as other aspects of Chinese culture, was highly impacted by encounters with cultures as diverse as those in India, Central Asia, and even Rome. The influence of these cultures and their customs flowing into China during the Han (206 BCE–220 CE) through Tang (618–907) dynasties directly influenced the culture that resulted in the furniture forms, designs, and decor spread before us in this exhibition.

One of the most radical changes in Chinese furniture that occurred due to encounters with distant cultures is the slow, but still surprising, transformation from a mat-level lifestyle in China to a chair-sitting society. Fifteen hundred years earlier, an ancestor of the same Ming scholar would have knelt on a mat on the ground near a floor-length window that allowed light to reach the activity level. Were he literate, his brush would have inscribed ink characters on slips of bamboo laid flat upon a

Figure 1 Woodblock illustration from *Shi yu tu pu*, published 1612.

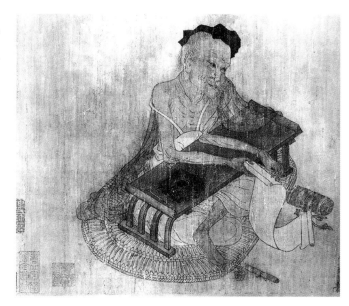

Figure 2 Attrib. to Wang Wei, *Fu Sheng Expounding the Classics*, Tang dynasty; handscroll, color on silk, 10 × 17½ inches (25.4 × 44.7 cm). Osaka Municipal Art Collection, Abe Collection.

low table (Fig. 2). This change from mat-level living allowed artisans the opportunity for a great surge of creativity and ingenuity to fill spaces and create seating paraphernalia—along with other types of furniture—to work with the heightened level of living, and to fulfill the comforts and tastes of the Chinese populace.

Early Chinese Furniture Characteristics

Mat-level Lifestyles and Early Furniture

A fundamental detail in establishing the development of Chinese furniture is the early mat-level lifestyle. During more than half of the 4,600-year-long period known as "Chinese civilization," from the Shang dynasty (seventeenth to eleventh centuries BCE) to the present, the great majority of people did not sit on elevated chair surfaces. Most, including the great sage Kongzi (ca. 551–479 BCE), known in English as Confucius, the early figures of Taoism, Laozi (ca. sixth to fifth centuries BCE) and Zhuangzi (ca. 350–300 BCE), and the first emperor to unify China, Qin Shihuang (259–210 BCE), sat either on the ground, on mats, or on low platforms in a kneeling position.[1]

The mat-level lifestyle in early China did not preclude furnishings. Low tables for eating or making offerings, and armrests (known as *ji*) for men of status to lean upon,[2] were all part of early mat-level living in China. These early pieces of furniture already bear elements of Chinese furniture that would persist for many millennia, through and beyond the transition to chair-level living.

The primary furnishings of elite spaces prior to the Han seem to have been various types of tables distinguished in function, construction, and form. The *zu* functioned as an altar for making sacrificial offerings (Fig. 3).[3] Its regular, flat top was often ringed by a low rim that prevented animal blood from spilling. On a Shang-dynasty stone *zu*, which would have imitated a wooden *zu* in form, the front legs, like the rear legs, descend from an apron running across the entire width of the *zu*. The apron between the legs on a wooden *zu* supports the verticality of these upright members and prevents them from splaying under the pressure of the top surface or any weight placed upon it. By the time of the Spring and Autumn period (475–221 BCE), the short ends of some *zu* culminated in upturned wave-shaped forms known as everted flanges (Fig. 4).[4] Their dramatizing effect was so successful that these celebratory "flairs," whose original function is no longer understood, became a signifying and significant element of ritual tables in Chinese tradition.

A second form of table from early China is the *an*. Similar in form to the *zu*, the *an* was intended to hold food. While some *an* have four distinct, independent legs, some—such as a lacquer *an* found in a tomb in Xinyang, Henan Province (Fig. 5)—have two legs on each of the short sides attached to each other by a floor stretcher. Like the apron on the *zu*, the floor stretchers add extra stabilization to the legs of the table. For millennia, both the side floor stretchers and the apron continued to be integral elements of many Chinese furniture types.

Another manner of elevating a surface off the ground was the box construction. *Jin*—rectangular boxes with open bottoms and rectangular cutouts along the sides—that have been excavated from both Shang and Zhou sites, were used to elevate wine vessels during sacrificial rituals (Fig. 6). The box construction is inherently more stable than a horizontal surface supported only by four long legs. In addition to the floor "frame" fastening the four vertical planes along the ground, the seams joining the vertical planes at the corners prevent splaying of the legs or twisting of the entire structure.

The box construction continued to be used for generations. In the Han dynasty, higher-ranked members of society sat on low platforms of box construction while their inferiors remained on mats (Fig. 7). Over time, woodworkers discovered they could create open spaces within the vertical sides of the box, enforced with aprons and reenforced with floor stretchers that completed the box.

Even after the introduction of the chair and the development of joinery and construction techniques that rendered the box construction unnecessary, a penchant for archaism and the restrained elegance of the form preserved the box construction for sitting and sleeping platforms through the early Qing dynasty.

Figure 3 *Zu*, Anyang, excavated from Henan Province, Shang dynasty. Drawing by Jessica Eng after Dong Boxin, *Zhongguo Gudai Jiaju Zonglan* (Hefei: Anhui ke xue ji shu chu ban she, 2004), 11.

Figure 4 *Zu* with everted flanges, excavated from Shangyang, Hubei Province, Zhou dynasty (1050–221 BCE). Drawing by Jessica Eng after Dong Boxin, 22.

Figure 5 *An*, excavated from Xinyang, Henan Province, Zhou dynasty. Drawing by Jessica Eng after Dong Boxin, 26.

Figure 6 *Jin*, excavated from Baoji, Shaanxi Province, Zhou dynasty. Drawing by Jessica Eng after Dong Boxin, 12.

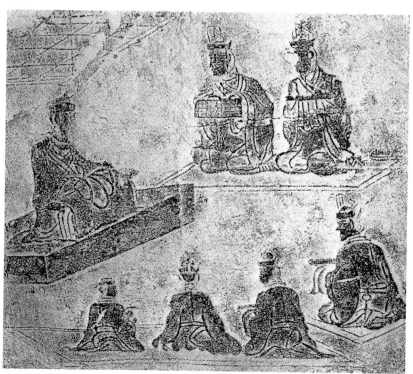

Figure 7 Man seated on a *jin*. Rubbing from a Han-dynasty tomb tile, Sichuan. Courtesy of the Chinese Culture Foundation, San Francisco.

Joinery

Closer examination of this ancient furniture permits consideration of the manner in which the components were fastened to one another. Among furnituremakers, scholars, and connoisseurs today, Chinese furniture is renowned for its joinery techniques. The structure of boxes, platforms, and tables echo early Chinese architecture, which clearly announces that the mortise-and-tenon joint was an elemental method of joining wooden architectural components. At the Neolithic site of Hemudu in Zhejiang Province, preserved remnants of a building's post-and-beam construction display clear indications that the structure used mortise-and-tenon assembly (Fig. 8).

The majority of Chinese traditional wooden buildings have always been post-and-beam construction. Columns and beams, with brackets to steady the beams, support the roof. This is essentially the same construction as a Chinese stool or table, where legs, with stabilizing stretchers, aprons, and spandrels, support a seat or table top. By the Song dynasty (960–1279), a basic approach to furniture construction

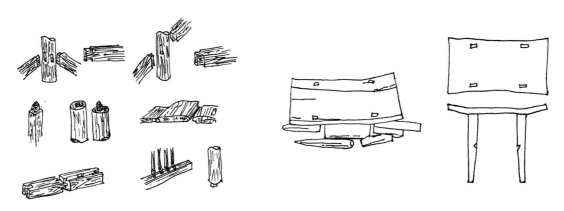

Figure 8 Hemudu joinery, Neolithic period (ca. 4500–2500 BCE). Drawing by Jessica Eng after Dong Boxin, 7.

Figure 9 Table, excavated from Liu'an, Anhui Province, third century BCE. Drawing by Jessica Eng after Dong Boxin, 23.

emerged as the predominant style. Round, recessed legs, with rounded stretchers for additional support, tenon into a horizontal framed seat or table top (Plate 37), just as round columns and round beams of the traditional Chinese edifice support the roof. This standard construction and style has remained a primary model for wooden furniture.

Several excavated wooden *zu* from the Warring States period (475–221 BCE) demonstrate that the mortise-and-tenon technique was also used to fasten together wooden components of tables. In one example from Liu'an County in Anhui, four distinct legs support a rectangular table top (Fig. 9). The tapered upper extremities of the legs penetrate the table's top surface and are exposed. Exposed tenons would continue to be a basic component of Chinese furniture for generations, until some late Ming and early Qing furnituremakers elected to conceal their technology for aesthetic purposes.

Wood and Lacquer

The lacquered surface is a distinguishing feature of early fine Chinese furniture. Aware of moisture's deteriorating powers on the softwoods they were employing, early woodworkers discovered that the application of sap from a certain sumac species (*Rhus vernicifera*) could form a protective layer for treasured wooden objects. The lacquer also provided a brilliantly shiny and luxurious surface, similar to the sheen of polished bronze. By the Shang period, craftsmen were mixing pigments with the lacquer and creating surfaces, and a millennium later dynamic red and black designs covered the surfaces of coffins, eating utensils, and furnishings. With its amazing capacity for imperviousness, lacquer preserved wooden artifacts not only for the lifetime of their users, but for later generations of admirers. Lacquer became

a staple component of most upscale furniture for thousands of years. Only with the importation of hardwoods centuries later would the surface appearance of fine Chinese furniture change.

Evidence from the Neolithic, Shang, Zhou, and Han furnishings discussed above point to the early existence of a number of formal native structural, material, and decorative aspects of Chinese furniture, which were maintained by woodworkers and their clients for another two thousand years.

Inspired from Afar

Roads Leading to Chairs

Domestic history and cultural-social trends would continue to inspire and impact the ever-changing styles and uses of Chinese furniture, but inspiration from beyond its borders brought on radical transformations in the furnishings, domestic interiors, and postures in China.

The adjustment or modification of a sitting posture for any individual—whether learning to sit straight while working at a computer or sitting cross-legged for meditation—can be a difficult, even impossible, transition. Over the course of eight hundred years, under the sway of imported customs and cultures, the Chinese population gradually moved from kneeling to sitting on a raised surface with their legs hanging pendant toward the ground. This change in seated posture represents an even larger cultural change than the mere presence of chairs in a room. The change was so demanding, in fact, that among many Chinese people strong hints of mat-level sitting postures endure today. The preference for stools that are close to the ground is still prevalent; the *kang*, a raised, heated platform for sitting and sleeping, is a common feature in the homes of northern China; and many people maintain the habit of sitting with one or both legs up on their chairs.

The increased prevalence of the chair in Chinese life in the six hundred years following the Han dynasty has been attributed first to a folding stool adopted from foreign cultures north and northwest of China, then to the introduction of the chair, which is associated with Buddhism coming from India. But first it is worthwhile to speculate on the initial willingness of some members of the Chinese society to begin adjusting their seated postures.

Military Inspiration?

In his book *The Impact of Buddhism on Chinese Material Culture*, John Kieschnick notices that, "unlike military technology, which demands acceptance of the latest innovations if a civilization is to compete with its enemies, the chair provides no significant advantages over alternative methods of sitting."[5] Or does it? Did sitting in chairs make people more prepared to get up and run to defend? The folding stool—called a *huchuang* (barbarian bed) in Chinese—was originally a seat for military commanders wherever it was in use, from Egypt to Rome to Central Asia. In Japan, where elevated chairs were introduced from China but were only used on special occasions, sitting on a raised seat or stool with legs hanging down was considered crude, and only appropriate when hunting or at war.[6]

One of the earliest forms of a raised seat came to China adopted from a hostile foreign culture in Central Asia. The Chinese battled with peoples of Central Asia for centuries beginning at least as early as the third century BCE. To defend against incursions by these expansive peoples, the Chinese rulers erected the Great Wall. Some of

these groups had military advantages that the Chinese eventually adapted such as riding into battle on horseback rather than on chariots, as the Chinese originally did. The folding stool was also adapted by Chinese generals and high officials from the foreigners referred to by the Chinese as barbarians, or *hu*. The stool offered an excellent raised perspective for reviewing troops and a battle site in a seated position that allowed for both resting the legs and, at the same time, being prepared to easily jump up and run to combat.

Trade, Battles, Religion, and the Entrance of the Raised Seat

The thoroughfares by which goods and people were transported from China to Central Asia, Persia, India, and even to Rome, often referred to as the Silk Road (Fig. 10), carried far more than just silk and consisted of many more than one individual road. Conflicts arising from territorial expansion by the Chinese and their neighbors led to China's development of outposts and roads in the vast regions north and west of the capital. Merchants carrying exotic luxury and utilitarian items soon followed along those new roads. The extent of the exchange of goods and information conveyed across these byways is demonstrated by the historic first-century CE prohibition against silk clothing by Tiberius in Rome, who was fearful of draining his empire's gold reserves when the Chinese ruler Wang Mang insisted that all Chinese exports be paid for in gold.

The customs, lifestyles, and belief systems of those traveling along these roads also journeyed across the mountains, rivers, and deserts. By the end of the Han dynasty, the Chinese interest in the Indian religion of Buddhism was so strong that Sanskrit texts from India were already being translated into Chinese. The ways and manners of this new religion would have deep impact on generations of Chinese ideologies and lifestyles.

The seating position on an elevated surface arrived in China from far beyond its borders. From several distinct directions, a diversity of apparatus to allow that position came with this pose. The folding stool and the chair—two of the most significant types of seating in China—were introduced and inspired by outside cultures and arrived via the routes of traders and religious seekers through northwest China. The folding stool was adopted from the Central Asian cultures and probably traces its own journey back to Rome and possibly even Egypt. The chair (complete with armrests and backrests) and an array of stools were of Indian origin.

Figure 10 Map of historic trade routes to and from China. Drawing by Leigh Mantoni-Stewart.

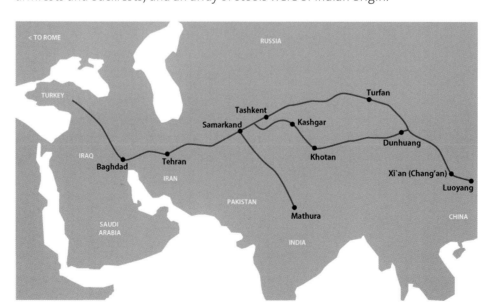

When the Han dynasty emperor Lingdi (168–189 CE) declared his fondness for what he called a "barbarian bed" (*huchuang*), he left definitive evidence of his understanding that this conveniently portable device for seating came from beyond the borders of his own country. The word *hu* used in this early term for the folding stool appears in the identifying term for a number of Chinese objects adapted from cultures beyond China's borders, particularly those to the west. Scholars have postulated that the people referred to as the Hu in Chinese records may have included the Xiongnu (sometimes identified as the Huns), with whom the Chinese had numerous encounters, friendly and unfriendly, over the centuries. The frequent contact with these foreigners resulted in the Chinese interest and adoption of *hu* customs. The account in the historical records of the Later Han dynasty, *Hou Han Shu* (Book of Later Han), notes that the emperor "Han Lingdi liked *hufu* (clothes), *huzhang* (curtains), *huchuang, huzuo* (seats), and *huwu* (dancing)."[7]

The application of the preface *hu* in describing the folding stool in Han China was more accurate than the Han emperor may have guessed. The folding stool had been a fixture in many non-Chinese lands for centuries. It was already in use in Egypt as early as the Middle Kingdom (2000–1500 BCE), and Tutankhamun (reigning 1332–1322 BCE) had a folding stool placed in his tomb almost 1,500 years before Han Lingdi considered this manner of seating. The lifestyles of the ancient Greeks, Etruscans, and Romans all encompassed folding stools and images of them abound in the murals and stone reliefs of the ancient Mediterranean.

Han Lingdi's selection of the seat, either knowingly or unknowingly, was also exceedingly appropriate. Though everyday people sitting on folding stools by the side of the road is a common sight today, Lingdi was following in the steps of his royal colleagues around the world when he adopted this distinctive stool as a seat for the powerful. In ancient Egypt, commanding officers, men of rank, and pharaohs sat on folding stools, often carved with goose-head terminals and inlaid with ivory (Fig. 11). In ancient Greece, the *diphros okladias,* usually ornamented with lion's paws for the feet, were reserved for men and women of high status (Fig. 12). And in Rome, the *sella curulis*—literally the "seat of the court [magistrates]"—was just that.

Figure 11 Egyptian stool, 1500–1300 BCE. Drawing by Susan E. Schopp after Ole Wanscher, *The Art of Furniture: 5,000 Years of Furniture and Interiors,* trans. David Hohnen (New York: Reinhold, 1967), 46.

Figure 12 Greek stool, ca. 520–10 BCE. Drawing by Susan E. Schopp after Ole Wanscher, 70.

What distinguishing feature of the folding stool attracted the likes of magistrates, emperors, and military commanders? Clearly, their portability, made possible by their folding mechanisms, made the stools convenient. Wherever the man of status traveled, he was assured an elevated place to rest. Moreover, in a society where primarily only the privileged traveled from place to place, the folding seat was, like a luxury car today, a symbol of status. It was carried high upon the shoulders of a servant as a Chinese official's entourage moved along a road, through the mountains, and passing through towns, a scene that was pictured in a number of Song-dynasty paintings. This portable furniture made as much of a statement to passersby as the

Figure 13 Woodblock illustration from *Tu Chishui Piping Jing Chai Ji*, published ca. 1595.

Figure 14 Folding settee for three *Sanren Jiaoyi*, late 18th to early 19th century; elm with red pigment, 40½ × 62½ × 16 inches (104 × 158.7 × 40.5 cm). Photograph by Jeff Dykes.

intentionally evident *X*s, formed by the crossing bars of the stools, in murals portraying Greek and Egyptian men of rank seated on their folding stools, always in profile.

The construction of the folding stool is worth considering, particularly in comparison to the woodwork construction that appeared in China prior to the entrance of the *huchuang*. Two square wooden frames, one slightly wider than the other, are interlocked. The side vertical "legs" of each frame are attached to their counterparts on the other frame at the central point along their lengths. This attachment is accomplished with a single pin, usually metal, that allows the two joined components to swivel against one another. With these pins on either side, the contraption becomes stabilized. A flexible fabric such as rope, mat, or leather forms the seat between the two top horizontal frame members. The seat is an integral construction component that holds the entire structure together, preventing the two frames from collapsing.

Therefore, what appears to be a simple stool is indeed a complex mechanism that required inspired engineering. While the linchpin relates the structure to the wheel, the axle, and the chariot (which the Chinese were using as early as the Shang), the construction is distinct from Chinese woodwork joinery before the Han. As described earlier, the Chinese had had a tradition of mortise-and-tenon wood construction since Neolithic times. With the entrance of the folding stool from the West came not only a new posture of raised seating, but a new form and a new technology, both previously unknown in China.

In the hands of China's inspired woodworkers, the *huchuang* developed in myriad directions. By the Song dynasty, the stool had a unique backsplat that offered the sitter an opportunity for greatly increased comfort. The beautiful rounded back wrapped around the sitter, creating both a backrest and armrests, so that the entire torso, not only the legs, was supported. The rounded crestrail became a significant accoutrement for the finest folding chairs. This new round-back folding chair then became a primary seat of status (Fig. 13). In many portraits of ancestors, emperors, and Buddhist priests, from the Song through the Qing (1644–1911) dynasties, the honored personage is depicted sitting in a round-back folding chair.

Creative minds of the Ming period (1368–1644) continued to devise more solutions for portable seating and lounging. They produced straight-backed folding chairs as well as "double" and "triple" folding chairs with backs that could easily be carried from home to watch an opera at the village temple (Fig. 14). An elegant elaboration of the folding stool was the *zuiweng yi* ("drunken lord's chair"), which offered the man

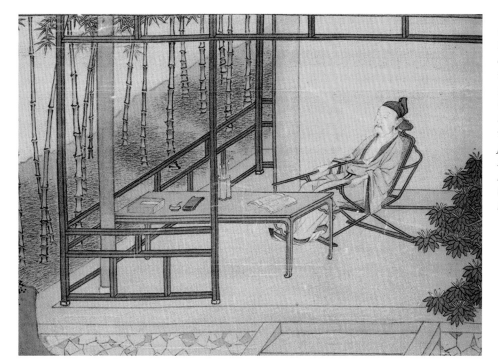

Figure 15 Qiu Ying (1494–1552), *Reading Quietly in the Shade of the Wutong Tree;* hanging scroll, ink and color on silk, 57⅞ × 25¼ inches (147 × 64.3 cm). National Palace Museum, Taipei. Lina Lin and Sergio C. Young, *Huo zhong jia ju te zhan/Catalogue to the Special Exhibition of Furniture in Paintings,* trans. Donald E. Brix (Taipei: National Palace Museum, 1996), 67.

of leisure support for a full and luxurious recline with the convenience of portability (Fig. 15; Plate 61).

When the folding stool arrived in China it consisted of an assemblage of eight wooden sticks. During the following centuries, the stool evolved into an elegant, even higher, often luxuriously ornamented form that seated emperors, priests, and ancestors. But with the abundance of chairs and chair forms in the current century leaders no longer need carry their own furniture around and new international trends have dictated alternative seating for them. Except among connoisseurs and collectors, the folding stool and chair have fallen from high fashion. It has far from fallen out of use, however. The convenient portability of the folding stool has maintained its consistent existence on the floors and ground of China. The folding stool still fits perfectly into the routine custom of many in the Chinese population who sit outside, day and night, to gather and talk with friends. The stool fits nicely into the cramped spaces of most urban Chinese homes. Lightweight, it can be easily transported. On the narrow *hutong* (alleys) of Beijing, on the doorsteps in rural villages, and along mountain pathways, the small folding stool endures (Fig. 16).

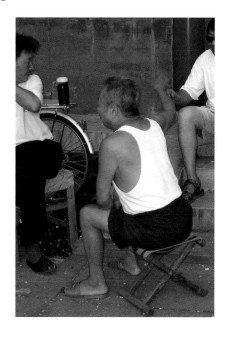

Figure 16 Man on street, August 2005. Photograph by Nancy Berliner.

As the concept of elevated seating became less "foreign," alternate modes of seating were introduced from cultures further south. Military strategy and state authority may have been motivations behind adoption of the folding stool. Religion, an equally powerful force, may have been the instigator for other seat types.

Buddhism traveled to China from India first along a route paved by merchants and military strategists. Once the populace in the Chinese territories became intrigued by Buddhist approaches and quests, many of the devout began to follow the old routes—through Turfan in the deserts of modern Xinjiang, to Tashkent and Samarkand (in modern Uzbekistan), Bamiyan (in Afghanistan), Peshawar (in Pakistan), to India. In pursuit of original texts and native teachers, these brave souls would spend years on the road gathering information to bring back to their compatriots. Some of these pious devotees recorded what they saw, detailing rituals, customs, accoutrements, and even the furniture—including chairs—used among the Indian practitioners at the source of the belief system. Close inspections of Indian relief sculpture and texts from the first centuries of the first millennium CE reveal an abundance of seat types.

Deities, kings, and their disciples depicted in this early Indian imagery sit on chairs, platforms, cushions, and round stools. The similarity between some of these accommodations and the forms that subsequently appear in later Chinese imagery is evidence of the Indian origins of many Chinese seating forms. The *Mahavagga,* the early Buddhist text probably first assembled in the fourth century BCE, specifies precepts for those following the Buddhist path. In addition to prohibitions against the taking of life and sexual intercourse, the precepts include guidelines that curb the disciples from living too luxurious a life.[8] Later commentaries on the text give further details on what types of furniture are allowed, specifying chairs with and without backs, chairs with and without arms.

A second-century CE stone relief from the Amaravati stupa in southeastern India presents a picture of a palace scene and a range of seating that most probably existed in India at that time. King Suddhodana sits on a stately yoke-backed throne, one leg folded up on the seat's surface (Fig. 17). Beside him stands his wife, Maya, who has just had an elaborate dream that an elephant—a potent animal in South Asian culture— had circled her three times with a lotus flower in his mouth and then entered her

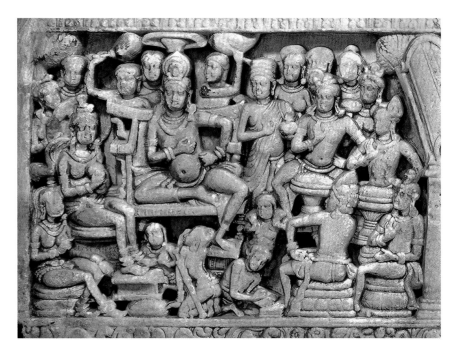

Figure 17 Amaravati relief, railing coping slab, Andhra Pradesh, India, second century. © Copyright the Trustees of The British Museum.

26

right side. The couple is surrounded by attendants, courtiers, and sages gathered to interpret the dream. As they deliberate, some members of the group stand, some are seated on the ground, but at least six sit on round stools.

Construction began on the stupa at Amaravati in the second century BCE, just after the reign of India's great Buddhist ruler Ashoka. Buddhism flourished in the following centuries, and the stupa, located in the region now known as Andhra Pradesh, was periodically repaired and enhanced. In the second and third centuries CE, a growing and increasingly wealthy merchant class in the region contributed a great number of carved reliefs such as this one to further celebrate the monument. The surroundings and seats in the relief imagery most likely reflect the lives of these merchants.

Round Stools

The stools on which the attendants around the king and queen sit fall into two categories. One type appears to be round and cylindrical, with fairly perpendicular sides, and comprises three sections. The roundness and slight bulging from the weight of the sitter suggest that these seats may have been a pile of round, stuffed cushions stacked one upon the other, or one cylindrical, stuffed fabric, tied at intervals.[9] The second stool type takes an hourglass form. Two members of the king's audience sit upon this type of stool. Cones taper from the wide, round seat and base, meeting and joined sturdily at the central point. The materials used for each of the two stools seem to differ. The one on the right shows thick strands of a material that emanate from the central join. The thick strands may have been a strong plant fiber.[10]

The left-hand hourglass-shaped stool shows no sign of these fibrous strands and could have been a clay, wood, or even metal version of the former. According to Amin Jaffer, a number of eighteenth- and nineteenth-century Indian miniature paintings depict craftsmen creating wooden and clay stools of this shape.[11]

Now, let us make the return trek to China, where this stool has been termed a *quandun*. The Chinese character for *quan* is written with the ideographic element (known as a radical) for bamboo indicating the material of which it must have been commonly constructed. The word itself is usually used to mean a "bamboo fishing net" and the fiber stool does resemble a type of a fish trap. The word *dun*—literally a block of stone, a mound, or a stump—is commonly used in Chinese to refer to round stools that resemble a block. *Dun* are definitively differentiated from *deng*, square or rectangular stools with four legs; unlike the *deng*, which is derived from architectural construction, the *dun* seems to be an imported form.

The hourglass stool took its place among the various seats of China and for many centuries was a standard option in a diverse variety of forms and materials. It appears, for example, in Buddhist *jataka* tales in fourth-century murals at Dunhuang as well as the seats for Tang dynasty female tomb figures. The variety of appearances of the hourglass stools suggests the type was popular enough that furnituremakers experimented widely with its appearance (Figs. 18 and 19).[12]

The scholar Dong Boxin speculates that the *quandun* is the ancestor of a stool type known as the *xiudun*[13] that appears in the Song dynasty and continues to be a basic element in Chinese furniture through to the twentieth century. The hourglass-shaped stool virtually disappears from the Chinese seating roll call, while paintings, woodblock prints, and actual artifacts provide strong evidence of the *xiudun*'s ascendancy in its place. The *xiudun* is a round stool made from reeds, bamboo, wood, or even stone and shaped like a Chinese drum—a cylinder with bulging sides—or created from a hexagonal assembly of vertical rings topped by a round seat (Plate 48). It served the same purpose and had similar limitations as the *quandun*. As with the

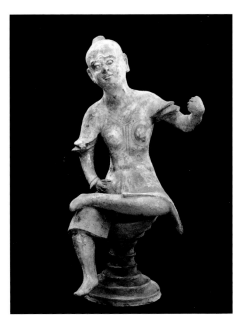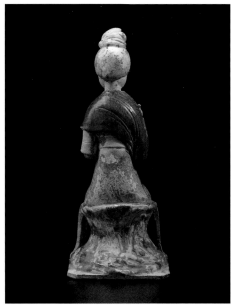

Figure 18 Man on stool, Henan, sixth to seventh century; earthenware, color pigments, height 16⅜ inches (41.6 cm). With permission of the Royal Ontario Museum © ROM.

Figure 19 Seated female figure, Henan/Shaanxi Province, North China, Tang dynasty; earthenware, color pigments, 13 × 5½ × 6⅛ inches (33 × 13.9 × 15.7 cm). Gift of H.W. Kent, 1938. National Gallery of Victoria, Melbourne, Australia.

quandun, the sitter could rest on the *xiudun,* but only with legs hanging down. It did not allow for the complete lolling possible with the armrests and backrest of a chair. Likewise, the *xiudun* allowed for making hierarchal differentiation visually apparent. A quick glance at a group of seated men will immediately reveal the ranking among them by who is sitting in what type of seat.

In China, the hourglass stool was an imported form that was experimented with over several hundred years by Chinese artisans, in whose hands it was molded into a range of forms and materials. It graced rooms and supported Buddhist disciples as well as proper ladies. Then, unlike the folding stool, it lost its appeal among the Chinese fashion setters and lost its utility among those needing to rest their feet. The form that it sparked, however, the *xiudun,* reverberated with an enduring set of Chinese aesthetics and lasted for many more generations.

Like the *quandun,* the earliest *xiudun* were probably constructed from reeds. The artisan curved bundles of reeds to form a ring, which he then secured with a tie. Five of these reed rings were placed in a circle vertically and were then attached to horizontal rings at the top and bottom. As with the *quandun,* the folding stool, and other foreign-style furniture entering China, the construction of the *xiudun* did not relate to the mortise-and-tenon joinery that was the staple of Chinese furniture. Like the folding stool, the *xiudun* was light and portable, perhaps advantaging its endurance through the generations. In time, the *xiudun* shape—like that of the *quandun*—came to be formed with a wide variety of materials, from bamboo to finely crafted and joined wood components, ceramic, and stone.

The wealth of stools mimicking and improvising on the *xiudun* in shape and construction demonstrates the popularity of this form. The *xiudun* form was stable, convenient, and attractive to the Chinese eye. By the twelfth century, paintings depicted figures seated on lightweight bamboo and reed *xiudun* (Figs. 20 and 21) as well as their solid and much heavier cousin, the stone drum stool. These variations all continued to trigger further versions. There are stone imitations of the original reed-ring construction, complexly joined wooden versions that maintain the evocative oval openings around the sides, cloisonné metal stools with the characteristic intertwined rings on the sides and metal knobs around the rim in imitation of the nails around a drum's edge, and solid-stone drum stools with trompe l'oeil textiles draped atop them for the virtual comfort of the sitter (Plates 49, 50, 53, and 54).

With Chinese Buddhist monks recurrently making the arduous journey to India to search for the sources and deeper comprehension of the wisdom of their religion, a continual, if slow, flow of information about Buddhism as well as Indian lifestyles made its way into China.

Already during the Han dynasty, as we have seen, the Chinese elite were sitting on elevated, if relatively low, platforms with four legs. Often screens encompassed two or three sides of the platform to protect the sitter from winds. But the chair is a different and more complex object than either the platform or the stool. Ever since it arrived in China, the chair form has inspired sitters and artisans to embrace it as well as embellish it.

Returning to the revealing relief of the interpretation of Maya's dream from the Amaravati stupa, let us focus on the seating accoutrement of the king. He listens attentively to the thoughts of his audience while seated in an elevated chair (Fig. 17), one leg upon the chair's surface and one hanging to the floor. The thronelike chair—and the king is the only one provided with such a chair—has arm supports and a handsome back support. It expresses a celebration of the sitter, which is particularly apparent in the crestrail that protrudes beyond the rear posts of the chair and lifts upward at each end in a manner now so familiar to Ming-furniture connoisseurs.

The armchair was not limited to this single appearance on a panel at Amaravati. In addition to the textual references from the *Mahavagga*, a handsome armchair with ornamentally carved legs, a back, and arms is the honored seat for a king depicted at Sanchi. The king makes good use of the chair's back and armrest. He sits far back in the seat, his back against the chair's rear railing and his arm draped over the armrest, balanced by his hand at the front. Similar chairs appear in several other monuments from the same time period.[14] And, by the fifth century, Chinese Buddhist sculptures and paintings depicted the Buddha and Buddhists seated in chairs with their legs in a hanging position.

Many Buddhist texts, some translated into Chinese as early as the third century, refer to chairs, in particular "corded beds," *shengchuang*. The name implies cords or rope strung or woven across the axis of a seat. The seventh-century Chinese monk Xuanzang (602–664 CE), who traveled to India in pursuit of sacred texts, described

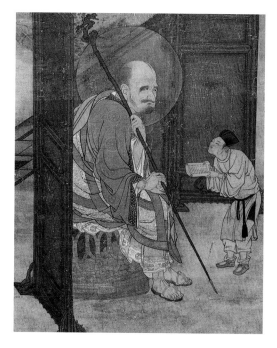

Figure 20 Liu Songnian (active ca. 1175–after 1207), *Lohan* from *Images of Lohans;* hanging scroll, ink and color on silk, 46¼ × 22 inches (117.4 × 56.1 cm). Lin and Young, 79.

Figure 21 Woodblock illustration from *Shuihuzhuan* (The Water Margin), Ming dynasty.

elite members of society sitting on elaborate *shengchuang*. Indian Buddhist texts additionally reveal that these chairs had become common accoutrements in monasteries for the seating of respected religious men.[15] By the eighth century, Chinese poets were already using the term *shengchuang* in their poems and presumably using these "corded bed" chairs in their daily lives. The "cords" of their chairs were most likely the origin of the woven cane seats that became so basic to Chinese chairs and stools.

The first most distinguishing factor of a chair is the attached backrest. Like a screen, this section provides a sense of veneration to the sitter. The grand backrest frames the respected sitter. However, unlike a screen, this new element also allows the sitter to lean backwards, to relax in a position that supports the weight of the torso and the muscles of the back. The woven rope on the seat of the *shengchuang* also afforded a comfortable and flexible surface.

The armrests of the chair offered further comfort. The chair's height also allows the sitter's legs to hang toward the ground rather than being folded up on the seat. As can be seen in many Indian and later Chinese images, many people chose to keep one leg on the surface and one hanging. In time, as can be seen in Buddhist figures at Yungang and Mount Xumi as early as the fifth century, the option of hanging both legs was growing in popularity.

Chair construction is a far more complex manipulation of joinery than that of the stool, table, or screen. The backrest and armrests of a well-utilized chair are subject to bearing great amounts of weight and stress, as they project into space without auxiliary supports. Furnituremakers needed to develop structures of joined frameworks to accommodate the weight and forms of the chair (Plate 40). The rounded backrest, discussed above, was one of the ingenious solutions to add greater comfort and visual enhancement to this seating arrangement (Plate 47).

The great Tang dynasty saw China's capital city, Chang'an, bustle with foreign merchants—Persians, Arabs, Indians, and Jews sold gems, spices, and medicines from distant kingdoms. Buddhism had become so popular that Empress Wu Zetian (625–705) replaced Taoism with the foreign belief as the state religion. By this time, the chair was becoming standard apparatus among the elite members of society. This was noticed by the Japanese Buddhist monk Ennin (794–864, full posthumous name Jikaku Daishi), who traveled in China, first as a member of a Japanese official mission and then, from 838 to 847, on his own to study Buddhism.

Ennin kept a detailed diary recording all of his ventures, his observations about Buddhism, and all the peculiarities and customs of daily life in China. Chairs, which were not part of Japanese mat-level lifestyles, were among the objects he noted in the environments he visited. He describes visiting at a temple, where he met with Li Deyu, an important scholar and official. Ennin and his companion were invited to sit on chairs during their discussion with the esteemed official. Elsewhere, he tells of the preparations made at a monastery for the emperor's visit. On such occasions, the emperor ordered the monasteries "to arrange benches, mats, and carpets, to tie flowered curtains to their towers, and to set out cups and saucers, trays, and chairs."[16] Interestingly, a twelfth-century Japanese portrait of Ennin shows him seated in a chair.[17]

The adoption of the chair by the Chinese elite is comprehensible. While the folding stool may have offered a military advantage and the elevated seat provided a visual status as well as distance from a cold ground, the chair offered comfort. They both carried the prestige of an exotic foreign style.

In an Elevated China, an Abundance of Designs

The most dramatic impact of non-Chinese cultures on Chinese furniture and interior living styles was the adopted custom of sitting higher off the ground. This change provided artisans with an opportunity to use their imaginations and skills to create a wide range of intriguingly shaped and ornamented chairs and stools as well as tables and other large furnishings to support living higher off the ground. In the centuries following the general population's adoption of raised seating contrivances, as furnituremakers and their sophisticated patrons devised manifold designs, a distinct Chinese style—or styles—began to coalesce. It is these styles and those that further percolated from them that came to represent Chinese furniture as we think of it today. The Chinese historic furniture in this exhibition reflects the flourishing of design that developed following the Song dynasty and the styles that came into being during the Ming and Qing periods.

Returning to our Ming scholar sitting on his elegantly proportioned armchair at his desk, the lines of the table's and chair's rounded spandrels and round legs evoke a satisfying balance between the round and the rectangular. Looking closer, we might also see that there is no thick lacquer on the surface of this desk. Instead, the scholar's books and papers sit on an exposed, beautifully planed, and delightfully grained wood. The wooden cylindrical pot holding his brushes is formed from an organically shaped chunk of a tree, reinforcing the scholar's identity as one with nature. Contemporaries of our quintessential Ming scholar were amassing large collections of rocks and organically shaped wood; others were writing treatises on interior decor and garden design. They were keenly aware of aesthetics and philosophies. Many were determined to infuse their surroundings with meaning, reflecting principles imbued in Taoism, Buddhism, and Confucianism. The result was the apparently simple and plain, but, in point of fact, highly studied, carefully proportioned, and elegantly designed realm of Ming-style furniture.

The restrained-style chair in plate 40, with its architectural, round members, expresses the dignity and earnestness that the seventeenth-century Chinese scholar strove for in all of his environments. Frills and ornamentation were considered frivolous and gaudy. The sole superfluous decoration on the chair is a branch of the plum blossom and a poem carved into the backsplat (Fig. 22). Plum branches, which blossom during the chill of the very early spring, are a frequent motif in scholar painting and poetry, conveying the stalwart righteousness of virtuous scholars and officials in difficult times.

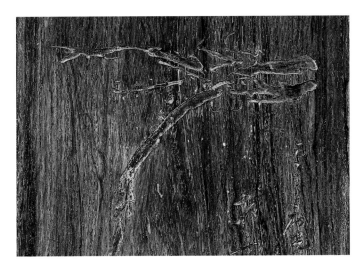

Figure 22 Backsplat of chair, 16th–17th century; *huang-huali* (detail of Plate 40).

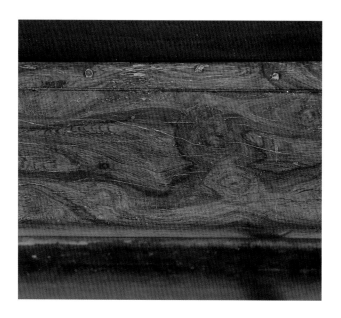

Figure 23 *Huanghuali* wood
(detail of Plate 66).

While Ming-style furniture has commonly come to be considered quintessentially Chinese, it is apparent that the flow of foreign cultures into China did not entirely drain away, and foreign cultures continued to have an impact on furniture forms and styles. One of the most significant influences on Chinese furniture during the middle of the Ming dynasty was the influx of large quantities of fine hardwoods from southwestern China and Southeast Asia. Import regulations were modified in China during the sixteenth century allowing timbers such as *huanghuali* (*Dalbergia odorifera*; Fig. 23) and *zitan* (belonging to the *Pterocarpus* genus; Fig. 24) to enter the domestic market and have a surprisingly vital effect on Chinese furniture fashions and history.

The low *zitan kang* table (Plate 36), which would have been used on the raised surface of the brick oven *kang*, where northern Chinese lived, slept, and entertained during winter months, articulates the outstanding capacities of working with hardwood materials. Because of its fine and tight grain, *zitan* wood—which is so dense that it sinks in water—can polish to a brilliant and glossy surface that clearly has no need for a thick, opaque lacquer coating. Its tight and fine grain also permits artisans to carve *zitan* with exquisite precision. In Chinese literature on furniture, carved *zitan* is often compared with the carvings of jade, another extremely hard and dense material that can be shaped by master artisans into delicately carved, velvety surfaces. The *kang* table's stretchers imitating a thick, twisted rope are a superb example of this quality of the most desirable of Chinese furniture woods (Fig. 25). The illusionary rope with

Figure 24 Detail of the leg
and apron of a 17th-century
zitan table.

Figure 25 *Kang* table,
18th century; *zitan*, jade
(detail of Plate 36).

its perfectly executed knots is not the primary device binding together the table's parts. Invisible to most viewers is the stunning and intricate joinery: multiple tenons at the ends of the table legs and the stretchers and stepped mortises on the legs and table surface, all of which fasten together the components of this *zitan* furniture.

The complex joinery made possible by hardwoods also enhanced the grace and detail of beds—the most celebrated works in a household of furniture—which must be dismantled and reerected whenever they are moved through the narrow and low doors of a Chinese bedroom. Intricately incised coats of polychrome lacquer and inlaid ornamentations were primary decorations for some beds, but with hardwoods, works such as the seventeenth-century bed in plate 66 were possible. The exquisite latticework of this bed reveals the beauty that could be attained when hardwood was worked by the finest artisans. The lattice was not created by whittling away wood from a single plank. Instead, furnituremakers carefully fabricated small lengths of *huanghuali,* each with a mortise at one end and a tenon at the other. The lengths fit together tightly to create a complex and captivating web of latticework, a translucent partition that functions as a railing as well as a mysterious and elegant frame for the paramount activities of the bed.

New techniques, styles, and motifs continued to drift into China providing a world of new decorative and aesthetic possibilities to cover the bounteous array of furniture that was filling Chinese indoor and outdoor spaces. The stunning blue-and-white porcelain that became such a symbol of Chinese style in Europe, America, Southeast Asia, and the Arabian countries only came to fruition in the Yuan dynasty (1279–1368), when cobalt was imported to China from Persia. Porcelain makers soon applied this pleasing glaze mixture with stunning designs to create ceramic blue-and-white drum stools for seating in the highly designed gardens of the period.

Cloisonné—a technique of melting colored enamel paste within brass-wire enclosed spaces to create vibrant, multicolor surfaces—provided yet another decorative aesthetic variation (Plate 63). Probably originating during the sixth or seventh century in the Byzantine empire, from where it traveled east to China and west to Europe, the technique can often be seen on Byzantine and medieval European ritual implements. Appearing in China during the Yuan dynasty, cloisonné rose to popularity during the Ming dynasty's Jingtai reign period (1449–1457), from which it took its Chinese name, *jingtailan* (Jingtai "blue"), as blue is a predominant color in much cloisonné. The emboldened Qing-dynasty imperial workshops created an abundance of sumptuous cloisonné vessels and furnishings, exploiting the multiple colors, combinations of patterns, and variety of shapes possible with these techniques.

The fanciful seventeenth-century cloisonné drum stool (Plate 49) borrows its form from the bamboo and rattan *xiudun* that had been used in China for centuries among both the well-to-do and the less privileged, who used only locally available materials. But the *xiudun* form contributed neither the structural engineering nor the decorative surface of this stool. The maker instead made use of a metal structure and the cloisonné technique to provide a vibrant and colorful texture for a piece that certainly would have stood out in a room of monochrome wooden furniture.

The influence of China on Japanese culture—from written language, to the transfer of Buddhism, to porcelain and painting styles—is well known. Less remarked upon is the influence of Japanese design on Chinese furniture during the late Ming and early Qing periods. Japanese lacquer furnishings became desired objects among the Chinese elite. "Sprinkled gold cupboards, sprinkled gold writing tables, painted gold cosmetic boxes, sprinkled gold portable boxes, plastered gold painted screens" were all noted as objects coming from Japan to China during the Wanli reign (1573–1620).[18]

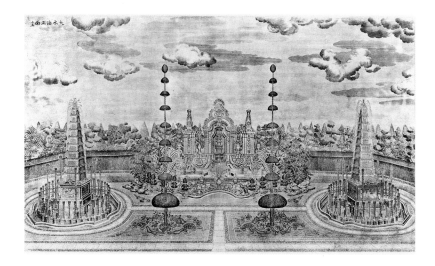

Figure 26 Copperplate print of European palaces at the Yuan Ming Yuan, 1783; 34½ × 20 inches (87.6 × 50.8 cm). Photograph © Christies, Inc.

The great late-Ming lifestyle commentator Wen Zhenheng (1585–1645) also mentions Japanese objects, including their lacquered incense boxes, dressing cases, tables, cupboards, and display shelves.[19] The Japanese cupboards and display cases most likely were the primary inspiration for a new asymmetricality that appeared in Chinese cabinets and display cases during the late seventeenth and eighteenth centuries.

Armed with a multiplicity of furniture forms and materials, aesthetics, and joinery, Chinese furnituremakers, from imperial workshops to village squares, created an array of variations on furnishing themes. The objects of Chinese furniture presented to the contemporary furnituremakers at the workshop leading up to *Inspired by China* are among the products of those prolific creators. While what is today commonly called traditional Chinese furniture displays influences from Persia, Central Asia, India, Constantinople, and even Southeast Asia, the term rarely includes objects influenced by Europe and America. In fact, foreign cultures, including Europe and America, never ceased to sway the forms, types, and decor of furnishings in China.

Inspired by Europe

The close of the sixteenth century marked a turning point for some among the Chinese elite who were looking for fresh aesthetic inspiration from beyond their cultural borders. Christian missionaries arrived from Europe, carrying illustrated Bible stories as well as European artistic techniques. Before long merchants docked, loaded down with their own accoutrements and, soon thereafter, they brought commissions for European-style furniture. The elite and the artisans were the first to come in contact with this new type of foreigner, who were different from those of Central Asia, and they were intrigued. While no revolutionary sitting postures or construction techniques emerged from these contacts, new aesthetics and decorative details slowly slipped into Chinese living spaces.

The Kangxi, Yongzheng, and Qianlong emperors all favored the Jesuit artist Giuseppe Castiglione (1688–1766), who went to China as a missionary in 1715 and became an influential painter and designer in the imperial workshop in Beijing. Under the Qianlong emperor, Castiglione also assisted in the design of European-style palaces within the vast imperial garden complex known as Yuan Ming Yuan on the outskirts of Beijing (Fig. 26). The styling and ornamentation of these grand stone buildings, unlike anything seen before in China, introduced new and dramatic possibilities for three-dimensional decor. The influence of Castiglione—and that of other Beijing-based Jesuits with similar artistic talents—on the aesthetics of the eighteenth and nineteenth centuries are evident from the rococo and European

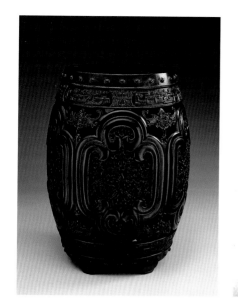

elements integrated into some Chinese furniture such as an ornately carved, eighteenth-century *zitan* drum stool (Fig. 27).

The eighteenth and nineteenth centuries brought to China's shores an increasing number of Americans and Europeans, most of whom were now outside the walls of the imperial household. Foreign merchants and government officials, sensing that great fortunes could be made, bludgeoned their way into Chinese territory. Wars were fought resulting in foreign governments claiming rights on Chinese territories, including Shanghai and Hong Kong.

During the nineteenth century, the growing presence of Europeans and Americans, often as longtime sojourners in treaty port towns, stimulated a rise of European- and American-style furniture, particularly in the urban areas of China. Later the influence even spread inland, where missionaries were being allowed to settle and often commissioned furniture in the styles of their homelands.

The popularity of these "foreign"-style furnishings is apparent in the pages of the popular late nineteenth–century illustrated, Shanghai-published periodical *Dianshizhai*. A sitting room depicted in one illustration shows an intriguing mixture of traditional Chinese-style furniture and European-style furnishings (Fig. 28). The lady of the house plays a game with tiles on a round pedestal table, a table type that was so revolutionary and fashionable in nineteenth-century Europe and America that it radically transformed sitting rooms. Inspections of Chinese-made, European-style furniture from this time period often reveal that the furnituremakers used Chinese methods of joinery in their fabrication of these non-Chinese forms.

A generation or two later, Shanghai women who could afford to were still surrounding themselves with furnishings of the latest sophisticated international styles. In a late 1930s photograph (Fig. 29), a young woman, posed with a popular film magazine and an electric lamp, her hair permed into fashionable curls, sits in an upholstered metal-tube chair surely influenced by the Marcel Breuer (1902–1981) Wassily chair (1925) and his cantilevering 1928 Cesca chair.

With the advent of Chinese Communist-party rule in 1949, ruling fashions in dress and interior design tended to follow the revered Soviet precedents in the neighboring U.S.S.R. While the masses sat in whatever old chairs they had inherited, whether battered Ming or aging Deco, Mao and his comrades sat in the type of stuffed and upholstered chairs—politely covered at the appropriate spots with lacy antimacassars—that they had seen on visits to their northern co-Communists.

Figure 27 Drum stool, 18th century; *zitan* wood, 20 × 14 inches (50.8 × 35.6 cm). Photograph by Dean Powell.

Figure 28 Illustration from *Dianshizhai*, late 19th century; lithograph.

Figure 29 Portrait of a Shanghai woman, ca. 1930s. Private collection.

Late Twentieth Century—
A Revival of the Chinese Furniture "Tradition"

In 1976, the Cultural Revolution officially ended and by the early 1980s scholars were returning to their desks and artists to their studios. Publishing on ancient traditions was no longer prohibited, while images of European and American art and design began to filter into China. The art historian Wang Shixiang (born 1914) had been collecting and studying Chinese furniture since the 1940s and, in 1985, he was finally able to publish his treatise on the subject. He wrote about the woods, the joinery, the history, and the elegant design of what he called "classic Chinese furniture." The book, filled with large color plates, stimulated a new generation of collectors, connoisseurs, and devotees of Chinese furniture eager to learn more about this institution that seemed to represent not only a form, but a philosophy and approach to life. For a young generation, Ming furniture reflected both deep traditions of China and a modern approach to life.

Tian Jiaqing was a Chinese-furniture enthusiast and researcher long before he became a furnituremaker. As a disciple of Wang Shixiang, Tian took on the task of organizing international symposia for furniture researchers and collectors, plunging into his own research on joinery, and publishing on the then-unexplored field of Qing furniture. After ten years of research, restoration, and reproduction work, Tian felt ready to begin designing and creating what he calls his *Ming Yun* ("charms of the Ming dynasty") furniture (Plate 6). The earnestness with which Tian dedicated himself to the task of following in the steps of his Ming predecessors and the significance with which he imbues furniture is reflected when he remarks that "a piece of furniture is an illustration of the craftsman's spiritual and aesthetic taste, distinctively individualized like the man himself."[20]

China's new elite can again afford the luxury of fine furniture. Many of the well-to-do in China today are turning away from purely "foreign" styles and looking for a style that is both modern and reflective of traditional Chinese ideals. Tian's large, powerful pieces, such as his monumental *Reclining Dragon* altar table, carrying the lines and grace of Ming-style furniture, and made from the finest of hardwoods, have found a hungry market since 2000.

Many Chinese artists and designers, who twenty years ago were immersing themselves in American and European realms of contemporary-art thinking, are also now turning to the traditions of their native land for inspiration. During his first months in New York in the 1980s, the young Chinese artist Ai Weiwei became absorbed by the books of fluxist artist Joseph Beuys. Many of his works from that time reflect his deep interest in conceptual art. In the early 1990s, Ai Weiwei returned to Beijing, where he designed and built a modern courtyard residence using the same grey bricks that comprise old Beijing's courtyard homes. The house includes an office for his design firm and a large workshop where he works with traditional master woodworkers to create his works.

Together with the craftsmen, all from rural Anhui Province, Ai Weiwei designs furniture-sculpture that combines wood components of antique furniture and architecture, held together with intricately designed and crafted joinery. The large and powerful works, such as his *Table with Beam* (Plate 68), express the artist's deep reverence for the arts of traditional Chinese carpentry and what he calls the Ming approach to creating objects, an approach that demands maintaining a modest appearance though the hidden interior joinery holding the piece together may be considerably complex.

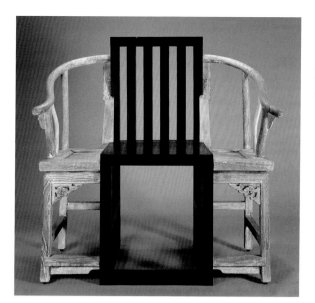

Figure 30 Shao Fan, *King*, 2000; elm and catalpa, 42 × 42½ × 30 in. (107 × 108 × 53 cm). Photograph courtesy of the artist.

Shao Fan, whose works deconstruct historical pieces of furniture, often marrying them to modern pieces, also transforms and manipulates traditional forms in new pieces (Fig. 30; Plates 4 and 52). He likewise expresses a deep reverence for traditional Chinese furniture and notes the resonance between the Ming and contemporary styles: "Ming-style furniture is a self-sufficient world. When you gaze at it, you yearn to travel into it, and when you travel into it, you try to restructure a whole new world for yourself. Ming-style furniture possesses a very special characteristic of Chinese classical aesthetics, but is also very fitting with modern people's sense of beauty."[21] The work of Shao Fan and Ai Weiwei can be viewed as the result of contemporary furnituremakers and designers assimilating ancient Chinese aesthetics—so distinct and removed from their modern Beijing lifestyles that those aesthetics could be considered foreign—into contemporary international art traditions. Alternatively, their works can be considered creations of Chinese furnituremakers integrating contemporary international art concepts into Chinese traditions.

For the past two thousand years, an awareness of outside and ancient cultures has been a fundamental part of the cultural tradition of China. The assimilation of aspects of those outside cultures has also long been part of the Chinese tradition. As scholars, artists, and furnituremakers—Chinese and American—look toward China's traditions for inspiration, the ever-evolving and amalgamating aspects of China's traditions become apparent. Foreign objects and customs such as chairs and folding stools, and the custom of sitting with pendant legs became so integrated into the Chinese lifestyle that they are now part of accepted Chinese tradition. A Chinese artist today, searching back to what he or she thinks of as ancestors' traditions, does not even consider that the chair was an importation from a foreign culture. Cross-cultural encounters, including those with the "foreign" cultures of the past, have continuously charged Chinese culture with a new vitality and transformed its tradition.

The Kangxi emperor once poetically noted that "Wheels move and times turn round." He was speaking specifically about European mechanical clocks of which he was unabashedly enamored, but also metaphorically about his nation's culture.

> The skill originated in the West,
> But, by learning, we can achieve the artifice:
> Wheels move and times turn round,
> Hands show the minutes as they change
>
> —Kangxi emperor (1654–1722)[22]

Notes

I would like to acknowledge the profound inspiration in regards to pursuing the history of Chinese furniture that I have received from the great scholar Wang Shixiang during the past 23 years. I am extremely grateful to Ned Cooke for his insightful critique of this text and whose collegiality, originality, and expertise has made this a most joyful professional collaboration.

1. According to John Kieschnick (*The Impact of Buddhism on Chinese Material Culture* [Princeton, NJ: Princeton University Press, 2003], 225), sitting with legs stretched out, with the weight of the torso on the buttocks, or squatting, was considered offensive and ill-mannered. Sages noting that outstretched legs indicated a lack of etiquette suggests that some people did relax in that position.

In pre-Shang dynasty tombs, in a Xiaotun grave pit site, two skeletons were found in the kneeling position. This posture continued through at least the Han dynasty, and extended not only to those in stationary positions, but also to those in motion. A close inspection of two half-scale model bronze and gold chariots found in the tomb of Qin dynasty (221–206 BCE) emperor Qin Shihuang reiterates the elementality of this position. The emperor's chariot drivers either stand or kneel, but never, as would be expected in a European cart driver, sit with legs pendant.

2. The *ji* was an H-shaped construction with a horizontal bar on which the seated person, body forward, could lean and rest the weight of his upper torso. The form of the *ji* evolved over centuries eventually becoming a three-legged object with a U-shaped horizontal surface that wrapped around the front of the body. With the arrival of the raised seat and then the chair centuries later, postures changed and the sitter could rest his weight backwards and sideways, on the backrest or armrests, rather than forwards. The *ji*, as a type of domestic furniture, had almost completely slipped from use by the late Ming dynasty.

3. Dong Boxin's book, *Zhongguo Gudai Jiaju Zonglan* (A Compendium of Historic Chinese Furniture) (Hefei: Anhui Kexue Jishu Chubanshe, 2004), provides an excellent overview and a superb assembly of images of ancient, excavated furniture. The thoroughness of this book has made it an invaluable resource in the research for this essay.

4. *Hubei Dangyang Zhaoxiang 4 hao Chunqiumu Fajue Jianbao* (A Brief Report on the Excavation of the Spring and Autumn Period Tomb Number 4 at Dangyang Zhaoxiang in Hubei Province), *Wenwu* 10 (1990): 25–32.

5. Kieschnick, 248.

6. Koizumi Kazuko, "The Furniture of the Shosoin in Relation to Ancient Chinese and Korean Furniture," in *The Treasures of the Shosoin*, ed. Kimura Norimitsu (Kyoto: Shikosha, 1992), 44–51.

7. It is interesting to note that in Japan, until the Nara period (710–794 CE), all chairs and stools were used only among the ruling elite for ceremonial purposes—and fell under the name of *agura*, the Japanese pronunciation for the characters *hu chuang*. Kazuko, 44–51.

8. Precept 87 in the "Pacittiya" section of the text notes that "acquiring a bed or bench with legs longer than eight *sugata* fingerbreadths after making it—or having it made—for one's own use is a *pacittiya* offense." http://www.accesstoinsight.org/lib/authors/thanissaro/bmc1/

9. The *Mahavagga* also mentions cotton as being a luxurious material. These cushionlike stools may be the sumptuous seats that the texts prohibit.

10. Another stool that appears in the Amaravati carvings was drawn in 1816 by the British surveyor general of India, Colin MacKenzie (1754–1821). It is clearly constructed of woven bamboolike strands. This *Amaravati Album* by MacKenzie is now in the collections of the British Library and can be viewed on the internet at http://www.bl.uk/collections/amaravati/mackamaravati.html. In the eighteenth century, these stools, known in India today as *morha*, were already being exported to England, where they were readily adapted, used as side tables or stools. Today, the *morha* is still produced and used as seating in India.

11. Amin Jaffer, *Furniture from British India and Ceylon* (Salem, MA: Peabody Essex Museum, 2001), 394.

12. Among the multitude of figures depicting a *jataka* tale on a mural in the Northern Liang period (397–439) cave 275 of the Dunhuang Buddhist temple complex in northwest China, one man clearly sits upon a stool with characteristic lines tapering toward a central, narrow waist. From the western regions of Dunhuang, the distinctively shaped stool also found favor further into the heart of China's territory. Over a century later, an image incised with flowing lines into a stone funerary building, dated 573, in Shandong Province, 1,500 miles to the east, depicts a host speaking with a visitor. The host, wearing an official's cap, a wide-sleeved belted robe, and pants, sits on an hourglass-shaped stool, with one leg down and the other across his knee.

The shaped stool continued to find favor in the following years. Among the many funerary objects excavated in 1955 from the eighth-century tomb of a noblewoman at Wangjiawen, Xi'an Shaanxi Province, were three three-colored glazed ceramic female figures, each 47.5 cm in height. Each of the women sits on a slightly differently constructed seat. One of them, like the model on the Amaravati stupa, appears to be constructed of entwined fibrous materials. The materials depicted in the other two are difficult to determine. The surfaces of both are decorative and may have been carved from stone or wood, built up from pottery, or possibly even bronze. Moreover, we can see from these figures that, by the Tang dynasty, stool seating was no longer reserved for ranking men. Women, at least women of some status, had literally moved up.

Moving further east, a clay figure excavated from a tomb in Henan Province sits on an hourglass stool formed to appear as a series of short cylindrical shapes piled upon each other in ever-decreasing and then ever-increasing diameters. Like the Tang women's stools, this stool again demonstrates the diversity of forms that this stool type inspired among craftsmen.

13. Dong Boxin, 105.

14. A. L. Sriastava, *Life in Sanchi Sculpture* (New Delhi: Abhinav Publications, 1983), 75 *n*25.

15. The *Dharmaguptakavinaya*: "When a visiting bhiksu arrives and sees the room of a resident bhiksu, the resident bhiksu should set out sitting implements like a corded chair." Kieschnick, 238–39.

16. Edwin Reischauer, *Ennin's Travels in T'ang China* (New York: Ronald Press, 1955), 247.

17. Ibid., frontispiece.

18. Recorded in the Wanli period book *Riben kao* (A Study of Japan) by Li Yangong and Hao Jie, as noted in Craig Clunas, *Superfluous Things: Material Culture and Social Status in Early Modern China* (Urbana: University of Illinois Press, 1991), 58.

19. Ibid., 59.

20. From Tian Jiaqing, "While Others Seek after Extravagance, I Indulge in Simplicity: The Design and Manufacture of Wang Shixiang's Grand Painting Table," 2005. Unpublished draft.

21. Handwritten correspondence with author, 2005.

22. Jonathan D. Spence, *Emperor of China* (New York: Vintage Books, 1975), 63.

Edward S. Cooke, Jr.

In and Out of Fashion Changing American Engagements with Chinese Furniture

The reengagement with China in the post-Mao era and the surge in exports of historic Chinese furniture to American collectors and museums in the past quarter-century begs the question of the relationship of American and Chinese furniture histories: What is the basis of this new interest, does it have long roots, and how intertwined are the two histories? A traditional way to characterize this relationship has been to describe the aesthetic influence of Chinese furniture upon American cabinetmakers. Rather than emphasize such a simple narrative, however, one might shift the orientation of the question to focus upon the various ways Americans have viewed, valued, and interacted with Chinese furniture over time. Drawing from postcolonial theorists such as Edward Said and Homi Bhabha, it is essential to recognize that the American engagement with China, and specifically Chinese furniture, is directly connected to the American general perception of China as the exotic "other," a fluid sort of view that runs the gamut from desirable to undesirable and changed constantly over time.[1] The resulting story of reception is not one of continuum but instead might be described as a series of cultural ebbs and flows.

Americans first encountered Chinese furniture through trade via Europe and England in the late seventeenth century, but as English colonists their experience was shaped via the prevailing taste in the mother country. Beginning in the mid-seventeenth century, the English, like many Europeans, began to place great value on the prodigious luxuries of China—especially silk, porcelain, and lacquerwork—and initially projected a positive view of Chinese goods as rich, curious, and ingenious, presumably since they were convinced that they had the commercial superiority to exploit China. Domingo Navarette, a Spanish Dominican who lived in China from 1659 to 1664, explained that both prized raw materials and skilled craftsmen contributed to the desirability of Chinese goods:

> A great deal might be said of the Handy-craft rank of People, for in China there are Handicraft Workmen of all sorts that can be imagined, and such numbers of them that is prodigious. The Curiosities they make and sell in the Shops amaze all Europeans.... All things necessary to furnish a Princely House, may be had ready made in several parts of any of the aforesaid Citys.[2]

During the late seventeenth century, the English actually lagged behind the Hapsburg and Bourbon courts, which established themselves as the greatest consumers

Latticework from bed
(detail of Plate 66)

of Chinese luxury goods, especially porcelain. Considered novelties, Chinese imports served as acceptable markers of luxury and high social status. In this initial phase of appropriation of Chinese material culture, influential members of the English upper social classes began to incorporate certain choice Chinese objects into their lifestyle, seen in lacquered and gilded paneling of small private rooms such as the closet or bedroom, the display of blue-and-white porcelain, and the fascination with tea drinking as a form of exclusive elite social ritual. Yet the English maintained a certain studied ambivalence about how the Chinese goods might negatively impact English standards if uncontrolled or not provided with structured order. For example, William Temple commented on the dangers of Chinese aesthetics in an essay on gardening in 1685:

> Among us, the beauty of building and planting is placed chiefly in some certain proportions, symmetries, or uniformities; our walks and our trees ranged so as to answer one another, and at exact distance. . . . But their [the Chinese] greatest reach of imagination is employed in contriving figures, where the beauty shall be great, and strike the eye, but without any order or disposition of parts that shall be commonly or easily observed: and, though we have hardly any notion of this sort of beauty, yet they have a particular word to express it, and, where they find it hit their eye at first sight, they say *sharawadgi* is fine or admirable, or any such expression of esteem. And whoever observes the work upon the best India gowns, or the painting upon the best screens or purcelans, will find their beauty is all of this kind (that is) without order.[3]

In terms of furniture, the most explicit fascination with China during this period can be seen in the great popularity of lacquered furniture, especially lacquered screens and cabinets, as the ultimate status symbols that signified a worldly view. The interest in the gentleman's cabinet of curiosities to display one's collection of natural and cultural specimens led certain English aristocrats to commission local cabinet-makers to build stands for imported Chinese lacquered cabinets, thereby elevating the showcase to equal status of its contents. Cabinets were the most prestigious type of lacquered ware, but other types of furniture associated with personal possessions and appearance—powder boxes, jewelry boxes, jewelry trunks, comb boxes, frames, and screens—were also lacquered.[4]

The cache of Chinese lacquerwork also led to the development of local versions of lacquer decoration, referred to at the time as japanning, a term that demonstrates the European lack of specific knowledge of the cultures in East Asia and a condescending disinterest in distinguishing among them. Unable to procure the specific ingredients of lacquer, which were indigenous to East Asia, English painters and decorators developed a substitute of a black or red ground with varnish coating that was decorated with gold or silver paint and raised composition elements of gum arabic and whitening. The taste for this type of decoration and the process of achieving it was codified in John Stalker and George Parker's *Treatise of Japaning and Varnishing* (1688). The authors explained the need for their publication as a response to great demand in Europe and the necessity of adapting the decorative technique to European forms and matching suites of furniture:

> We have laid before you an Art very much admired by us, and all those who hold any commerce with the Inhabitants of Japan; but that Island not being able to furnish these parts with work of this kind, the English and Frenchmen have endeavored to imitate them; that by these means the Nobility and Gentry might be completely furnisht with whole Setts of Japan-work, whereas otherwise they were forc't to content themselves with perhaps a Screen, a Dressing-box, or Drinking-bowl . . . but now you may be stockt with entire

Furniture, Tables, Stools, Boxes, and Looking-glass-frames, of one make and design, or what fashion you please.[5]

At the end of the book, the authors also revealed their ambivalence regarding China; they embraced the imagery but sought to embed it in antique classical principles of design:

In the Cutts or Patterns at the end of the Book, we have exactly imitated their Buildings, Towers and Steeples, Figures, Rocks, and the like. . . . Perhaps we have helpt them a little in their proportions, where they were lame or defective, and made them more pleasant, yet altogether as Antick.[6]

By the 1690s, colonists in Boston and New York owned japanned English furniture and local production followed. Boston, the focal point of English imperial endeavors from the 1680s to the 1730s, supported a number of japanners, such as Thomas Johnston, William Randle and Robert Davis, through the first half of the eighteenth century and was the dominant center of japanning (Fig. 1). During this period, many of Boston's elite purchased elaborate japanned furniture that preserved the exotic imagery, extensive use of gold paint, and deep shiny dark surfaces of the real imported lacquerware. Johnston offered japanned "Looking-Glasses, Chests of Draws, Chamber and Dressing Tables, Tea Tables, Writing Desks, Bookcases Clock-Cases & c." in 1732, revealing a broadening of appropriate forms. A few examples of New York japanned clocks, the survival of japanned panels of the 1720s from a house in Newport, and vernacular examples made in several Connecticut towns suggest the continuation in the Northeast of japanning as a popular form of exotic decoration for important new interiors and case furniture.[7]

What heightened this sort of fashionable fantasy was the lack of real, direct contact with China. Chinese trade restrictions funneled all commercial activity through the southern port of Canton and prohibited any English interaction with Chinese people outside that trade zone. With lack of direct knowledge, English tastemakers relied upon numerous travelogues by Jesuit missionaries such as Father Gaspar DaCruz, the published illustrations of Johan Nieuhoff and Arnold Montanus, and the few examples of Chinese material culture that made the journey around the world. While England's East India Company, founded in 1600, focused mainly on the importation of tea, raw silk, and porcelain, employees of the company brought back

Figure 2 Tea table, 1725–50, perhaps Salem, Massachusetts; walnut, 26¾ × 36¼ × 18½ inches (68 × 92.1 × 47 cm). Peabody Essex Museum collection 133,583 Gift of Mary Yusko.

Figure 3 Armchair, about 1740–60, probably Massachusetts; walnut, maple, 40¼ × 28¾ × 18 inches (102.23 × 73.02 × 45.72 cm). Randall 138, Museum of Fine Arts, Boston, Gift of Mrs. George H. Davenport, 33.571. Photograph © 2006 Museum of Fine Arts, Boston.

finished goods such as silk fabrics, wallpaper, lacquerware, and hardwood furniture. Other members of the English beau monde procured a small number of such objects through Dutch and Portuguese sources, but the numbers at this stage were not substantial. In 1664 John Evelyn marveled at the "rarities, sent from the Jesuites of Japan and China" that a Jesuit showed Londoners while en route home to Paris.[8] These items included gold-embroidered vests, large fans with long, carved handles and Chinese characters, and landscape views of China. In 1685 the Jesuits arranged for the visit of Shen Fu-tsung to London, and the novelty of the first Chinese person in England caused great excitement, including Godfrey Kneller, the favored painter of the fashionable elite, painting his portrait. In the late seventeenth century the English and their American colonists thus developed their knowledge secondhand through popular literature and rare objects. In many ways these goods encouraged fantasizing through a form of visual and haptic association.[9]

In the early eighteenth century, the emergence of a new commercial class, who began to purchase and demand fashionable commodities, expanded the possibilities for the English adaptation of Chinese forms and aesthetics.[10] The surge in the importation of tea, for example, documented the broadening of the theater of tea drinking and exerted an impact on English and American furniture production. The rituals of tea drinking required a specialized equipage that included a tea table and chairs in addition to silver tea services and porcelain cups. For tea drinking, Anglo craftsmen developed a new table form that owed its origins to the Chinese *kang* table, a low table usually set upon a *kang,* a raised, heated platform commonly found in homes in northern China. *Kang* tables were used for tea drinking, card playing, and eating during the Ming dynasty (1368–1644). The waisted construction, gracefully curved cabriole legs, and cyma curves on the skirt of the Chinese prototypes all became defining characteristics of the Anglo-American tea table of the second quarter of the eighteenth century and suggest that the Western craftsmen searched for an appropriate Chinese form on which to set out the Chinese drink (Fig. 2). To sit comfortably and appropriately at such tables, English craftsmen developed crooked-back chairs with yoke-shaped crestrails and solid splats that were derived from Chinese high-backed scholars' chairs (Fig. 3). Such an appropriation of Chinese elements is more direct than simply constructing mounts and stands for imported lacquerware. In addition to Chinese forms and lines, the use of solid mahogany boards, rather than solid oak or veneered deal or pine, to construct these new forms is also noteworthy and may have been the result of English artisans seeing Chinese hardwood examples in which the polished *huanghuali* boards, replete with bold figure, were fastened together to construct solid wood furniture.[11]

Still to be explored is the manner in which Western trade might also have influenced Chinese furniture at this time. The Jesuits' strong presence in cultural matters of the Qing dynasty, beginning in the late seventeenth century, might have provided the opportunity for indigenous craftsmen to draw ideas from Western forms. For example, the Jesuit painter Giuseppe Castiglione came to China in 1715 and introduced Western conventions such as perspective and chiaroscuro. Perhaps the Jesuits provided new ideas or models for woodworkers as well. Related to this question of the West's influence within China is the influence of Chinese, Indian, and Indonesian furniture in the mix of the broader oriental style of this period. As furniture history becomes a more international endeavor, a better sense of the connections between regions and cultures will become clearer.[12]

While Chinese taste possessed exclusive associations in the late seventeenth and early eighteenth centuries, it became a more frivolous and aestheticized sort of popular culture in the middle of the eighteenth century. The chinoiserie of this period was not simply a style but a cultural phenomenon that offered an opportunity for the growing commercial classes and women to test out a form of self-fashioning possible during a time of cultural flux. English-made objects in a loosely Chinese fashion satisfied the period's craving for domestic goods that combined historical weight and fashionable novelty, decorative elements of spectacle and sensuality mediated by forms that connoted moral integrity and substance, and a flexible sort of hybridity. It was at precisely this time when the English debate about aesthetics pitted the neo-Platonic classicism of Shaftesbury against the wild emotions of the rococo. English tastemakers accepted chinoiserie elements as long as they remained in service of English taste, which became a codified style that blended French rococo, gothic, and chinoiserie elements within rational, classically derived compositions. The basis for this new fanciful visual language came not so much from real examples of Chinese furniture but rather from European engravings as well as the scenes depicted on imported porcelains and wallpapers. It was an English view of Chinese culture that became the source of the new chinoiserie: pagodas were substituted for gothic spires, latticework for Greek key moldings, and asymmetry set within symmetrical forms. Engraved images in several English publications of the 1750s, such as Thomas Chippendale's *Gentlemen and Cabinetmaker's Director,* inspired cabinetmakers to use pierced fretwork for chair backs or tea table skirts and legs, carved latticework for moldings, and carved pagodas for finials.[13] Colonists eagerly followed the lead of the bourgeois in England. John Wentworth, the royal governor of New Hampshire, imported a stylish set of English chinoiserie seating furniture (two settees, six armchairs, and four stools) as well as Chinese wallpaper around 1765 (Fig. 4). During the same time period, members of the prestigious Brattle Street Church in Boston commissioned a settee with open fretwork back (Fig. 5).

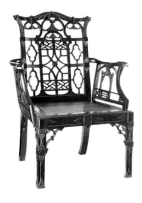 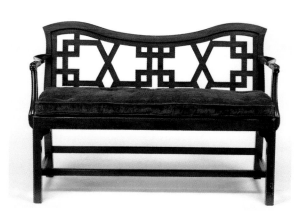

Figure 4 Wentworth Chinese Chippendale chair, 1763–64, London; mahogany. Moffat-Ladd House and Garden, Portsmouth, N.H., The National Society of the Colonial Dames of America in the State of New Hampshire. Gift of Alexander Haven Ladd, Jr., Robert W. Ladd, and Miriam Ladd Bliss. Photograph by David Bohl. Courtesy of Historic New England.

Figure 5 Settee, 1760–70, Boston, Massachusetts; mahogany, white pine. Massachusetts Historical Society.

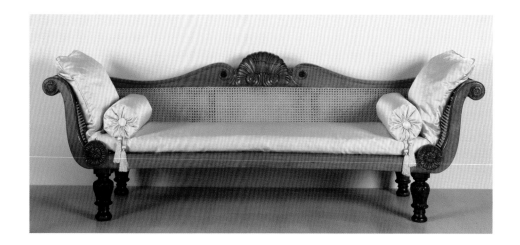

With independence and the establishment of direct trade with China in 1784, Americans enjoyed greater opportunities for the purchase of Chinese goods at the end of the century. Rather than celebrate the particularities of Chinese culture to establish their own aesthetic sensibility, they instead seemed to think of China merely as another supplier, much like Wedgewood ceramics or Sheffield silverplate. They focused primarily on Chinese porcelain with armorial or American decoration, Chinese silk fabrics and wallpaper, lacquered work tables and writing boxes, and rosewood neoclassical furniture (Fig. 6). Certainly Americans such as Caleb Cushing had direct contact with Chinese furniture, but there seemed to be little interest in the authentic Chinese forms. A drawing of Cushing signing the 1844 trade treaty with Chinese officials, the first official treaty between America and China, reveals how Cushing and his entourage sat on hardwood chairs and ceramic stools and wrote at a square table, but the experiences did not trigger a renewed interest in authentic Chinese material culture (Fig. 7). Instead it seems that Americans preferred to have the Chinese craftsmen make Western-style furniture in the neoclassical styles or with lacquered surfaces. The Chinese craftsman, for his part, may have eagerly sought to please the growing American market and adjusted his work to the new demand. Yet this Sino-American class of furniture, often featuring denser decoration than the older lacquered wares, retained notions of the exotic souvenir.[14]

One of the few elements of Chinese furniture traditions that found new cultural value was bamboo. Although in the mid-eighteenth century William Chambers had noted it as one of the three cabinetmaking woods used in China and illustrated a suite of bamboo tables and chairs, praising the genre for being "cheap and neat," bamboo or faux bamboo played little role in the chinoiserie fashion of mid-eighteenth-century Anglo furniture. Around the turn of the nineteenth century, American turners

Figure 7 George R. West, *Signing of the Trade Treaty,* 1844; watercolor on paper. Collection of the Manuscript Division of the Library of Congress, Caleb Cushing papers.

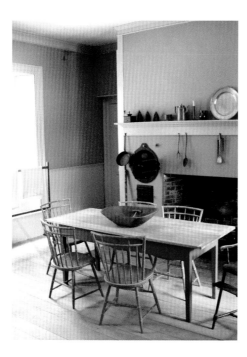

Figure 8 Interior of the Gardner-Pingree House, Salem, Massachusetts, with James Chapman Tuttle Windsor chairs, ca. 1810; maple, white pine. Peabody Essex Museum collection 135374.1.

began to produce legs and chair parts that resembled bamboo. American Windsor chairmakers eschewed the bulbous architectonic turnings and instead articulated the frame with swellings and grooves that recalled the look of bamboo (Fig. 8). Turners providing legs for card tables in the Salem and Boston areas, ports that supported considerable trade with China, also began to provide tapered legs with three equally spaced rings that also suggested bamboo. However, such internalized adaptation of Chinese furniture seemed isolated.[15]

In the mid-nineteenth century, American interest in China waned further as Matthew Perry opened up direct trade between America and Japan, and Americans celebrated the pure, refreshing artistic sensibilities of Japan. While Japan captured the American imagination as a preindustrial exotic territory directly across the Pacific and within the sphere of American influence, China remained mired in the American view as a stale or petrified culture. Like the English, who developed a more racialized version of empire at this time and began to denigrate the Chinese, the Americans expressed frustration with Chinese obstructionist trade policies, no longer valued Chinese philosophy or art, ridiculed chinoiserie merely as a form of popular amusement, and considered most Chinese to be liars or fools. Americans seemed to be asserting their own imperial perspective in East Asia and looked to Japan to legitimize this perspective. Right from the start, they had direct and primary contact, rather than being confined to a secondary position as they had with China. The Japanese were the new noble savages who could be modernized by America at the same time that Americans could gain strength from appropriating some aspect of their culture. Artists such as James McNeill Whistler and John LaFarge and designers such as Edward Moore of Tiffany & Co. drew heavily upon Japanese ideas of asymmetry and the importance of contrasting light and dark.[16]

The Chinese exhibit at the 1876 Philadelphia Centennial Exhibition provides another snapshot of American attitudes toward, and taste for, Chinese furniture. The exhibit included a wide range of Chinese furniture including both carved furniture in Western forms, such as round center tables and upholstered armchairs, as well as more traditional forms such as beds and square tables (Fig. 9). Many of the displayed forms were carved hardwood or lacquered examples, suggesting that the Chinese government sent the work they thought would impress and entice the American audience, who seemed to prefer the most ornate furniture with highest

visual content. It was essentially European-style furniture made by Chinese crafts-men out of their preferred materials. Strikingly absent was the work in the older historical styles, such as the restrained Ming-period furniture, more traditional forms like folding chairs, or vernacular examples. Even though much of the furniture dis-play was sold, the purchase of furniture paled in comparison to Chinese ceramics and cloisonné and lagged behind sales of Japanese goods as well. Chinese furniture was thought to be an occasional aesthetic accent piece within the artful home, but there was little appreciation for the joinery skills of the makers or celebration of the craftsmanship.[17]

Influential English writers commented upon the declining reputation of Chi-nese craftsmen. Owen Jones, the design theorist of the South Kensington School that influenced so much of American taste in decorative design in the 1870s and 1880s, dismissed the Chinese artisans as "totally unimaginative, and all their works are accordingly wanting in the highest grace of art—the ideal." To Jones, the work of China was merely "manufactured articles" in the same way he characterized the work of British industry.[18] Another important writer, William Morris, disparaged Chi-nese craftsmen as human machines who merely performed repetitious tasks and lacked the ability to exercise free creative will. Thus when the 1893 World Columbian Exposition opened in Chicago, American critics praised the medieval solemnity of the Ho-o-den Japanese temple, while relegating the Chinese stand to the popular amusements of the Midway.[19]

While American furniture designers and craftsmen of the last quarter of the nineteenth century continued an imprecise orientalizing attitude, the roots of which stretched back into the seventeenth century, they developed a specific approach that combined a variety of loosely defined Asian motifs and details with other exotica derived from a variety of non-Western cultures, particularly Islamic and Moorish, but all interpreted in western-European forms with European construction and deco-rative techniques. However, rather than receiving an orientalism filtered through England, Americans began to act as the primary bricoleurs who would blend and mix their own version of internationally based design. At this time, Americans viewed

themselves increasingly as a world power, and appropriating aspects of "the other" from throughout the world was felt to be a badge of power and prestige that established America as the formidable new world power.[20]

The emergence of an American cultural imperialism can be seen in a wide range of products, including furniture. For example, Christian Herter, the most fashionable designer active in New York during the 1870s and 1880s, designed a fire screen for the Mark Hopkins residence in San Francisco that included a Chinese silk embroidery set within a frame that featured latticework along the lower edge. But the form is a modern gothic one rather than an accurate Chinese type and it includes classically inspired moldings, a Renaissance-inspired carved swag along the top, small painted portraits, and a gilded finish (Fig. 10).[21] Similarly, in the 1880s, the Boston furniture-maker James Wall imported bamboo from China, but assembled chairs from it with Western post-and-rung construction and laid out the elements to produce an asymmetrical composition that was more Japanese than Chinese (Fig. 11). No designers

Figure 10 Herter Brothers, fire screen, ca. 1878–80; gilded wood, painted and gilded wood panels, brocaded silk, embossed paper; 51⁷⁄₈ × 30 × 22¹⁵⁄₁₆ inches (131.8 × 76.2 × 58.3 cm). © The Cleveland Museum of Art, The Severance and Greta Millikin Purchase Fund 1997.58.

Figure 11 James E. Wall (fl. 1881–1917), bamboo armchair, ca. 1886; bamboo with lacquer panel, 45½ × 22 × 25 inches (115.6 × 55.9 × 63.5 cm). Museum of Art, Rhode Island School of Design. Gift of N. David Scotti 82.111.1.

were looking closely at real Chinese furniture and then drawing inspiration directly from it. Rather Chinese furniture was one of the several oriental wells from which American designers appropriated motifs that they blended into a distinctive, artistically tasteful object.[22]

The limited selection of Chinese furniture in America and Morris's writings prevented many Arts and Crafts enthusiasts from drawing inspiration from Chinese furniture traditions in the same way they drew from Japanese woodworking, carving, and finishes. Out on the West Coast, however, a greater number of Chinese immigrants and Pacific Rim trade led to more frequent firsthand experience with a wide variety of Chinese furniture. In Hawaii, Yven Kwock opened a general merchandise shop in 1898 but, after a fire devastated Honolulu's Chinatown in 1900, he hired many displaced Chinese carpenters and opened a new furniture shop under the name Fong Inn Company. Initially the shop continued to make Western-style furniture in local woods such as pine and koa, even venturing into the new mission style. In 1915 Kwock traveled back to China and purchased silk fabrics that sold quickly in Hawaii. Such commercial success led him to expand into furniture imports, making frequent buying trips and using local agents as well. Being Chinese, he was able to navigate the

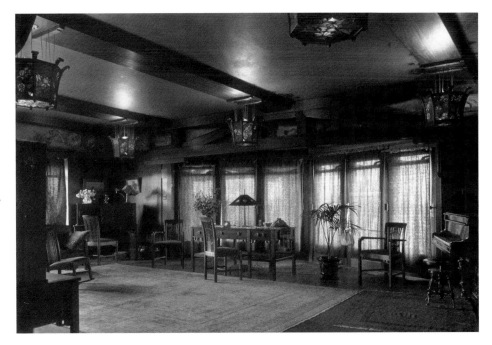

Figure 12 Robert Roe Blacker Estate, Pasadena, California [living room, looking east], 1907–1909; photograph. Collection of Robert Judson Clark. Greene & Greene Architectural Records and Papers Collection. Drawings and Archives, Avery Architectural and Fine Arts Library, Columbia University, New York, N.Y., NYDA. 1987.003.00012.

country effectively and acquired a wider variety of lacquer and hardwood furniture, which he then sold to prominent Hawaiian citizens.[23]

Chinese ancestry also proved a distinct advantage in Los Angeles, where the Chinese immigrant Fong See established several shops, including one in nearby Pasadena. See's shop, F. Suie One, originally sold curios but then began to sell fine furniture, silks, embroideries, bronzes, and other antiques around 1900. See and his American wife took a buying trip to China in the fall of 1901, just after the end of the turbulent period caused by the Boxer Rebellion, and were able to establish contacts with many Chinese who supplied old domestic objects for his American stores and for his frequent auctions. Regional aesthetes, visitors to Pasadena, and Hollywood set designers all stopped by See's shops to see a variety of Chinese antiques, drink tea, and have Fong See regale them with stories of mysterious China. Such patronage bordered on amusement and cultural voyeurism, but See's ability to import a variety of hardwood furniture set this retail experience apart. Few others had such advantages in purchasing the real things. His contacts encouraged others such as John Bentz and Grace Nicholson to open Asian import shops in Pasadena as well.[24]

Direct access to real examples of Chinese furniture had a specific impact on the design work of the Pasadena architects Charles and Henry Greene. The furniture they designed for their ultimate bungalows, especially the Blacker House, reveals familiarity with the real thing and a newfound appreciation of the craftsmanship and technical virtuosity of the Chinese work. The Greenes did not simply appropriate form (the hanging lamps in the Blacker House parlor, for example) or details, such as the inwardly turned horse-hoof feet or the hump-backed stretchers found on many of the tables and chairs, drawer pulls, or carved details; they also instructed the Hall Brothers shop, which made their furniture, to house the mortise-and-tenon joints and to use ebony splines on the crestrails of their chairs in a manner similar to the use of brass corners on Chinese examples (Fig. 12). The Greenes viewed the Chinese furniture they encountered from an Arts and Crafts perspective that privileged honest construction, authenticity, and vernacular roots. Chinese hardwood furniture certainly possessed those desirable qualities. The Greenes' and Halls' work implies firsthand exposure to more than the usual import furniture. In California during the Arts and Crafts movement, the celebration of Chinese joinery signals the end of the idea of the Chinese woodworker as machine and the start of a new interest in the hand of the maker.[25]

Figure 13 Paul Theodore Frankl (American, b. Austria, 1886–1958), desk and chair, "*Puzzle*," ca. 1927. Made by Frankl Galleries, New York; red baked enamel, sheet steel, aluminum, glass. Photograph Willard Associates, Miami, Florida. The Mitchell Wolfson, Jr., Collection, The Wolfsonian–Florida International University, Miami Beach 83.11.2.1.

The hardwood furniture that Fong Inn and F. Suie One carried was very unusual in the first quarter of the century. For most Americans, Chinese furniture continued to mean lacquerware and luxury. Publications and museum collections of this period privileged the ornate japanned or carved lacquer examples. Even Paul Frankl, a progressive designer of the 1920s, demonstrated an interest in combining rich, solid-colored lacquered cabinets with Chinese-inspired metal hardware and chinoiserie elements such as Chambers-like latticework for chair backs (Fig. 13).[26]

Not until the 1930s did mainstream American furniture design embrace a fuller sense of Chinese furniture, one that included hardwood examples. But the impetus was no longer a sense of curiosity or history. Rather, it was the resonance with modernist principles of simplicity and function. A German-trained academic who taught in Beijing and traveled throughout China, Gustav Ecke was drawn to the simple historic hardwood furniture, which he praised for its structural emphasis and "tectonic design." Exhibiting a resonance with the writings of such modernists as Lewis Mumford and Sigfried Giedion, Ecke praised the "rational features of Chinese domestic furniture" that "bring forth the vigour of the type and its adequacy." Revealing a debt to Arts and Crafts ideology as well, Ecke celebrated "the intricate and daring joints" that permitted "steel-like slenderness or muscular vigour which are the outstanding features of Chinese structural design." Ecke examined a great number of examples during his residency in China and published the seminal *Chinese Domestic Furniture* in 1944. The value of this volume was considerable, as it offered an intelligent discussion of forms, materials, and history, but also provided detailed photographs of construction and measured drawings with joinery clearly noted. The author had gained such intimate knowledge by disassembling several pieces of furniture.[27]

While Ecke's original book appeared in a limited portfolio edition, George Kates, an American living in China in the 1930s, wrote a more accessible book on Chinese hardwood furniture. Kates began his book in 1937, examining, measuring, and photographing the furniture owned by the foreigners living in Beijing at that time. Access to the collections of such important collectors and experts as Ecke, William and Robert Drummond, Charlotte Horstmann, and Laurence Sickman provided Kates with considerable expertise. Upon his return to the United States, he parlayed his experiences into a career as a museum curator with a focus on Chinese art. As curator of oriental art at the Brooklyn Museum, he organized an important 1946 exhibition on Chinese furniture that, in conjunction with another exhibition the same year at the Baltimore Museum of Art, brought fine hardwood furniture of the Ming and Qing periods to the attention of a broad American audience. Two years later, Kates published the widely circulated *Chinese Household Furniture*. Like Ecke, Kates recognized the comfortable fit of Chinese furniture and modern design, commenting that "simple, elegant design appealed to the contemporary Bauhaus influenced taste of the time."[28]

Figure 14 Hans Wegner (Denmark, 20th century), armchair; walnut and cane, 30½ × 24½ × 18¼ inches (77.5 × 62.2 × 46.4 cm). Yale University Art Gallery, Millicent Todd Bingham Fund 1971.67.4.

Ecke's and Kates's publications had an immediate effect upon the soft modernism favored by American designers in the 1950s. The prominent furniture designer and writer T. H. Robsjohns-Gibbings, who adamantly called for the rejection of furniture in either mawkish reproduction or harsh modern styles, argued that contemporary designers would be best served to base new work on a combination of classical and Chinese precedents. Unlike mid-eighteenth-century English design theorists like William Chambers, who felt that classical design far exceeded that of China, Robsjohns-Gibbings extolled the grace and beauty of Chinese furniture and found it comparable and sympathetic to ancient Greek forms. He still criticized the florid quality of Chinese architecture and the garish presence of lacquerwork, but he commented on the continuum of loving, benign Chinese craftsmanship, timeless "infinitely quiet and self-contained" forms, and a "tranquil earthbound grace" stemming from the deep feeling of wood. This revised perspective on Chinese furniture, in which Americans valued the "authentic Chinese furniture … ranging from the Ming to eighteenth century" for its "serviceable simplicity" and household utility, dealt critically with the "exotic, glittering, and desirable" lacquered wares that seemed to suggest trivial frivolity.[29]

Robsjohns-Gibbings also praised the work of Scandinavian modern designers for its "gentle" forms and "fine" construction and finish.[30] Among the most influential of these understated designers was Hans Wegner, who in 1949 first introduced the "Kinastol," a dining chair based loosely on a Chinese round-back chair (Fig. 14). The spare, turned frame and sculpturally shaped armrail evokes the simplicity of Ming-period furniture, but relies on modern methods of production such as duplicating lathes and finger joints to make affordable batches of this form. These Wegner chairs were popular imports to the United States and led to a number of American makers producing similar examples of Scando-Sino work. A special issue of *House & Garden* in 1949 embraced this new melding of Ming furniture and modernism and featured new work by prominent designers such as Robsjohns-Gibbings, Hollis Baker, Tommi Parzinger, Edward J. Wormley, and Ray See (Fong See's son who ran the See-Mar design firm). Throughout, the clean lines of Ming furniture were combined with contemporary Herman Miller furniture and design, eighteenth-century antiques, and contemporary and historic artwork.[31] Robert and William Drummond, who collected and sold Chinese furniture while in Beijing in the 1930s, returned to New York, where

they began to sell Chinese furniture in the postwar period. With limited access to old Chinese furniture, the Drummonds established Dynasty Furniture, a company that employed Chinese craftsmen working in Hong Kong to make Ming-style furniture for a contemporary customer. Made and then disassembled in Hong Kong, the furniture was shipped to New York, where it was put together and sold (Fig. 15).[32]

While the design community of the 1950s responded so favorably to the "discovery" of Chinese hardwood furniture and drew inspiration from the forms and lines, few responded to the intricate joinery that Ecke detailed. This might seem

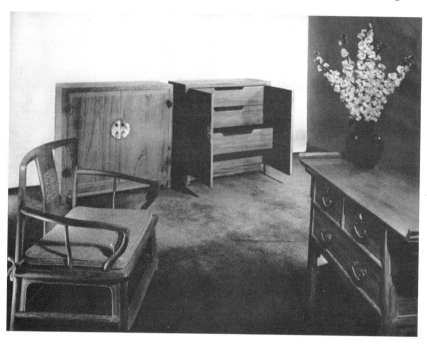

Figure 15 Chair, dressers, and commode made by Dynasty Furniture, New York, ca. 1955. Illustrated in *American Artist* 19, no. 5 (May 1955): 41.

quite striking given that the same time period fostered the rise of a particular type of small-shop custom artisan, who has become known as a "studio furnituremaker," and who capitalized on the demand for visibly well-crafted, personal wooden furniture. In the immediate postwar period, many of these makers were self-trained and lacked the knowledge and skills to undertake complex Chinese joinery. They demonstrated little interest in historical furniture for inspiration, choosing instead to work in a Scandinavian-modern or Shaker-like style.

Even as the skill level of this group of furnituremakers increased, they demonstrated little interest in studying Chinese joinery. The only real evidence of studio furnituremakers' deep interest in Chinese furniture can be seen in the work of Richard Koga and Daniel Jackson, who worked in Philadelphia in the 1960s. Koga had been trained as a cabinetmaker in Hawaii and had the opportunity to see firsthand fine examples in the Ecke collection on view at the Honolulu Academy of Fine Art. Jackson began as an antiques restorer before studying furniture design and construction at the Rochester Institute of Technology and in Denmark (Fig. 16). Both expressed a deep interest in respectful use of wood, simplicity of line, and expressive joinery. But their explorations were isolated. Curiously, as the studio furnituremakers of the 1970s and 1980s developed consistently higher levels of technical skill and drew inspiration from closely studying historical furniture, they did not develop an interest in Chinese furniture. Instead, they looked primarily to American and European examples. In terms of Asian influence, only Japan seemed to capture their imagination as a number of studio furnituremakers eagerly adapted Japanese woodworking chisels and saws, explored Japanese traditions of lacquerwork, and demonstrated an interest in tansu chests and shoji screens (Fig. 17).[33]

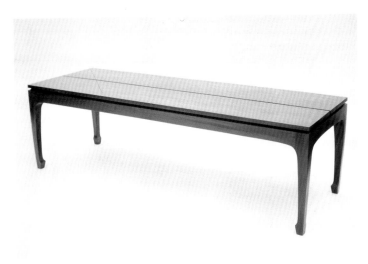

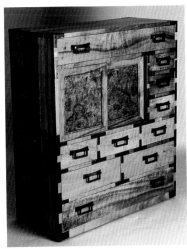

Figure 16 Dan Jackson, coffee table, 1974, Philadelphia, Pennsylvania; rosewood. Current location unknown; photograph courtesy of Julia Browne.

Figure 17 Evert Sodergen, tansu chest, ca. 1984, Seattle, Washington; koa, Carpathian elm burl, marupa, brass. Private collection.

As had occurred a hundred years earlier, easy and direct access to Japan had trumped the inaccessibility of China. By 1951, a United States trade embargo prevented the importation of any Chinese objects, and China stopped issuing export licenses, even in regard to private possessions. The flow of furniture and exchange of knowledge about the subject thus came to halt, until the trade ban was lifted in 1971. Within China, Communist rule and the Cultural Revolution of the 1960s and early 1970s further undercut appreciation and study of historical furniture. In this vacuum, knowledge and appreciation of Chinese furniture remained stuck in the perspective of the Beijing expatriates, who gave collections and offered advice to a number of American museums. Only with the fall of Mao did Chinese furniture become a dynamic field again.

As China reopened to the West in the early 1970s, the market for historic Chinese furniture grew in Hong Kong and China, spurred on by the publication of two new books. In 1970, the dealer Robert Ellsworth published the first new book on the subject in almost thirty years. His handsomely illustrated volume represented an update of the Kates volume. Wang Shixiang's volume, published in 1986, was a masterwork, taking full advantage of the author's ability to travel throughout China, examine works in museum collections, and talk with craftsmen. Its detailed discussion of forms, woods, and techniques, all fastidiously researched and well illustrated, quickly made it the authoritative source. Collectors and museum curators found it essential in guiding their decisions regarding new purchases. Even with this new interest in Chinese furniture, the modernist design perspective, which favored the fine hardwood style of the Ming and early Qing periods, prevailed right up through the 1990s. Such a tendency attests to the power of Wang Shixiang's seminal work. Only in the 1990s did a number of American museums and collectors demonstrate new interest in a more ecumenical view of Chinese furniture, one that incorporated lacquer, hardwood, and vernacular examples. Such a broadening paralleled the broadening interest in vernacular American furniture as well.[34]

The reestablishment of trade with China and that nation's keen economic interest in producing goods for a global market have combined to usher in a new chapter in the American reception of Chinese furniture. In an era characterized by an over saturation of domestic design products, many Americans have chosen to purchase objects that look like they possess cultural authenticity. Whereas in the early twentieth century, American consumers would have purchased colonial revival or European antique furnishings with historical associations to soften modernism, in the beginning of the twenty-first they are looking more globally to personalize their homes.

Chinese hardwood and vernacular furniture has found a new audience beyond the West Coast. Stores carrying imported examples, many of which have been made within the past century, have sprung up, and national chains such as Pottery Barn and Crate & Barrel have capitalized on this interest by offering furniture with Chinese-derived forms, surfaces, or hardware. Target has even instituted a "Global Bazaar," in which Chinese objects are sold alongside products from African and Southeast Asian countries. Yet this taste for Chinese culture is also accompanied by an ambivalence. Some Americans welcome the rise of China as the next economic and cultural super-power because it bodes well for American global business interests, while others continue to express unease about such changes. To paraphrase Henry Luce's assertion in *Life* that the twentieth century was "the American Century," these Americans seem anxious that the twenty-first century will be "the China Century." They are thus torn between celebrating the historical China and questioning the contemporary China. The concept of the "other" has grown more complex. For its part, China relishes the opportunity to enter the global economy through both the production of consumables and the exportation of patrimony. The competitive spirit between the two countries has thus entered a new, but not unfamiliar phase in which the taste for furniture provides important evidence.

Even with the renewed interest in historic Chinese furniture, American studio furnituremakers have remained largely unaware of the Chinese-furniture traditions. In an era when globalization means more than the transmission of ideas through print sources or festishized objects, the personal interaction of talented individuals and collections-based inquiry signal new possibilities by which Americans and Chinese makers can draw knowledge and inspiration from each other and from each other's furniture heritage in a nonhierarchical or linear fashion. The rationale behind the workshop that initiated *Inspired by China* was to provide just such an opportunity. The variety of responses on the part of the Americans and Canadians underscores the complexities of the current situation. Like cabinetmakers of the eighteenth century, some contemporary makers such as Silas Kopf, Brian Newell, and Michael Hurwitz (Plates 25, 33, and 31) responded by adapting motifs such as cracked ice or lattice-work to updated forms. Michael Cullen, Judy Kensley McKie (Plates 15, 26, and 55), and others drew inspiration from traditional forms, but put their own personal spin on them. The fantasy of chinoiserie can be found in the playful work of Garry Knox Bennett (Plates 2, 43, and 46). Yeung Chan (Plate 41) venerated the hardwood Ming furniture so valued through much of the mid-twentieth century, but updated the technology to join and shape it. On more cultural levels, Wendy Maruyama (Plate 67) explored notions of racial identity through her creation of a furniture form, the main purpose of which was self-fashioning. Gord Peteran (Plate 64), on the other hand, was drawn to the tension of China venerated for its cultural traditions and despised for its mass production of throw-away consumables.

Yet each of the makers touched on elements of form, ornament, technique, and cultural meaning while grappling with the notion of "What is Chinese furniture?" and commenting on the possibilities of cross-cultural exchange. Studio furnituremakers thus provide a distinctive insight into the newly awakened interest in China's furniture history and the nation's deeper complexities. Bringing together makers from both sides of the Pacific helps diffuse received histories and assumptions and sets a foundation for continued give-and-take among creative people.

Notes

I would like to thank Jon Prown, Sarah Fayen, Ethan Lasser, Glenn Adamson, Nancy Berliner, and Ben Cooke for reading and commenting on an earlier draft of this paper. Their thoughtful comments and generous suggestions greatly improved the thrust of the argument.

1. On the importance of understanding one's point of view, see Edward Said, *Orientalism* (New York: Pantheon, 1978); and Homi Bhabha, *Location of Culture* (New York: Routledge, 1994). On the shifting and complex Western views of China, see Jonathan Spence, *The Chan's Great Continent: China in Western Minds* (New York: W. W. Norton, 1998); and, more specifically, Craig Clunas, "Chinese Furniture and Western Designers," *Journal of the Classical Chinese Furniture Society* 2, no. 1 (Winter 1992): 58–70.

2. Navarette, as quoted in Spence, 39–40. The positive associations and restricted availability of Chinese goods within the fashion system and economics of seventeenth-century Europe is well chronicled by Dawn Jacobson, *Chinoiserie* (London: Phaidon, 1993).

3. William Temple, "Upon the Gardens of Epicurus; or, Of Gardening," in *The Works of Sir William Temple* (London: S. Hamilton, 1814), vol. III, 237–38. David Porter provides a clear sense of late seventeenth–century England in "Monstrous Beauty: Eighteenth-Century Fashion and the Aesthetics of the Chinese Taste," *Eighteenth-Century Studies* 35, no. 3 (2002): 395–411.

4. On the particulars of the cabinet of curiosity, see Patrick Mauries, *Cabinets of Curiosities* (London: Thames and Hudson, 2002); and Susan Stewart, *On Longing: Narratives of the Miniature, the Gigantic, the Souvenir, the Collection* (Durham, NC: Duke University Press, 1993). On the taste for Chinese furniture in England, see Adam Bowett, *English Furniture, 1660–1714: From Charles II to Queen Anne* (Woodbridge, England: Antique Collectors' Club, 2002), esp. 20–24 and 144–69. The types of objects typically lacquered is drawn from a list of designs provided by John Stalker and George Parker, *A Treatise of Japaning and Varnishing* (Oxford: printed by the authors, 1688).

5. Stalker and Parker, "Epistle to the Reader and Practitioner," in *Treatise of Japaning and Varnishing*.

6. Ibid.

7. On American japanning, see Morrison Heckscher and Frances Safford, "Boston Japanned Furniture in the Metropolitan Museum of Art," *Antiques* 129, no. 5 (May 1986): 1046–61; and Dean Fales, *American Painted Furniture, 1660–1880* (New York: E. P. Dutton, 1972), 58–69.

8. Evelyn as quoted by Spence, 63–64.

9. Shen's visit is also noted by Spence, 65. A good summary of the fantasizing is found in Jacobson, *Chinoiserie*.

10. On the connection between American and English consumption of this period and the rise of the commercial class, see Colin Campbell, "Understanding Traditional and Modern Patterns of Consumption in Eighteenth-Century England: A Character-Action Approach," in *Consumption and the World of Goods*, ed. John Brewer and Roy Porter (New York: Routledge, 1993), 19–57; and Cary Carson, "The Consumer Revolution in Colonial British America: Why Demand?" in ed. Cary Carson, Ronald Hoffman, and Peter Albert, *Of Consuming Interests: The Style of Life in the Eighteenth Century* (Charlottesville: University Press of Virginia, 1994), 483–697.

11. On the early history of the *kang* table, see Sarah Handler, "On a New World Arose the Kang Table," *Journal of the Classical Chinese Furniture Society* 2, no. 3 (Summer 1992): esp. 32–39; and on the influence of Chinese chairs, see Robert Symonds, "A Chair from China," *Country Life* 114 (November 5, 1953): 1497–99. Fourteenth-century incense stands also usually featured cabriole legs. While there is neither specific written evidence about the *kang* table's influence on the tea table nor surviving examples with histories of ownership in early eighteenth–century England, the material evidence suggests that Chinese furniture significantly influenced the furniture made in England at that time. See also Clunas, "Chinese Furniture and Western Designers"; and Ross Taggart, "The Impact of China on English and American Furniture Design," *Journal of the Classical Chinese Furniture Society* 2, no. 3 (Summer 1992): 56–65.

12. For suggestive endeavors in this regard, see Nancy Berliner's essay in this volume; and Amin Jaffer, *Furniture from British India and Ceylon* (London: V & A Publications, 2001).

13. An excellent theorization of the middle of the eighteenth century is Porter, "Monstrous Beauties." The design books published at this time included William Halfpenny, *New Designs for Chinese Temples, Triumphal Arches, Garden Seats* (1750); William Halfpenny, *Rural Architecture in the Chinese Taste* (1752); Matthias Lock and Henry Copeland, *A New Book of Ornaments in the Chinese Taste* (1752); Mathias Darly and George Edwards, *A New Book of Chinese Designs Calculated to Improve the Present Taste* (1754); Thomas Chippendale, *Gentlemen and Cabinetmaker's Director* (1754); and William Chambers, *Designs of Chinese Buildings, Furniture, Dresses, Machines, and Utensils* (1757). Chambers was particularly clear in praising the Chinese as "great, wise," and "distinct and very singular," but he asserts that they were not in competition with the ancients or moderns of Europe.

14. Christina Nelson, *Directly from China: Export Goods for the American Market, 1784–1930* (Salem, MA: Peabody Museum of Salem, 1985).

15. The best source for American Windsor chairs is Nancy Evans, *American Windsor Chairs* (New York: Hudson Hills, 1996). On the turned table legs, see Benjamin Hewitt, *The Work of Many Hands: Card Tables in Federal America, 1790–1820* (New Haven: Yale University Art Gallery, 1982).

16. The negative view toward China is well chronicled by Jacobson, 178–79. See also Spence.

17. Jennifer Pitman, "China's Presence at the Centennial Exhibition, Philadelphia, 1876," *Studies in the Decorative Arts* 10, no. 1 (Fall–Winter 2002–2003): 35–73.

18. Owen Jones, *The Grammar of Ornament* (1856; London: Day and Son, 1865), 85–87.

19. William Morris, "The Lesser Arts of Life" (1882), in William Morris, *Architecture, Industry, and Wealth* (London: Longmans, Green, 1902), 44 and 47–50. On Chicago, see *The World's Fair, Being a Pictorial History of the Columbian Exposition* (Philadelphia: National Publishing Co., 1893), esp. 560–61, 618–24, and 677–79. My thanks to Graham Boettcher for bringing this to my attention.

20. See, for example, William Hosley, Jr., *The Japan Idea: Art and Life in Victorian America* (Hartford, CT: Wadsworth Atheneum, 1990).

21. On Herter, see Katherine Howe et al., *Herter Brothers: Furniture and Interiors for a Gilded Age* (New York: Abrams, 1994), esp. 186–87.

22. The work of Wall is discussed by Christopher Monkhouse and Thomas Michie, *American Furniture in Pendleton House* (Providence: Museum of Art, Rhode Island School of Design, 1986), 200–201. A helpful period compendium of photographs of interiors decorated in this oriental style is *Artistic Houses* (New York: D. Appleton, 1883–84).

23. On Fong Inn Company, see Irving Jenkins, *Hawaiian Furniture and Hawaii's Cabinetmakers, 1820–1940* (Honolulu: Daughters of Hawaii, 1983), 252–54.

24. A rich account of Fong See was written by his granddaughter Lisa See, *On Golden Mountain* (New York: Vintage, 1995), esp. 67–88. My thanks to Ted Bosley for bringing this book to my attention. See also the Grace Nicholson Papers (Huntington Library, San Merino, California).

25. On the Greenes and the Halls, see Randell Makinson, *Greene & Greene: Architecture as Fine Art* (Salt Lake City: Peregrine Smith, 1977), esp. 55 and 142–43; Randell Makinson, *Greene & Greene: Furniture and Related Designs* (Salt Lake City: Peregrine Smith, 1979); and Edward S. Cooke, Jr., "Scandinavian Modern Furniture in the Arts and Crafts Period: The Collaboration of the Greenes and the Halls," in *American Furniture 1993*, ed. Luke Beckerdite (Hanover, NH: University Press of New England, 1993), 55–74.

26. The period's common perception that Chinese furniture was lacquerware is detailed by Craig Clunas, "What Is Chinese Furniture: The Changing Western Image of Chinese Furniture," in *Chinese Furniture: Selected Articles from "Orientations" 1984–2003* (Hong Kong: Orientations Magazine, 2004), 16–25. A good period example is Herbert Cecinsky, *Chinese Furniture* (London: Benn Brothers, 1922). On Frankl, see Karen Davies, *At Home in Manhattan* (New Haven: Yale University Art Gallery, 1982); and Alastair Duncan, *American Art Deco* (New York: Abrams, 1986).

27. Gustav Ecke, *Chinese Domestic Furniture* (1944; reprint ed., Rutland, VT: Charles E. Tuttle, 1962), 1–2 and

28. Although only two hundred copies of the first edition were printed, they had a profound impact on the field, as evident in the designer and writer T.H. Robsjohns-Gibbings acknowledging that "Gustav Ecke's splendid portfolio Chinese Domestic Furniture" filled a striking vacuum regarding early Chinese furniture and "will counteract the previous misguided belief that chinoiserie and Chinese Chippendale were Chinese": *Homes of the Brave* (New York: Knopf, 1954), 62.

28. George Kates, *Chinese Household Furniture* (New York: Harper & Brothers, 1948). For a good summary of Kates's career, see Sarah Handler, "George Kates: A Romance with Chinese Life and Chinese Furniture," *Journal of the Classical Chinese Furniture Society* 1, no. 1 (Winter 1990): 67–72. On the expatriate community in Beijing at this time, see George Kates, *The Years That Were Fat* (New York: Harper & Brothers, 1952); Robert Picus, "Charlotte Horstmann at Eighty-Two: Twentieth-Century Evolution of Western Interest in Asian Art," in *Chinese Furniture: Selected Articles from "Orientations" 1984–2003*, 318–25; and Lark Mason, Jr., "Examples of Ming Furniture in American Collections Formed Prior to 1980," in *Chinese Furniture: Selected Articles from "Orientations" 1984–2003*, 130–37.

29. Robsjohns-Gibbings, 61–62.

30. Ibid., 54–57.

31. "Far East Influence in Contemporary Decoration," *House & Garden* 96, no. 4 (April 1949): 88–109. This special feature was followed by an article by George Kates entitled "How to Recognize Chinese Household Furniture," 110–13.

32. On Dynasty Furniture, see John D. Morse, "Dynasty Furniture," *American Artist* 19, no. 5 (May 1955): 40–41 and 70–72.

33. On the rise of studio furniture, see Edward Cooke, Jr., Gerald Ward, and Kelly L'Ecuyer, *The Maker's Hand: American Studio Furniture, 1940–1990* (Boston: Museum of Fine Arts, 2004). On Koga and Jackson, see *Craftsmen '67* (Philadelphia: Museum of the Philadelphia Civic Center, 1967); and Edward Cooke, Jr., "Wood in Its Consummate Material Expression: The Work of Daniel K. Jackson," in *Daniel Jackson: Dovetailing History* (Philadelphia: University of the Arts, 2003).

34. On the recent history of Chinese-furniture scholarship, see Lark Mason, "Chinese Furniture and American Collectors," in *Classical Chinese Wood Furniture* (San Francisco: San Francisco Craft & Folk Art Museum, 1992), 6–12; Robert Ellsworth, et al., *Essence of Style: Chinese Furniture of the Late Ming and Early Qing Dynasties* (San Francisco: Asian Art Museum of San Francisco, 1998), esp. 7; and Robert Piccus, "Chinese Furniture in Hong Kong," in *Chinese Furniture: Selected Articles from "Orientations" 1984–2003*, 179–82. The new volumes of this period include Robert Ellsworth, *Chinese Furniture: Hardwood Examples of the Ming and Early Ch'ing Dynasties* (New York: Random House, 1970); and Wang Shixiang, *Classical Chinese Furniture: Ming and Early Qing Dynasties* (Hong Kong: Joint Publishing Company, 1986). Articles in *Orientations* and the *Journal of the Classical Chinese Furniture Society* explicitly reveal the new fascination with Chinese furniture. The new, broader interest in Chinese furniture of all sorts can be seen in Nancy Berliner, *Friends of the House: Furniture from China's Towns and Villages* (Salem, MA: Peabody Essex Museum, 1995).

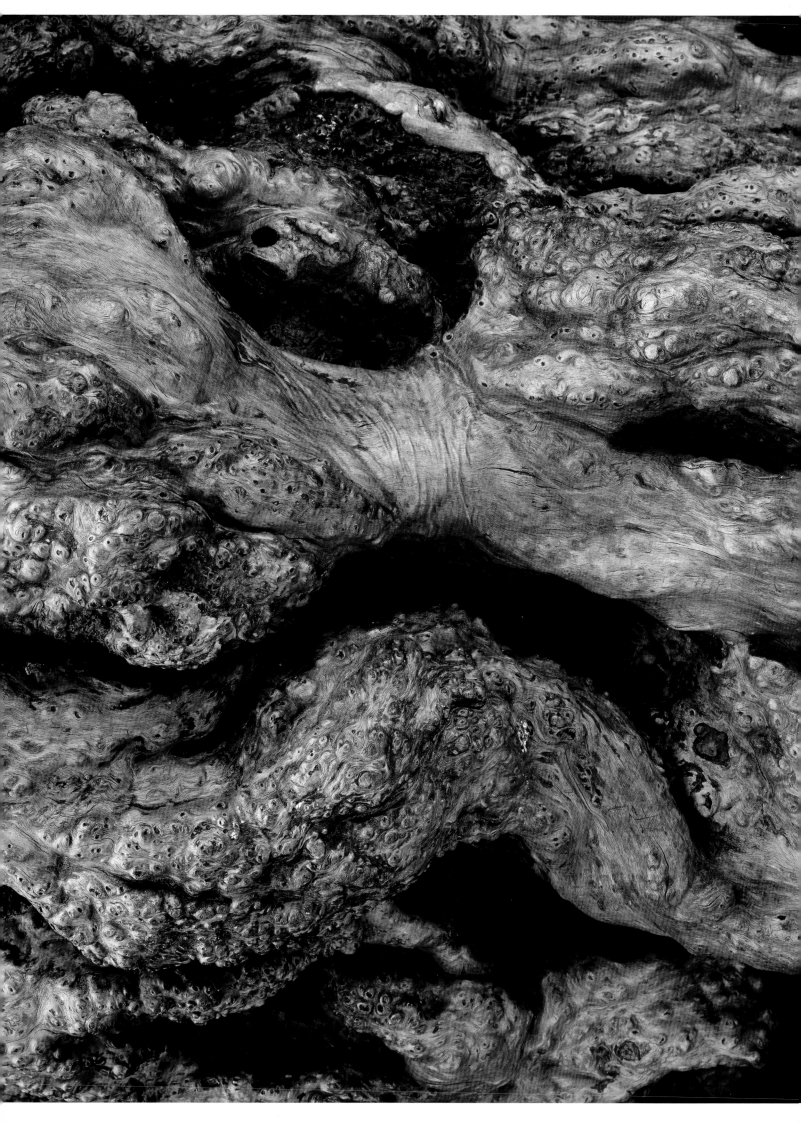

Nancy Berliner and Edward S. Cooke, Jr.

Furniture, Inspiring and Inspired

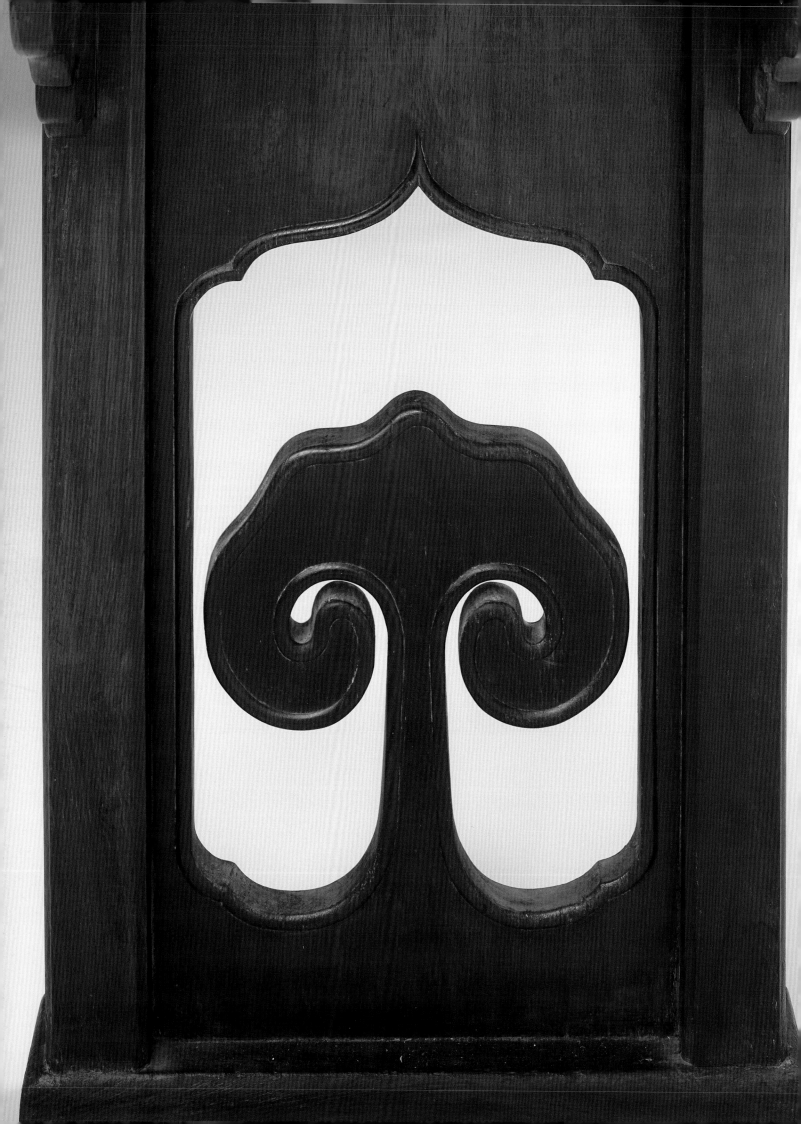

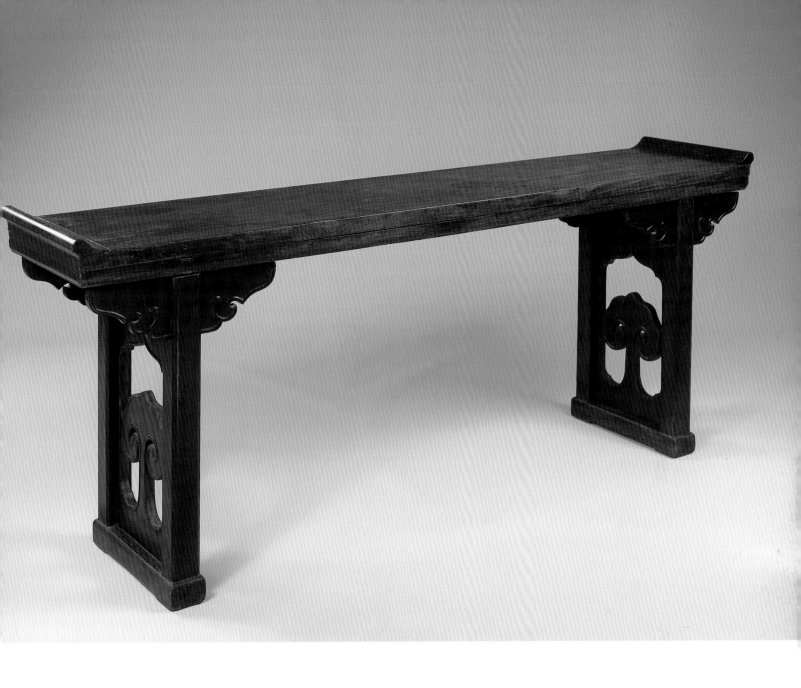

1. **Altar Table with everted flanges,** 17th–18th century
 Walnut
 36¾ × 95½ × 19⅜ inches (93.3 × 242.6 × 49.5 cm)

A table for placing offerings to ancestors and other spirits is one of the most ancient and significant types of furniture in China and one that continues to be a vital feature in many homes today. As early as the Shang dynasty, artisans created small tables—raised surfaces with four legs—on which offerings could be respectfully placed for the deceased ancestors. Stylistic and structural features of this table, such as the attached leg pairs at either end, the apron and spandrels, and the celebratory everted flanges on the extremities, are details that have conveyed the dignity of these tables for over two millennia. NB

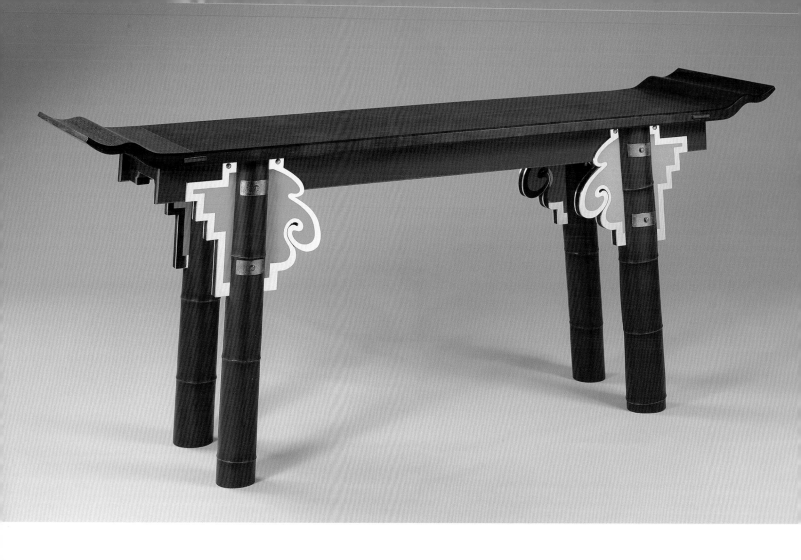

Garry Knox Bennett

2. **Altar Table,** 2005
Honduran rosewood, California walnut, timber bamboo, aluminum, copper, paint
40 × 96 × 16 inches (101.6 × 244 × 40.6 cm)

Bennett approaches the idea of inspiration with a studied irreverence. While claiming a lack of interest in historical styles (for example, he asserts he has never particularly liked the proportions of Chinese furniture or the dark brown colors of the wood), his work of the past two decades does reveal an affinity to traditional Chinese work. His large tables of the mid-1980s more closely resembled waistless altar tables than Anglo-American trestle tables, he effectively and prominently uses metalwork to reinforce joints and for elaborate hardware, and his curved bench ends and brackets closely resemble everted flanges and spandrels on Chinese tables. In response to Chinese furniture, Bennett chose not to get seduced by the exquisite joinery, which he often states can become an end unto itself, but rather to explore formal elements. In his version of an altar table, he combined bamboo timber, rosewood, walnut, aluminum, and copper to create the structure and relied on additional curved profiles and paint to provide his own signature decoration. The result is one of his most striking tables. On the underside of the table, he built in a special time capsule and provided the tools necessary to open it in the future. ESC

I've always overlooked Chinese furniture as kind of overdone. . . . I really like those big hall tables . . . there's an angle they put to those legs that are just out of 90, and it just makes the piece sing. So I'm going to do one of those . . . and it will probably really shake up those Chinese guys. I don't use traditional joinery. I rely on a lot of metal and epoxy. I wouldn't possibly try to emulate the joinery. That's the problem. You spend a whole lifetime learning to make those tricky doo-dad joints and you miss the whole picture. You make a beautifully joined piece of furniture but it may take you two years or one. . . . I know the Chinese don't use screws. They would if they had them.

—Garry Knox Bennett

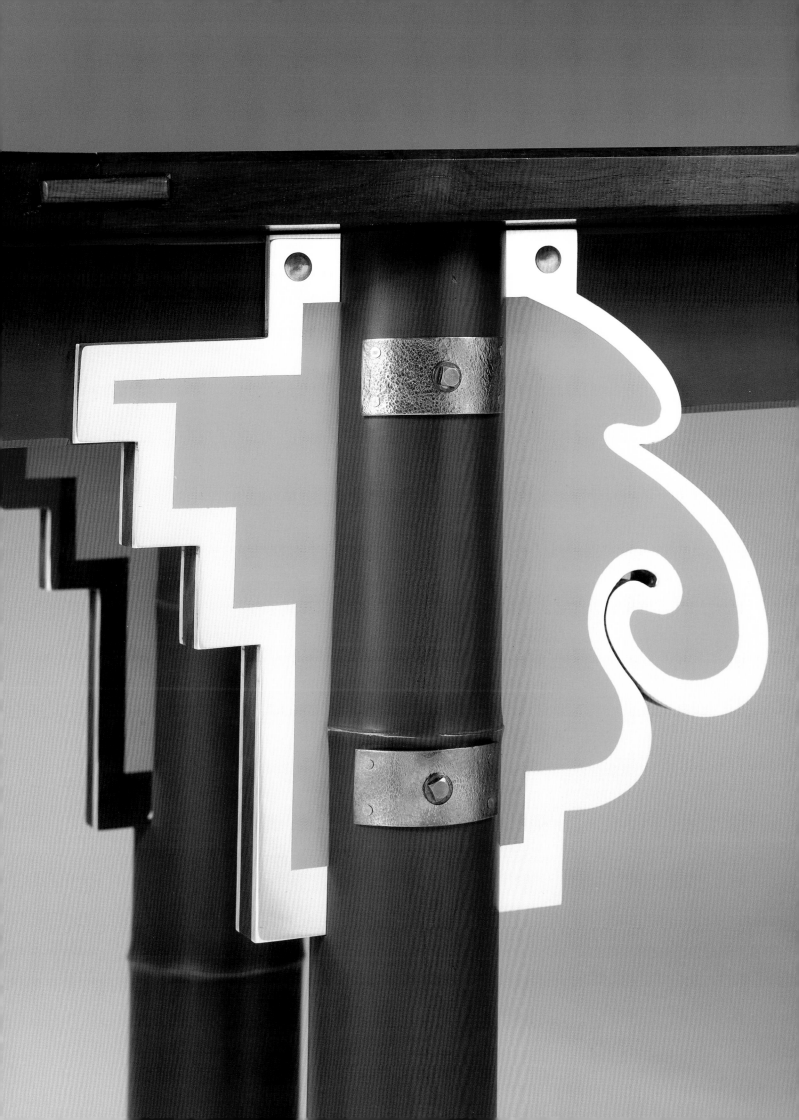

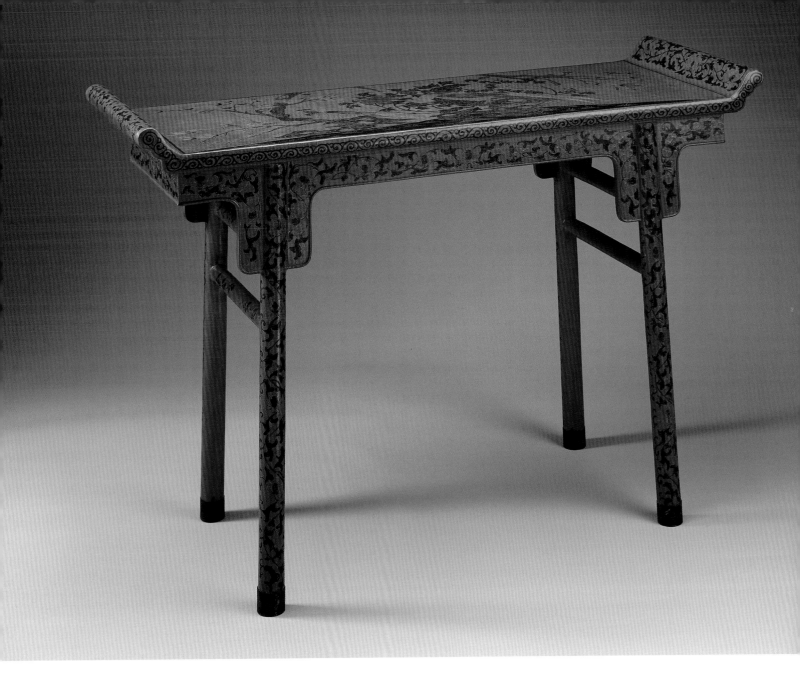

3. **Altar Table with everted flanges,**
17th–18th century
Softwood with lacquer
33 × 49 × 17½ inches
(83.8 × 124.5 × 44.4 cm)

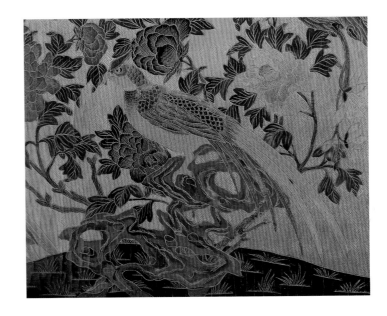

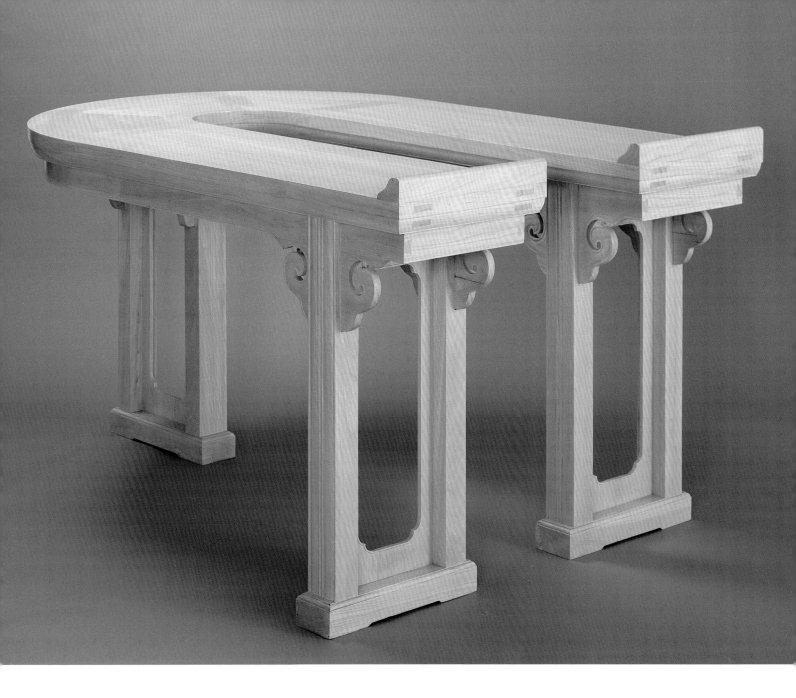

Shao Fan

4. ***U-shaped Altar Table,*** 2005
 Elm
 36½ × 69⅝ × 45 inches (92.5 × 177 × 114 cm)

In creating his *U-shaped Altar Table,* Shao Fan appears to have taken a rigid, straight plank of wood and gently molded it into a modern, rounded object. The altar-table form, with its elongated rectangular surface and everted flanges, is one of the most ancient types of Chinese furniture. As the piece of furniture on which offerings to deities and spirits are made, it is located in the most honorable location within a household or sacred space. In his transformation of this all-important prototype, and by making it practically nonfunctional in its traditional assigned space, Shao Fan asks the viewer to reconsider both the function and the form of the altar table. While visibly questioning the place of the altar table in the modern world, Shao Fan also strongly articulates that he is paying homage to the unnamed Ming furnituremakers and designers. NB

I feel that my pieces still maintain the fundamental aspects of Ming-style furniture. Its blood is still in them. They are made from a modern person's perspective and created by an artist, but their roots are still in the traditions of Ming-style furniture.

—Shao Fan

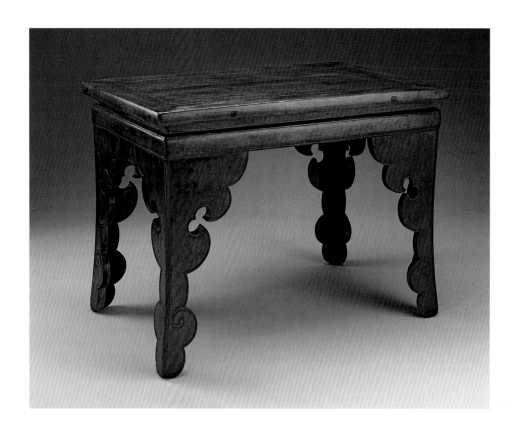

5. **Altar Table, waisted with cusped legs,** 16th–17th century
 Huanghuali, oak
 29½ × 40¼ × 25½ inches (74.9 × 102.2 × 64.7 cm)

This table, no doubt intended as a table for offerings, incorporates forms and motifs from Chinese decorative arts, but is an example of a unique, regional style that does not conform to the more widespread, expected Chinese furniture styles. NB

There's a table with the legs. It's the strangest, it's simple, it's the strangest, I don't even know when it was made or where it came from, but it's just about perfect. This piece has heavy character, and I don't know why. It has a cloud motif. It's got perfect proportion the way the legs go up and get fatter and fatter and fatter. And just a little bit of profile. I shouldn't like *that table—I shouldn't—but I* really *do. And that's a surprise too.*

—Brian Newell

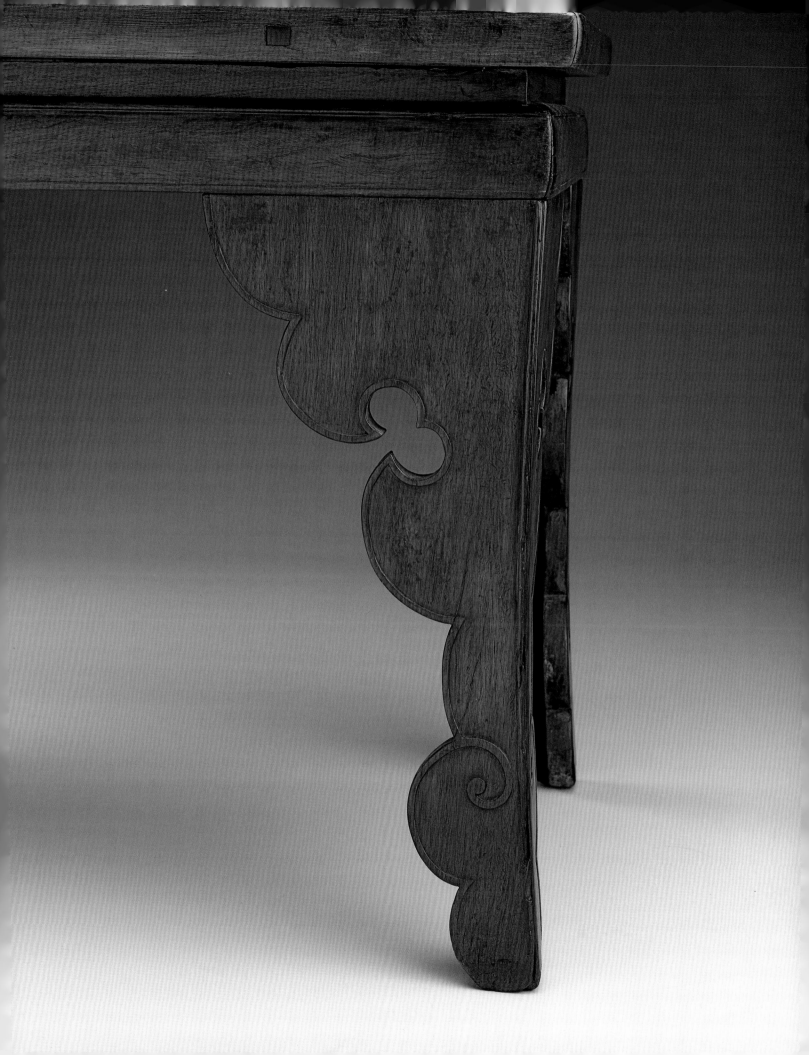

Tian Jiaqing

6. ***Reclining Dragon,*** 2005
 Huanghuali
 32⅞ × 34 × 174 inches (83 × 86.3 × 442 cm)

Tian Jiaqing entered the world of furnituremaking from an academic orientation. Sitting at the feet of the great furniture scholar Wang Shixiang, Tian Jiaqing studied the history of Chinese furniture with great enthusiasm, plunging into his own research on joinery and publishing on the then-unexplored field of Qing furniture. His admiration for the craftsmanship and his close work with elderly furniture restorers eventually led him to collaborate with Wang Shixiang and master craftsmen to design a grand desk for Wang Shixiang. Following the success of that table, and armed with a deep understanding of Ming furniture, he began, over ten years ago, designing and fabricating his own furniture. The *Reclining Dragon* altar table, so named by Wang Shixiang, is a tribute both to the lines of Ming furniture and the pure beauty of the wood. NB

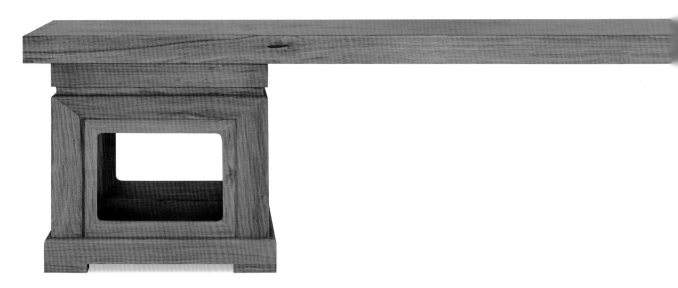

The arrival of this piece of wood was a real saga. It was an opportunity. I know a timber businessman. One day, out of the blue, I received a phone call. He said he was outside the country and had seen an enormous piece of lumber. He said: "Mr. Tian, you should buy it. You'll be able to chop out a very special piece of wood." But the biggest problem was shipping. And there was the real dilemma, that I hadn't seen it. In Beijing we say it's like "buying a cow, separated by a mountain." I didn't know anything about this piece of wood. He said to me, "Even if this timber is a little expensive, it doesn't matter, because you're going to have to pay a lot for the shipping. It's got to be loaded on a truck, and shipped and then go through customs. There are going to be a lot of procedures. At every location it will have to receive special packaging and its own vehicle." Now at that point I was thinking that this is a real pain in the neck. And I didn't even know if I would be able to use it. I didn't even know if the whole piece was going to be empty inside. So, during that first call, I didn't agree to buy it. After a day, he called again. Well, that day I decided it was fate. . . .

When he finally got it here [to Beijing] it was over six meters in length. There was no place to put it. And there was no place that could saw it open. We decided to go to a place almost in Tianjin.

The night before, I couldn't sleep. We were all really nervous. Because we knew that this timber was an immense piece of material, but we didn't [know until] after we opened it up if we would be able to make anything of it. How were we going to cut up this piece of wood? We spent a very long time looking at it from this direction, from that direction, to figure out how to saw it. We calculated very precisely. Everyone was so excited when we were about to make the first cut. The first cut was fine. And the second cut was really good. The only thing was that there were two small insect holes. We really regretted our cutting decision. If we had cut in a slightly different way, we might have been able to avoid the insect holes. But there is another Chinese saying: "Man's calculation is never as good as heaven's calculating." That is to say, we had already calculated as much as could have been calculated.

After we took it back, it was a single, solid plank. In classic Chinese furniture we call this a block of jade. As I was designing this table, I thought, the most important thing was that it has to have a Chinese-furniture soul and have a great amount of energy. I thought very slowly, and eventually I came up with this design. On one hand it is traditional; on the other hand it has a bit of modern style. I wanted it to be heavy and dignified, stately and honest.

After it was made, another dilemma came up. It had to be given a name. I've been thinking about writing an article about all the names that have been suggested. There have been about a hundred names. Some have called it The Great Wooden Horizontal Sky. *Some called it* Satisfied. *And* At Ease *with Oneself. Wang Shixiang has named it* Reclining Dragon. *In any case, this piece of furniture is among the ones I have designed with which I am most satisfied. And I feel it is a piece of fate. That is, I bought a cow separated on the other side of the mountain and I really got a cow, and that's not bad.*

—Tian Jiaqing

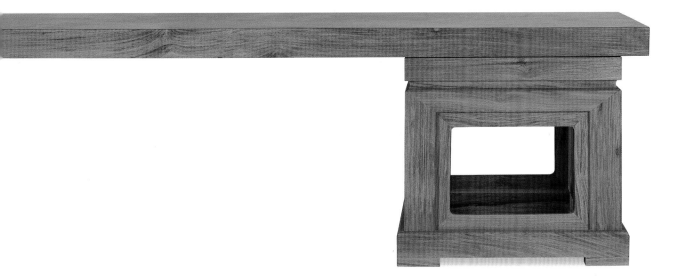

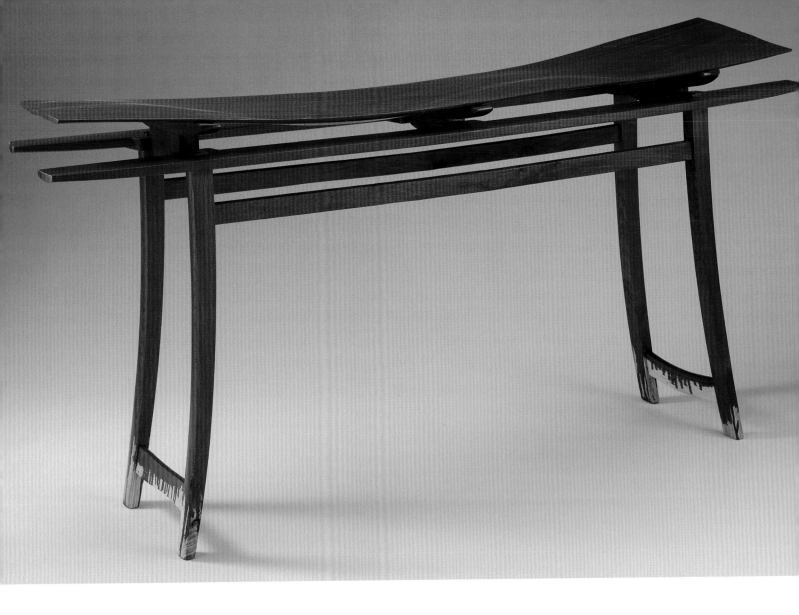

Hank Gilpin

7. ***Curiously Red . . .***, 2006
Elm, pigment, magnets
36 × 76 × 18 inches (91.4 × 193 × 45.7 cm)

Gilpin has been a strong, consistent voice in the no-frills, direct-furnituremaking vein. He typically shuns whimsical or narrative ideas, choosing instead to focus upon wood, structure, and joinery. Having built up a deep well of knowledge through study of historic furniture, he celebrates the natural beauty of wood, relates function to form, and draws upon appropriate cabinetmaking traditions. Eschewing paint or elaborate finishes, he favors oil or even wire-brushed finishes that do not obscure figure. Yet he has recently shown a predilection, when confronted by an extraordinary piece of wood, to incorporate that board as an aesthetic element in its own right. For this table, Hank was drawn to the tragedy of a grand elm in Providence, Rhode Island, that was choked by new building construction. To draw attention to this loss, he highlighted the living, organic quality of the tree by allowing a thin board with interlocked grain to dry with considerable rack and twist. He elevated this element by placing it on a beautifully constructed base, making the altar table top the object of contemplation as well, and then provided a dripping, blood-red finish to evoke the loss of the tree's life. ESC

Think altar table, the one with the BIG thick top and the stylized tree framed between the legs. . . .
The wood is elm. The lumber came from a very large tree at Brown University which, unfortunately but
predictably, died during the construction of a research lab. . . . I received a small allotment of the tree,
so to speak. And here we are—China/Elm, Elm/China. One thing led to another and now it's up to me
to do something worthy of the tree and the exhibition.

—Hank Gilpin

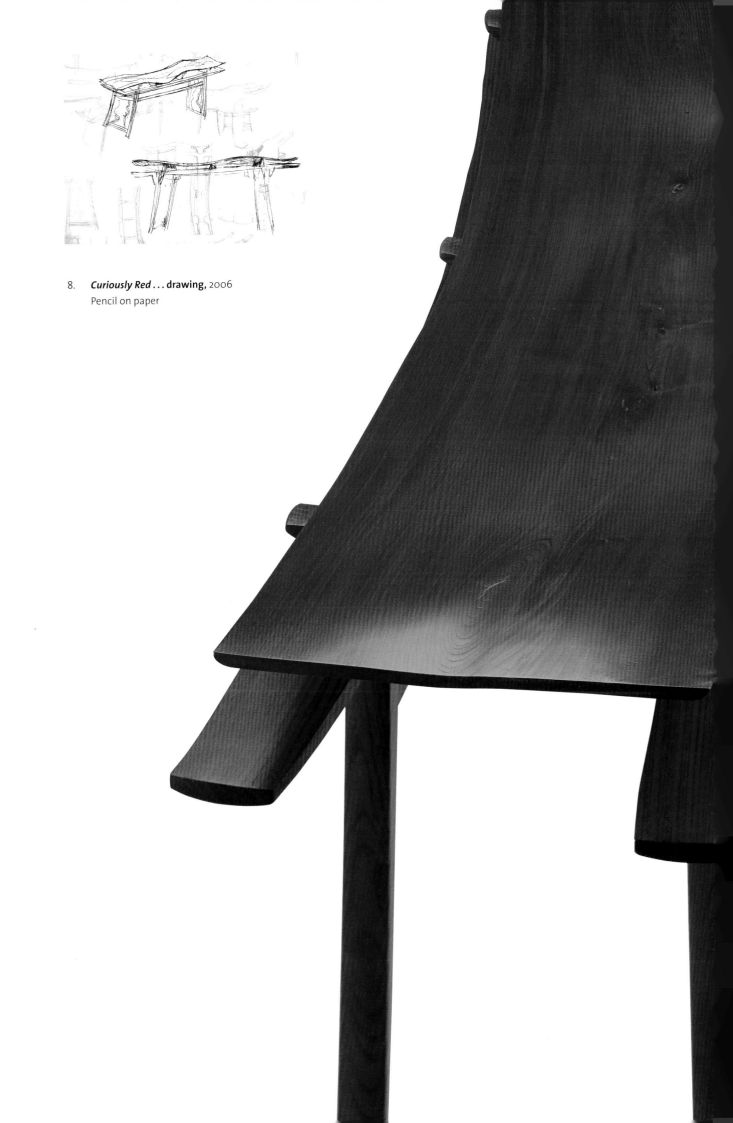

8. ***Curiously Red . . . drawing,*** 2006
Pencil on paper

9. **Taihu Rock,** Elizabeth Z. and Archibald R. Lewis
Garden Terrace, Peabody Essex Museum
Photograph: Dennis Helmar

10. **Screen,** 18th century
Wood
68½ × 46 × 15 inches (173.99 × 116.84 × 38.1 cm)

11. **Stool with storage cavity and cover,** 19th century
Tree trunk
21 × 26 × 23 inches (53.3 × 66 × 58.4 cm)

In a civilization where, over 3,500 years ago, artisans were already developing refined techniques to form raw minerals and metals into elaborate incised, inlaid, and ornamented ritual, decorative, and functional objects, an opposing, deep appreciation arose for the wondrous shapes and textures created by the natural environment. Traditional connoisseurship reserved a reverential place for objects that reflected their organic forms created without human interference. In the homes of connoisseurs, pedestals display rocks, wood, and bamboo in their natural forms, and men with financial resources have for centuries commissioned furnishings and desk accoutrements made of such materials. These organically shaped objects and furnishings, expressing their owners' disdain for man-made fineries and superficial decor, bespeak a profound—or a feigned—belief in the superior ways of nature. NB

Shi Jianmin

12. **Stool,** 2005
 Stainless steel
 20½ × 59 × 55 inches (51.8 × 150 × 140 cm)

Like the Chinese organically shaped tree-trunk stool that inspired it, this stool/table expresses a powerful energy, as if, like a glacier, it is still in the process of growing and changing its shape. Shi Jianmin is heartily devoted to the Chinese arts of calligraphy and painting as well as to the Chinese traditional art of appreciating organically shaped wood and rocks, and his works strongly reflect the force and movement of a brush on paper and the energy of an evolving biological organism. NB

This piece can be a table, or it can be used as a stool. Now, in art-design I feel that the primary visual effect is definitely to create a sense of a piece being a work of art. The first reaction should be "Ah, this is art. What is it? It's beautiful." And only then "Ah, this also can be used...."

—Shi Jianmin

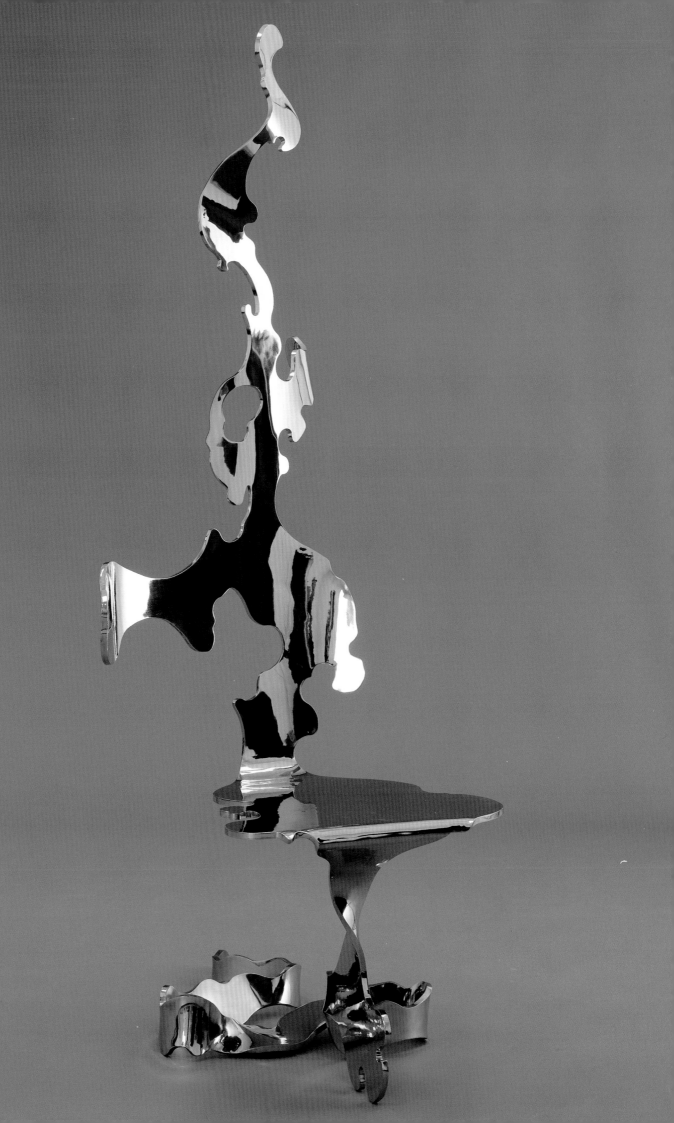

14. ***Stool and Chair* drawing,** 2005
Pen and ink on paper

Shi Jianmin

13. ***Chair,*** 2005
Stainless steel
84 × 36 × 36 inches (213 × 91.5 × 91.5 cm)

Shi Jianmin employs the very modern, unforgivingly rigid material of stainless steel to create unexpect-edly lyrical furniture that, just as surprisingly, evokes ancient Chinese aesthetic sensibilities. While trained as a contemporary designer, his penchant for Chinese aesthetics, culture, and tradition are abundantly palpable in his work. Earlier metal chairs by Shi strove to replicate the dynamism and forms of Chinese running-script calligraphy. While in the United States, he found himself drawn to the Chinese furniture and decorative art traditions that reflect a fondness for stone and wood in their natural and organic forms: chairs made of root wood, stools formed from tree trunks, and rocks placed in gardens. Chinese rock con-noisseurs maintain a list of attributes for assessing rocks including the terms *lean, awkward,* and *perme-able.* Shi successfully pursued these same qualities in creating the dynamic form of his chair's backsplat.

NB

In the past in China most furniture was made out of wood. But many people also enjoyed and appreciated [and collected] stones, from large ones that were gigantic mountain stones to small ones that were tiny gems. There are many principles about how to critique rocks. In dealing with rocks, you have to consider if a particular rock is alive or not. This "living" points to its insides. It has to have a natural beauty. In the creation of this chair, I wanted to express the inner life of the stone. This piece has borrowed some special characteristics of stones. For instance, it has some ghost faces, it looks like it has eyes, or an animal's mouth. It also has borrowed some techniques. Organically formed wood and rocks all inherently have something natural about them. This type of beauty is something that man-made objects cannot sub-stitute. So when I was designing this I really tried to emphasize this liveliness and naturalness, letting [the metal] flow naturally by itself and naturally create itself.

—Shi Jianmin

Michael Cullen

15. ***Star Table,*** 2005
 Red eucalyptus
 Height 18 × width variable 35–68¼ inches
 (45.5 × 88.9–172.7 cm)

Known for his exploration of color and texture, Cullen found himself drawn to the natural compositions and raw energy of root furniture. Finding a large, hundred-year-old eucalyptus tree that had been cut down two years ago and left to dry in the sun, he was inspired by the tree's asymmetrical, organic section and the cross-grained textures inherent in its structure. He had the sawyer Evan Shively cut a slab of the tree's trunk from down near the roots. Cullen envisioned a root coffee table in which the checks caused by the wood's drying resonate with the irregular starfish shape, and the silver gray of the trunk's exterior provides a dramatic contrast to the deep golden hue of the cross section. He used a carving gouge to lightly ripple the surface to accentuate the imprecision of the table. In this coffee table, Cullen extended the idea of root furniture to the part of a tree just above the ground in order to celebrate the natural aesthetics of a tree's trunk. ESC

The essence of this piece is not dissimilar from that of other natural objects—the shell can be traced to the ocean just by looking at it. Here, with this eucalyptus piece, I wanted to create something that left the tree and its life in the wood, as opposed to removing them. That is how my conversation began with Evan (the sawyer). I want to make something that doesn't take the tree out of the wood.

—Michael Cullen

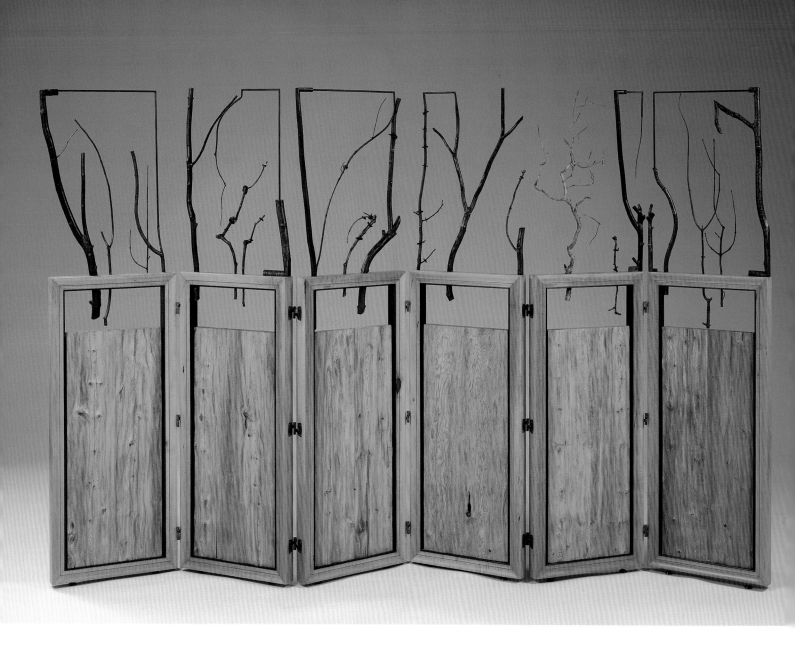

Tom Hucker

16. **Screen #1,** 2006
Swiss pearwood, English yew, bronze
69 × 111 × 1½ inches (175.2 × 281.9 × 3.8 cm)

Hucker has long had an interest in Asian furniture, as he seeks to understand the rituals behind furniture forms, how furniture fills and articulates space, and the relationship between details and the whole. While looking closely at Chinese furniture, he became intrigued with tensions inherent between object and image in folding screens and between nature and artifice in root furniture. His own folding screen balances these elements: the lower panels emphasize solidity and objectness, with paneled frame construction in which the rough-hewn yew panels have polished endgrain and are set within a soft, smooth pearwood frame, and the skeletal upper "panels" emphasize image through a combination of twigs and cast bronze "twigs" that merely suggest substance. The overall effect is one of ambiguity: As you approach the screen, your experience vacillates between the visual and the tactile. ESC

What I love about Chinese screens in contrast to the Japanese is that the Japanese are more interested in the paintings, whereas the Chinese seem to be more architectural, more concerned with issues of defining area, translucency, playing with the atmospheric qualities of space itself. The screen offers me an opportunity to play with both the concepts of furniture and the concepts of painting.

—Tom Hucker

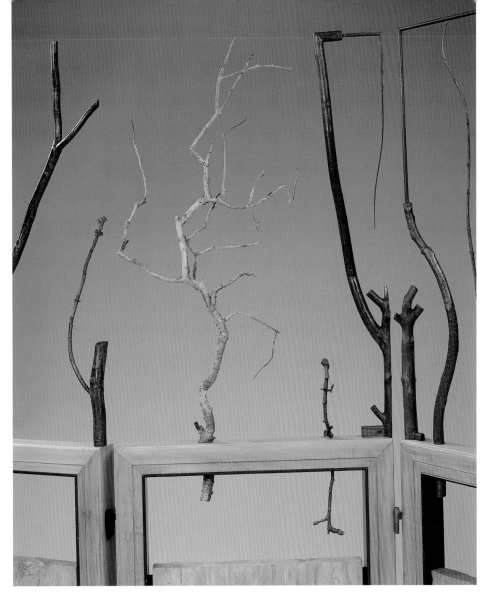

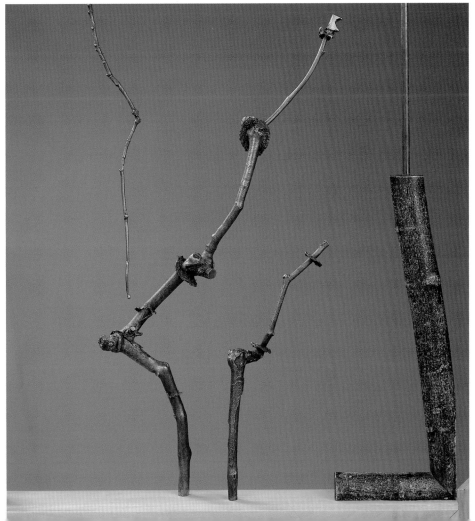

17. **Textile Screen,** 18th century
Silk, linen
144 × 288 inches (365.7 × 731.5 cm)

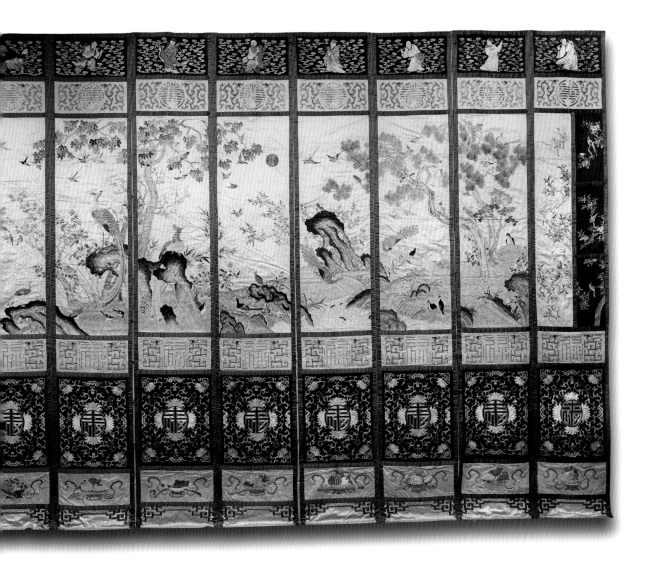

European missionaries painting in Beijing's Imperial Palace workshops introduced trompe l'oeil techniques to the Chinese emperor. By the late eighteenth century, this imperial taste had seeped into the elite society and decorative items of the late eighteenth and early nineteenth centuries reflected well-to-do viewers' and consumers' delight in these playful visual affects.

In China, the screen has historically functioned either as room divider, wind blocker, or background frame, which would be positioned behind a seat to lend dignity to the sitter. This grand textile flawlessly emulates the structure of a 12-panel wooden folding screen with 12 vertical "paintings" mounted within. The large surface of the textile is divided into the same structural divisions as a wooden folding screen. Twelve vertical panels are each comprised of seven divisions. The artists tackled each division with a different decorative-textile technique. Together, the entire piece presents age-old Chinese traditions of auspicious wishes. Separately, each division expresses the genius and creativity of artists working with needle, thread, and silk fabrics to produce a surface of lush textures and imagery.

This unusual screen has had a long and varied history. Photographic evidence shows that at one time it graced the walls of the home of an American, most likely William F. Spinney, a commissioner in the Chinese Imperial Maritime Customs in China, who spent time in Hong Kong, Fuzhou, and Beijing during the 1870s and 1880s. NB

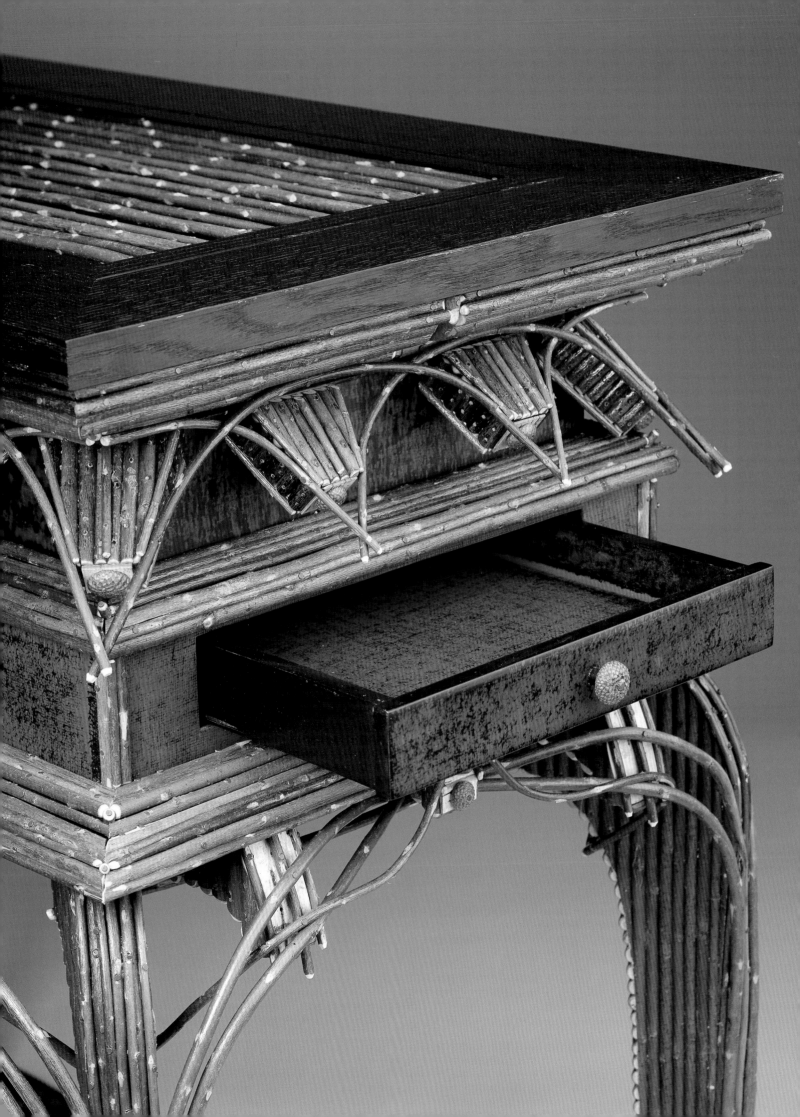

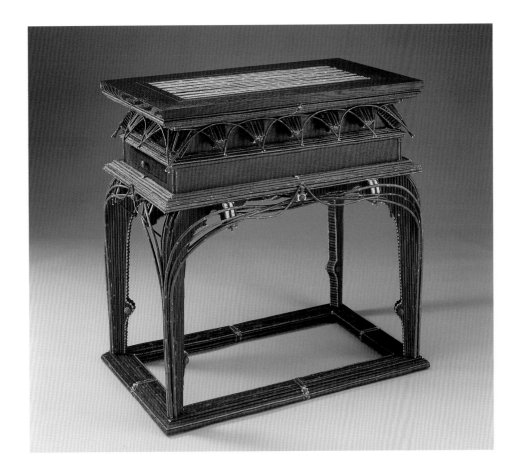

Clifton Monteith

18. ***Alter Altar Table,*** 2006
 Oak, willow twigs, aspen, black and cinnabar *urushi* lacquer
 35 × 36 × 22 inches (88.9 × 91.4 × 55.9 cm)

Monteith has discovered his particular voice through the use of willow twigs. However, he does not merely copy rustic twig furniture of the late nineteenth and early twentieth-century Adirondack styles. Instead he conceives of great sculptural forms and uses twigs in conjunction with color as a form of decorative icing, what he refers to as "willow mosaic." To achieve such a built-up form, he first constructs a solid-wood core, then embellishes this surface with twigs, color, and *urushi* lacquer to create a vibrant object that resembles a natural form as well as an engineered structure. In responding to Chinese furniture, Monteith blended an interest in lacquered tables with the seemingly natural construction of root furniture, in which several pieces of root material are mortised together to make a single object. His resulting table invites close examination of the play of nature and artifice, even on the underside. ESC

Because I work only with natural materials, and I use a lot of very small-diameter willow twigs in my work, I must go and collect them myself and work with them when they are green. And, because of that, instead of living in a cubicle in New York City, I get to wander around in the woods all the time in all kinds of weather, pleasant and foul, and really, really enjoy that a great deal. All of the wood that is in this piece—the willow, aspen, and oak—came from within twenty miles of my home, where I live. I know these trees, I know where they came from, I feel very close to them. My own work seems to be very symmetrical although . . . it's impossible to be symmetrical because I'm working with the twigs in their natural state. So one twig that has a mirror image on the other side is really a rough approximation and it's an illusion that it is symmetrical. I think that's one of the things that the Chinese aesthetic was trying to do—to bring the order from the natural world to the human world by incorporating things that were symmetrical.
 —Clifton Monteith

Joe Tracy

19. *Split Personalities in* Sequoia semper virens: *Three Case Studies,* 2006
 Wenge, split sequoia redwood, Indonesian red palm, Lebanon cedar,
 walnut, Damascus steel, silver leaf
 72 × 20 × 16 inches (183 × 50.8 × 40.6 cm)

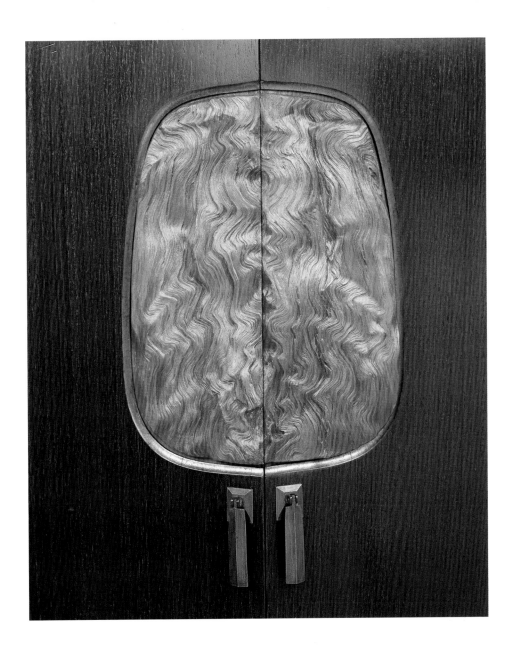

Intrigued by puzzle tables, folding screens, and root furniture, Tracy created a new hybrid—the folded puzzle cabinet—in which the creased elevation evokes hinged screens and the interchangeability of the tables (they can either flank or interrupt the cabinets) echoes the interchangeable plan of puzzle tables. In much of his best-known work, Tracy used ocean-smoothed granite as a central natural element, setting it off and enframing it within a visibly joined wooden frame. For these cabinets, he used a split curly redwood panel to provide such a focal point. Rather than saw out and dress the panels, he hewed the curly wood and thereby retained the visceral, textural quality of the material. Silver leaf in the molding around these panels accentuates the raw preciousness of the split redwood. ESC

I would also include in the group of pieces that influenced me the puzzle table group because of its modularity and the modularity of my piece, the clean lines of the puzzle tables, and the "broken ice" pattern of the lower shelf; and the large folding screen because I believe the front of my cabinets will suggest the articulated planes of a folding screen, when slightly folded.... The door center panels shall have split, figured redwood panels, which I have just returned with from a northern California wood-hunting expedition. This very rare wood came off timber company land that was originally logged for old growth redwood in the 1950s.... Splitting, while riskier and less predictable than simply sawing open to reveal figure, can yield a more rewarding piece, adding, literally, a third dimension of topography, along with texture, to the surface, creating an interesting contrast with the smooth and polished framing element of the doors.

—Joe Tracy

20.	**Vase with cracked-ice and plum pattern,** 19th century
	Porcelain
	Height 7⅛ inches (18.3 cm)
	Collection of the Peabody Essex Museum E72680
	Photograph: Dennis Helmar

21.	Detail, Crackled glaze on *ge* ceramic
	ware, Song dynasty
	Private Collection
	Photograph: Maggie Nimkin

Cracked Ice

The decorative pattern called "cracked ice" (*binglie,* meaning "ice cracks") has a long and rich background in Chinese culture. This unsymmetrical, weblike pattern acquired the connotation of heralding the spring as the lines reflect the configuration on water's frozen surface as winter's ice begins to thaw. The intriguing design has returned over and over in Chinese aesthetics and had a flowering in the seventeenth century that made a deep impact on all of the Chinese decorative arts.[1]

Affection for crackled patterning first arose during the late Song dynasty. The ceramic kiln known as the Ge kiln in today's Zhejiang Province began producing wares with blue-green monochrome glazes intentionally made to crackle by varying the kiln's temperature. The pattern is often referred to as *kaipian* (separated pieces). The appearance of deterioration in these pieces—known in Chinese as the aesthetic of the deficient—contrasting with the rich, pale-green glaze, appealed deeply to the poetic souls of sophisticated Song connoisseurs. The penchant for these elegant ceramics among the cultured classes during later dynasties may have inspired the cracked-ice patterning that appeared during the Ming and Qing periods in window-lattice design and garden paving as well as furniture-surface design.

The artist and garden designer Ji Cheng (1582–ca. 1634) produced a landmark manual on garden design in the last years of the Ming dynasty. In the text, where he writes primarily on the architecture and man-made aspects of gardens rather than plantings, he recommends the cracked-ice pattern for specific surfaces in a garden: "The cracked ice pattern is the most suitable for [lattice] shutters. The pattern is both simple and elegant; you may vary the design as you please. The subtlety of it is that it can be more widely spaced at the top and denser at the bottom." In the paving section he emphasizes that the designer should not be rigid in his manifestation of the imagery: "Cracked ice is suitable for paths through a mountain gully or on a slope by the water or before a terrace or beside a pavilion. The basic pattern can be seen above in my section on shutters, but you should be flexible in interpreting it and not be restricted in the way you lay the paving."[2]

During the seventeenth century, the cracked-ice pattern became associated with the imagery of plum blossoms. Plum trees blossom during the first lunar month of the year in China and thus are a symbol of the coming spring. The poignant image of plum blossoms dropped upon the cracked ice of a waterway became abstracted as a decorative motif and appeared frequently as a pattern on ceramics during the seventeenth century and soon appeared in other decorative media, such as architectural latticework, cloisonné, and garden stonework.[3]

The eighteenth-century Qianlong emperor was fond of the cracked-ice pattern and in his personally designed garden, within the walls of the Forbidden City, the pattern is found in the outdoor stone walls, and even in marquetry on interior corridor walls. This imperial proclivity for the design most probably sparked a further renaissance of the pattern in decorative features.

Eighteenth-century Europeans and Americans were equally intrigued by the dynamism of the cracked-ice patterns. In the late nineteenth century, blue-and-white ginger jars with the cracked ice and plum blossom motif were all the rage in America.

Today, the vitality of the cracked-ice pattern continues to dazzle and captivate viewers and artists looking to swim in and play with its entrancing irregularity, as evidenced by the furnituremakers who incorporated the pattern into their works.　　　　　　　　　　　　　　　　　NB

Notes

1. Daniel Sheets Dye, *Chinese Lattice Designs* (New York: Dover, 1974), 425. Dye, who did his research in Sichuan during the 1930s, refers to a Han-dynasty clay house model with cracked ice–pattern windows. He saw the piece at an exhibition of Han-dynasty funerary goods at the museum of the Union University in Chengdu, and includes a sketch of it in his book. After exhaustive reviewing of images of excavated Han clay models, I have not located any with cracked ice–pattern windows. Most have either rectangular- or diamond-shaped lattices. My conclusion is that Dye was looking at haphazardly molded or drawn imagery on a house model. Many were indeed haphazardly done, as they were goods intended for graves. The cracked-ice pattern would have been antithetical to Han aesthetics, with its very regular patterns, and does not seem truly to appear in decorative arts until the seventeenth century.

2. Ji Cheng, *The Craft of Gardens* [*Yuan ye*], trans. Alison Hardie, photographs by Zhong Ming, with a foreword by Maggie Keswick (New Haven: Yale University Press, 1988), 101.

3. For further discussion see Mary Gardner Neill, "The Flowering Plum in the Decorative Arts," in *Bones of Jade, Soul of Ice,* ed. Maggie Bickford (New Haven: Yale University Art Gallery, 1985), 193–243.

22. **Tangram pieces,** 1830–1860
Ivory
Box 3⅛ × 3⅛ inches (8 × 8 cm)
Collection of the Peabody Essex
Museum Gift of Miss Helen C. Hagar
E45893
Photograph: Dennis Helmar

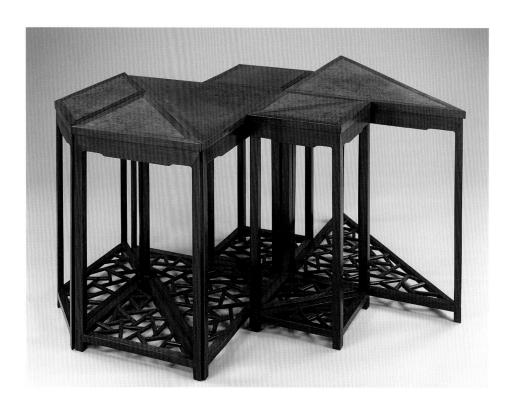

23. **Tangram Puzzle Tables with Cracked-ice Footrest Designs,** 18th century
Hongmu, burl
Seven-piece set
Square table 31¾ × 15 × 15 inches (80.6 × 38.1 × 38.1 cm)
2 large triangles 31¾ × 42 × 21 inches (80.6 × 106.7 × 53.3 cm)
2 small triangles 31¾ × 21 × 10½ inches (80.6 × 53.3 × 26.7 cm)
Medium triangle 31¾ × 30 × 15 inches (80.6 × 76.2 × 38.1 cm)
Parallelogram 31¾ × 21¼ × 15 inches (80.6 × 54 × 38.1 cm)

The tangram, developed during the Qing dynasty and known as *qiqiao ban* (seven ingenuity blocks), is a traditional amusement of configuring set shapes into a variety of groupings that may resemble objects, animals, humans, architecture, Chinese characters, or abstract patterns. The twelfth-century *Yan Ji Tu* described the many possible arrangements of variously sized rectangular tables for a range of seating purposes. In the eighteenth century, furnituremakers took tangrams one step further by creating tangram puzzle tables that could be used separately as stands and tables around a room or placed together in a variety of configurations for a larger layout. This set's footrests in cracked-ice lattice pattern echo the dynamic irregularity of the table shapes. NB

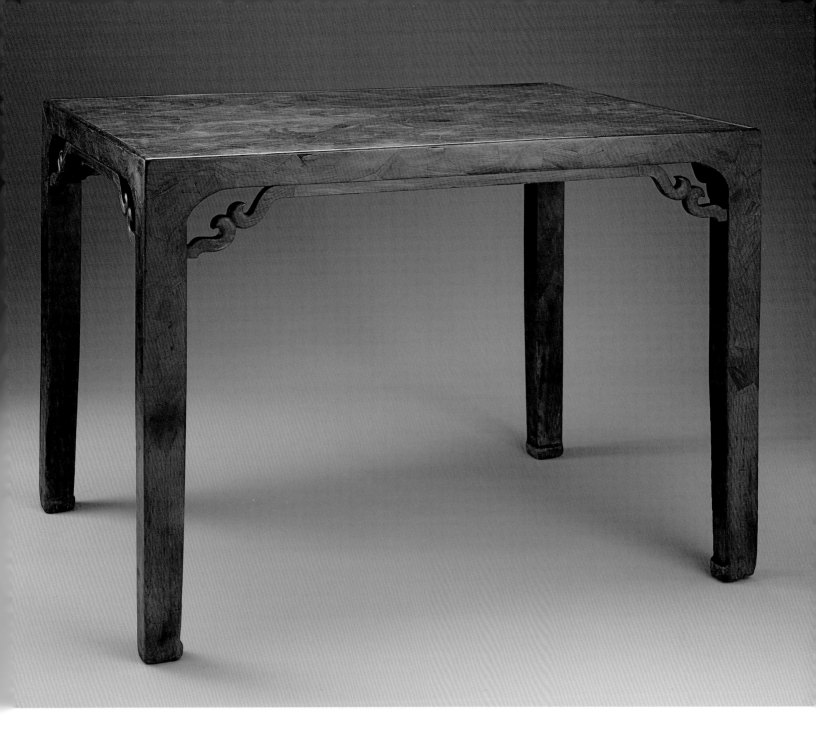

24. **Table with cracked-ice pattern marquetry,**
17th–18th century
Huanghuali, nanmu
31⅛ × 44¼ × 33³⁄₁₆ inches
(78.9 × 112.4 × 84 cm)

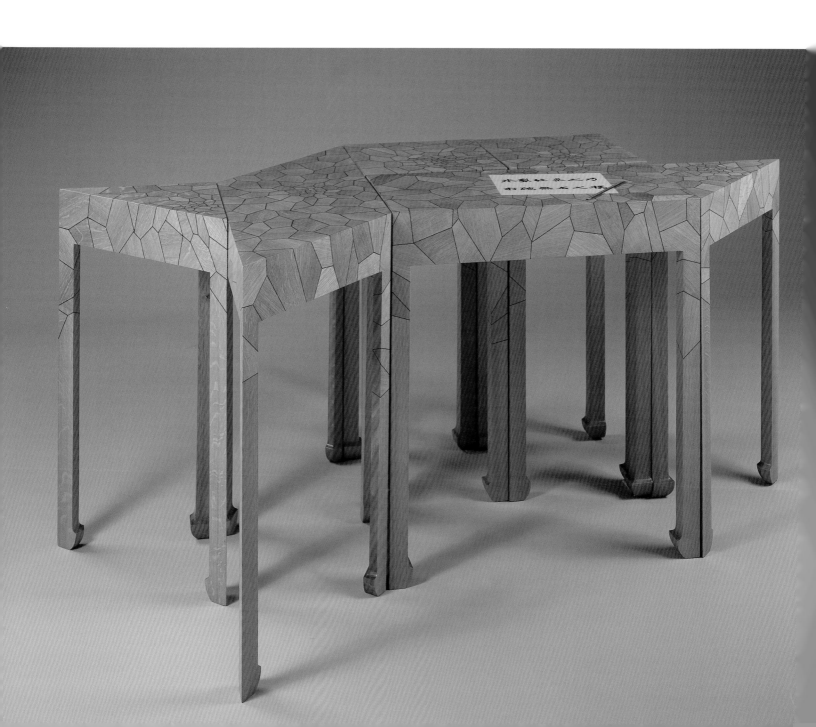

Silas Kopf

25. ***Cracked-ice Puzzle Tables,*** 2005
White oak, East Indian rosewood, various woods
2 squares, each 34 × 15 × 15 inches (86.4 × 38.1 × 38.1 cm)
2 triangles, each 34 × 15 × 15 inches (86.4 × 38.1 × 38.1 cm)
parallelogram 34 × 20 × 15 inches (86.4 × 50.8 × 38.1 cm)
rectangle 34 × 30 × 15 inches (86.4 × 76.2 × 38.1 cm)

Kopf is renowned for his command of marquetry, the creation of wooden pictures through the cutting and assembling of thin veneers. Drawn initially to cracked-ice marquetry on a center table, he soon realized that the concept could also be found in the arrangement of the parts of a puzzle table. To him, cracked ice thus was not only a decorative motif but also an organizing formal principle. He therefore set out to build a group of cracked-ice tables with cracked-ice marquetry. The marquetry inscription at the center of one of the tables draws ideas from Taoist notions of the uncarved block. This pictorial element represents a calligraphy brush and a piece of paper with characters that can be translated as "the artfulness of the cracked-ice tables shatters to pieces the uncarved block." ESC

The table at the museum had this cracked-ice pattern in the marquetry. But then I noticed it was a recurring theme in the decorative art we were looking at—in the latticework and things like that. . . . Well I knew that I wanted to put together the puzzle tables; I liked that right off the bat when I saw them. I thought that was an intriguing idea. We certainly have nothing like that in Western furniture, that style of decorating. You would use the furniture object in different configurations to do something. Our furniture only has one function and that's it. It's a plant stand, it's a coffee table, it's a cabinet, whatever. So the idea of all these different tables potentially being used in different ways is pretty exciting. Then I wanted to add the cracked iced to it and I wanted to do it in a way that was both very obviously wood-oriented, I wanted to pick a very grainy American wood. I used white oak and changed grain directions so that each piece, each one of the cracked pieces, was clearly different from one of its neighbors. The other thing that I wanted to do that I didn't see in the Chinese practice, the marquetry table, was to vary the size of the pieces. I wanted to have each table look as though there was one point where maybe someone took a hammer and shattered the ice and it broke from that point, and the pieces got bigger there. So every one of these tables has that smaller focal point, and then the pieces get larger and larger until they wrap around the edges and fade away at the feet. So it seemed to fit together to me as a way of using my skills in the marquetry world in this Chinese motif, and then the puzzle tables themselves, that was just a natural to go from the smaller shapes of the cracked ice to the larger designs in the tables themselves. . . . As the tables have been sitting around the shop here, I've pieced them together in any number of different ways and it's actually kind of interesting the possibilities. There are six tables altogether and it can go from an L to a larger sort of odd parallelogram as well. And I think that makes for an interesting decorative device. That if this were to be in someone's home they could separate it. They could use the small triangular tables to hold a vase of flowers, something like that. Or the larger tables to perform some other kind of function that a bigger table might want to do.

—Silas Kopf

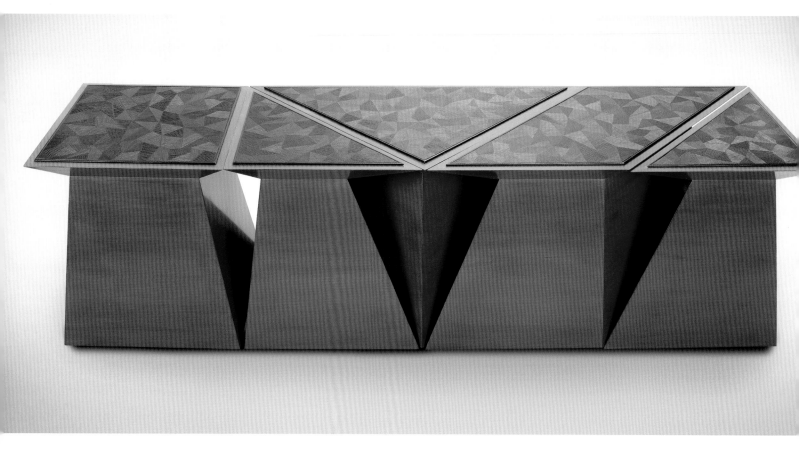

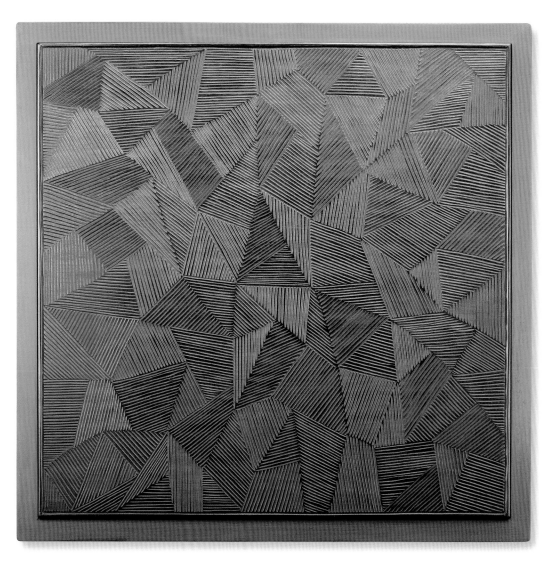

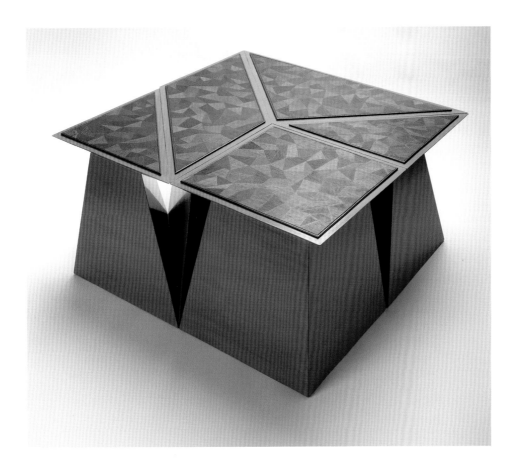

Michael Cullen

26. ***Quintet with Cracked Ice,*** 2006
 Mahogany, paint
 Square configuration 20 × 38 × 38 inches (50.8 × 96.5 × 96.5 cm)
 Rectangular configuration 20 × 72 × 18 inches (50.8 × 182.9 × 45.7 cm)

Like Kopf, Cullen responded to the way in which the decorative aspect of cracked ice mirrored the irregular shapes of puzzle tables. Whereas Kopf created illusionary pictorial images with marquetry, Cullen used paint and carved texture to provide the visual dynamic of the table tops. The different orientation of the carved veins provides a certain shimmering *chatoyance,* in which light and dark change constantly. It is a cracked-ice pattern with texture and the illusion of faceted depth. ESC

At this point, I am imagining that the piece will be strongest when shown in the rectangular configuration—the juxtaposition of the tops in relation to each other is strongest this way and the negative space created between the bases in this configuration is what drew me to this design initially. . . . The carving on the top was laid out like a cracked-ice pattern and then delicately carved with a small gouge to maximize how light impinges and is deflected on the surface—kind of like ice or mineral crystals. The panels were then painted with milk paint, rubbed out, and top coated (or sealed) with tung oil. The carving went through quite an evolution. After a couple of months and many ideas and tries, the final carving just popped out of nowhere—thirty minutes of "play" carving and there it was staring out at me like a red herring.

—Michael Cullen

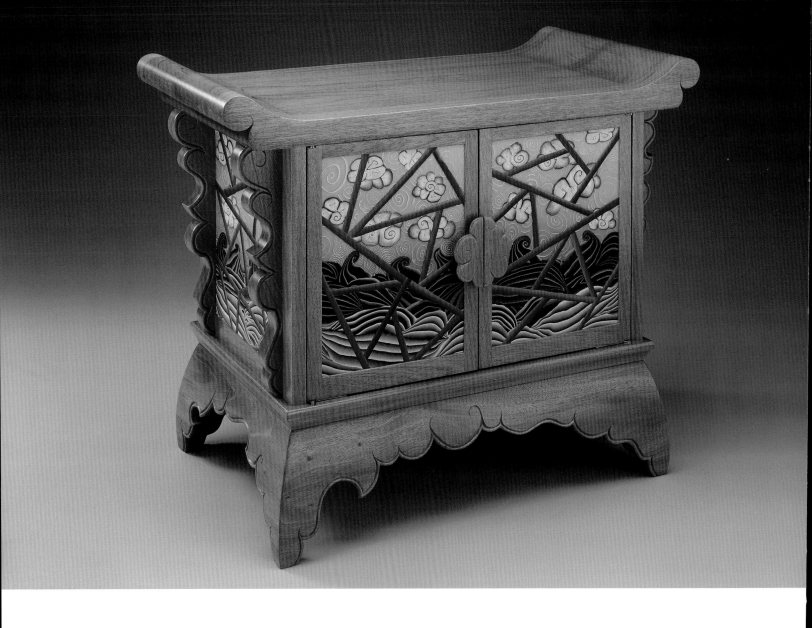

J. M. Syron and Bonnie Bishoff

27. ***Sea and Sky Altar Coffer,*** 2006
 Mahogany, polymer clay
 26 × 32 × 18 inches (66 × 81.3 × 45.7 cm)

Bishoff and Syron responded to the ritualistic use of furniture by creating a small cabinet in which to store devotional objects. The sawn, undulating profiles of the skirt and side brackets were derived from waisted tables and the everted flanges from altar tables. The swirling water and puffy clouds found on the exterior and interior surfaces resemble woodblock or wrought-needlework representations of such landscapes, but are here executed in polymer clay veneer. The clay is even used to provide the effect of slightly raised cracked-ice latticework, but the surface is all clay and flat. In many ways, the use of polymer resembles the traditional use of marble panels, with noticeable figure, to create natural scenes. ESC

I particularly love surface design, and I think a lot about things like fractal geometry and patterns found in nature. And then we get inspired by the use of materials because we combine so many types. We do carving and upholstery, but we also use polymer clay veneers in our furniture, which is sort of an unusual combination. Our work is a lot about melding things, partly because we're collaborating, and we're bringing two circles of ideas together, but we're also bringing two mediums together. For us, it's about how the whole thing reads or feels, and how it really sings together. . . . The cracked-ice patterns will actually be part of the flat polymer clay veneers creating a faux effect. The wood for the frame and cabinetry is mahogany. There will be a bit of carving to emphasize the curves. The inside of the cabinet has two drawers and two cubbies.

—Bonnie Bishoff

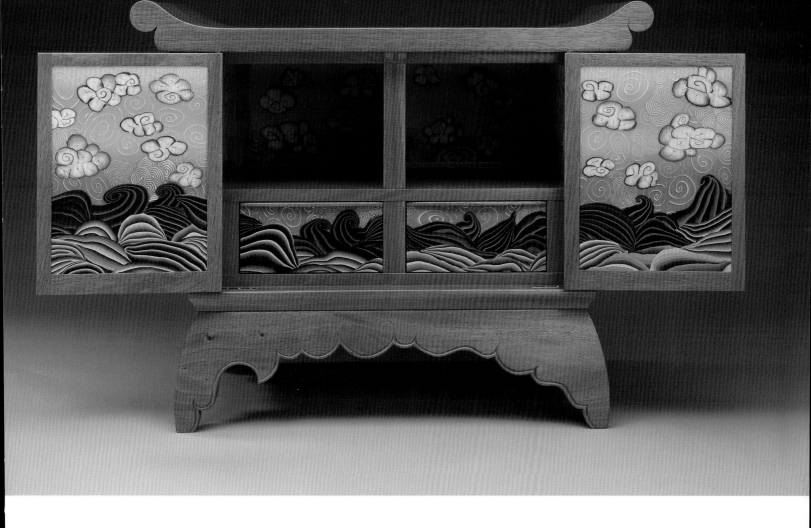

28. **Sea and Sky Altar Coffer** drawings
Colored pencil on paper

29. Detail, lower panel of chair cover, 18th century
Silk brocade
69.4 × 17.9 inches (176.3 × 45.5 cm)

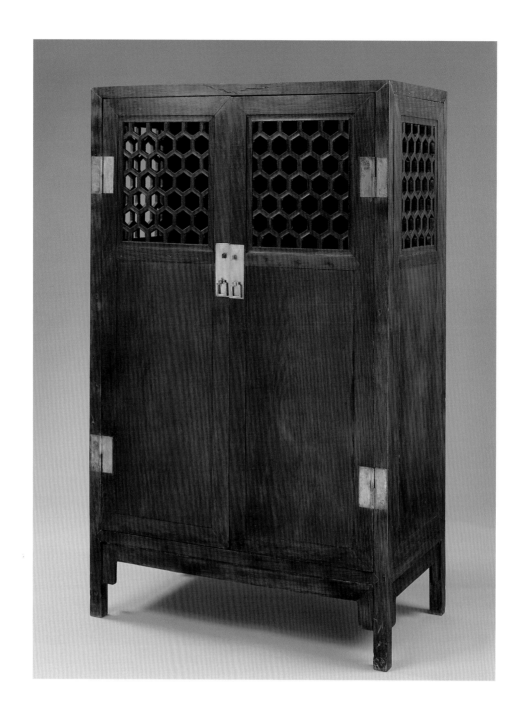

30. **Cabinet, square-cornered with lattice windows,** 17th–18th century
Tieli wood
74³⁄₄ × 46⁵⁄₈ × 25¹⁄₁₆ inches (189.8 × 118.1 × 63.7 cm)

The other aspect that interests me [is how] they deal with the issue of lattice. We're dealing with hiding a volume, and then piercing a volume. There's a certain balance of what I would call density, what you can see through and what you can't, what's revealed and what isn't. The piece behind me here, this latticework creates a wonderful rhythm of semitransparency against open against opaque. It's dealing with pattern against structure. The thing that's amazing about Chinese work is that on one hand it's all very obvious, and on the other hand it's all so sophisticated that if you don't pay attention you'll miss it. It's a very sophisticated game of looking extremely simple, and being some of the most complicated stuff ever made, and that's amazing.

—Tom Hucker

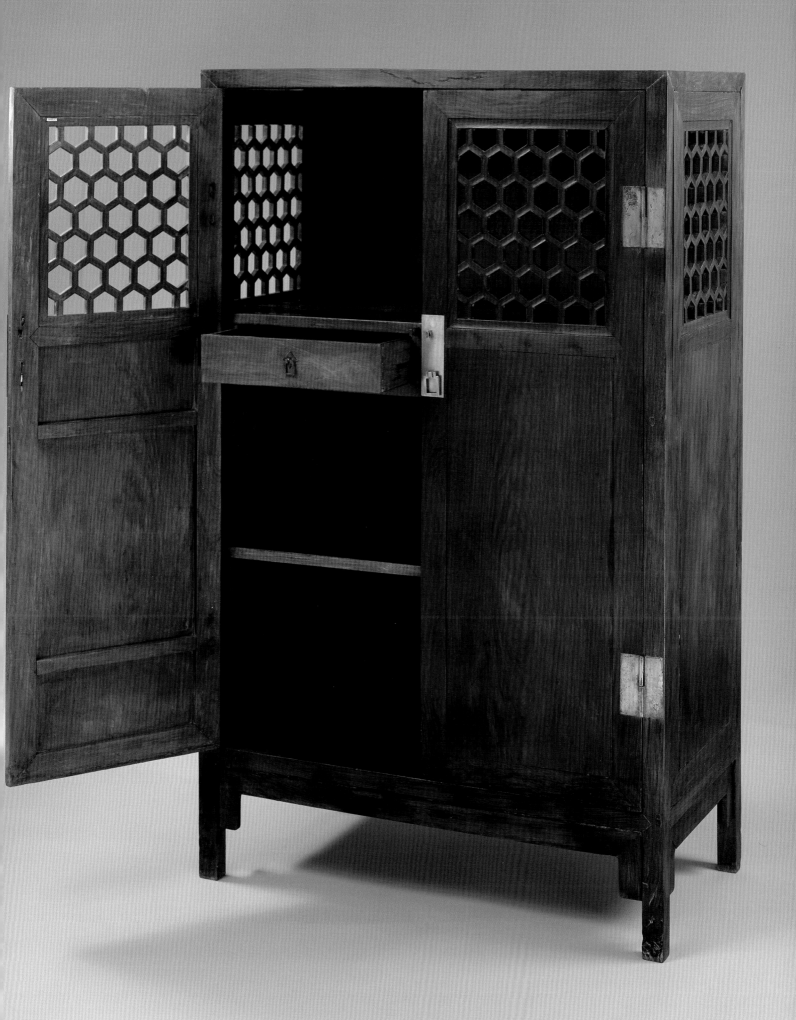

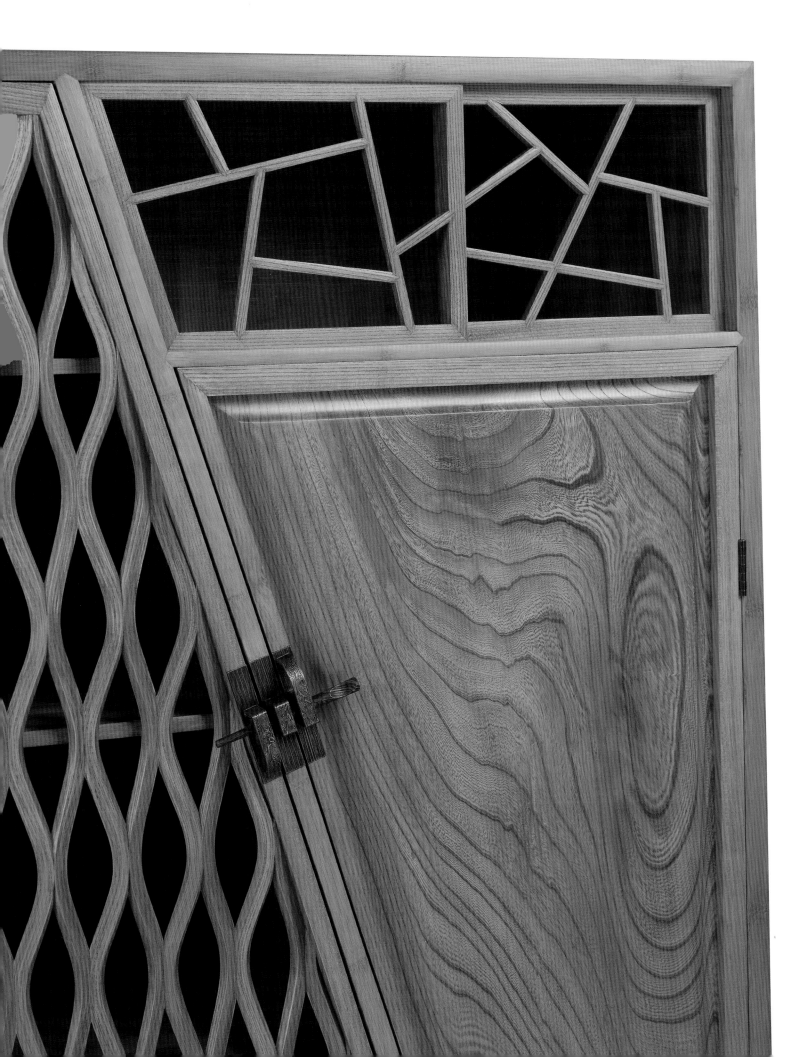

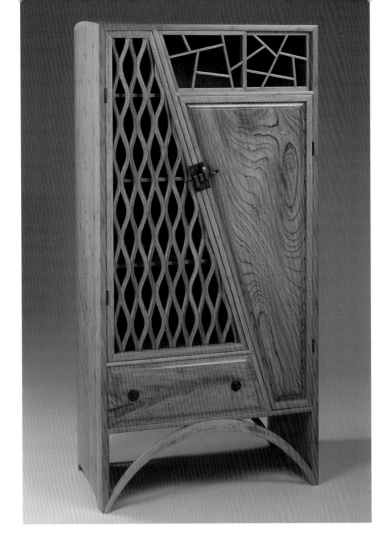

Michael Hurwitz

31. ***The Chinese Piece,*** 2006
Bamboo, zelkova, elm, Damascus iron, bronze
78 × 36 × 24 inches (198.1 × 91.4 × 61 cm)

32. ***The Chinese Piece*** drawing, 2006
Pencil on paper

Through several fellowships and subsequent travel, Hurwitz has closely studied woodworking and furni-
ture in Japan. In turning his attention to the Chinese traditions, he was drawn to the concept of paired
cabinets and the asymmetrical polygons of cracked-ice decoration. The relationship of different materials
in the Yin Yu Tang house at the Peabody Essex Museum provided his overarching aesthetic. He adapted
one of his favorite case-piece forms—a large cabinet with gently bowed sides and top—but integrated
a number of Chinese-influenced elements with Japanese elements, resulting in a new oriental pastiche.
He made the carcass of bamboo, but then used zelkova, a figured Japanese wood, for the façade. The
cracked-ice latticework of the sliding doors in the upper section and the bent laminated screens on the
left side of the cabinet evoke the piercings found on architectural screens, cabinets, and table stretchers.
The steel hardware on the triangular door is based on the scholar's brush, but is executed with Japanese
metalworking techniques. ESC

*I try to use as little material as possible, so my pieces tend to be lightweight, and there are not elements
that aren't justifiable structurally.... I think there's as much in that [Yin Yu Tang house] that I find exciting
about layers of history, patterns of use, kind of a combination of vernacular and high style, all of that is
exciting. And probably the thing that is most exciting and hardest to include is the sense that these have
been used. They've served a purpose, and you know they served a family. And that kind of surface that
evolves after that kind of use, it's impossible to fake. I want to refer to that.... I have a kind of idea for
something that would be kind of collage- or quiltlike. That would incorporate different kinds of elements
that wouldn't ordinarily go together in a classical piece of furniture from any country or discipline.*
—Michael Hurwitz

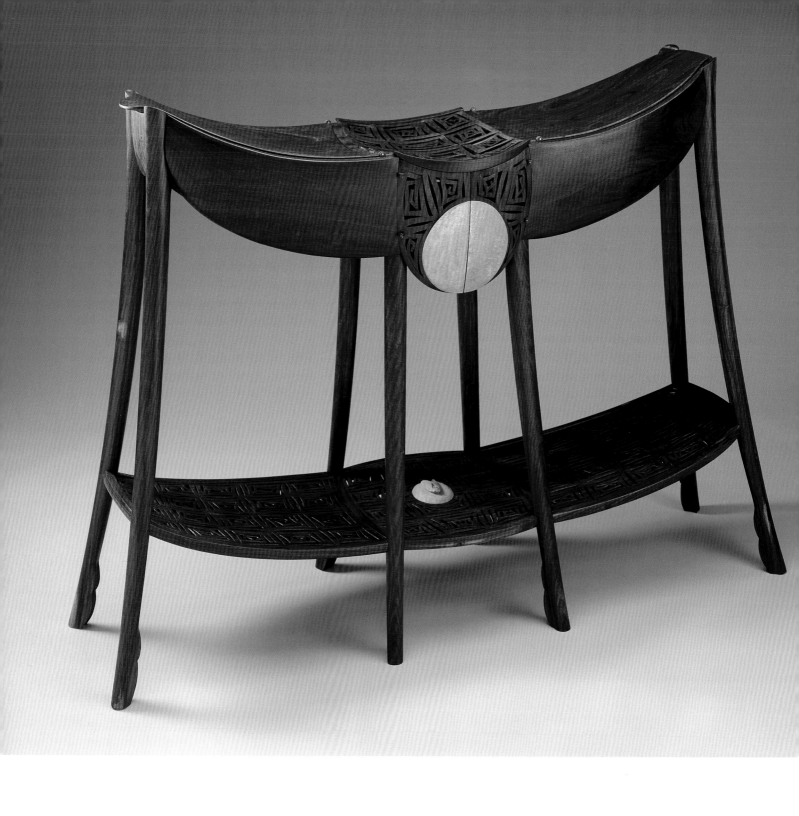

Brian Newell

33. ***Cicada Cabinet,*** 2006
Zitan, boxwood, brass
37½ × 42 × 12 inches (95.3 × 106.7 × 30.5 cm)

Newell has recently produced an extraordinary body of work that has drawn critical attention for its obsessive attention to craftsmanship in service to personal, almost mysterious cabinets that seem animated. Therefore it is not surprising that he drew inspiration from a cicada to provide the overall shape of this cabinet structure, replete with the upward, hinged wings and the mouthlike central cabinet, and the carved decorative element on the low central shelf. To provide additional surface texture he has carved the legs as well as the lattice shelves.

ESC

This evening I thought I should give you an idea of the cabinet that appeared on the ceiling and which, if the stars align, will appear in my shop. This will be a medium-sized cabinet, about as tall as a miniature pony, but a little less wide. The four legs will sweep outward and will be quite long. The cabinet will be divided into three chambers, the center one consisting entirely of lattice, and it will be larger than the others. You will recognize the pattern. When I left Beijing, Shao Fan gave me a jade pendant of his design, a stylized cicada. My cabinet will feature carved cicadas, either all over the lattice or focused on the plate between the doors. . . . The cabinet in the sketch is the one that got dreamed up in Beijing, but it got split in two. If you put these two cabinets together in your mind then you'll find there is a middle chamber. That chamber will be composed of screen. The screen motive will be distinctly Chinese, hardly altered, but from a pattern which is about three thousand years old. It's present on some bronzes and stones, I think. The cicadas will be around, or perhaps just one cicada. Like a small emblem instead of a major theme. This could change. It's always best to make every decision as late as possible when making this stuff. Of course there are crucial moments when you have to decide whether to cut something off or leave it, but the later the better. Cicadas fall into that category. The big oblong circle in the "center" of the cabinet is brass. Again, there are four hundred options as to how to treat its surface, but that is for later. The important thing now is to capture the cabinet's mood, if you'll allow me to be a little poetic in matters basically practical. The overall form and the scale are the crucial points thereafter. Then you figure out how to put the thing together, and this might require some adjustments to the form, or especially to the details. If you're lucky, it comes out right, although only occasionally does it come out the way you expected. That may be what keeps you in the shop for all those months—the need to see what the hell you are making.

—Brian Newell

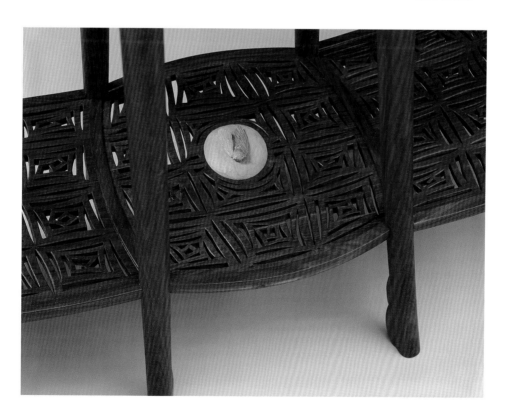

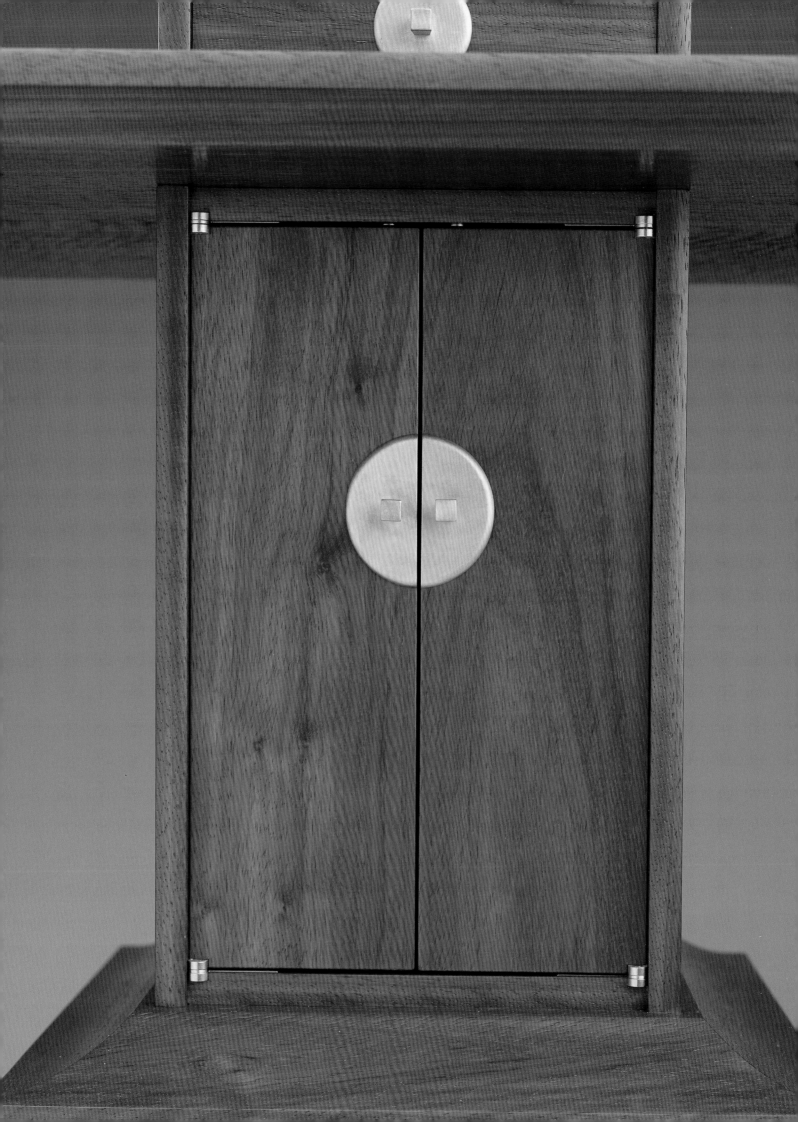

John Dunnigan

34. ***Standing Desk,*** 2005
 Padouk, brass
 48 × 66 × 20 inches
 (121.9 × 167.6 × 50.8 cm)

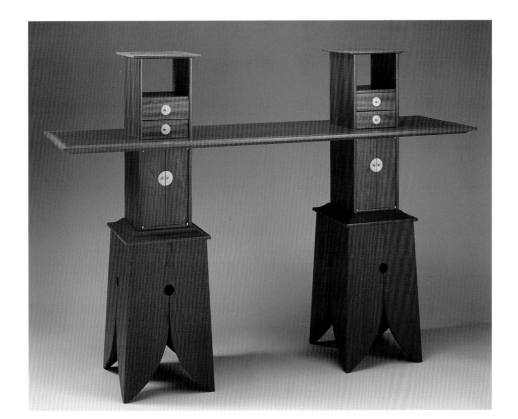

A serious student of historical furniture, Dunnigan responded not in a literal fashion to traditional joinery or decoration but in a very abstract sense to the Chinese interest in calligraphy and writing, developing the idea of a standing writing desk. He celebrates the activity by placing it high on two small pylons that are typical Dunnigan forms; the effect is altarlike. Then he provides ornamental rhythm by adapting Chinese hardware, but using it on a smaller scale. ESC

Usually I'm very interested in cultural issues and in the way relationships among those are reflected in the way things look. My work is typically driven in that way. Given that my knowledge of China is still limited and will remain so, I want to be careful to not fall into cliché or a superficial treatment. At this point to try to identify just one piece as my inspiration is proving difficult and to choose based on form alone seems unsatisfactory.... The waisted table, kang *table, altar table, and wine table all really interested me as objects. I have a long interest in writing desks and might do my piece based on that theme and referencing the above.*

—John Dunnigan

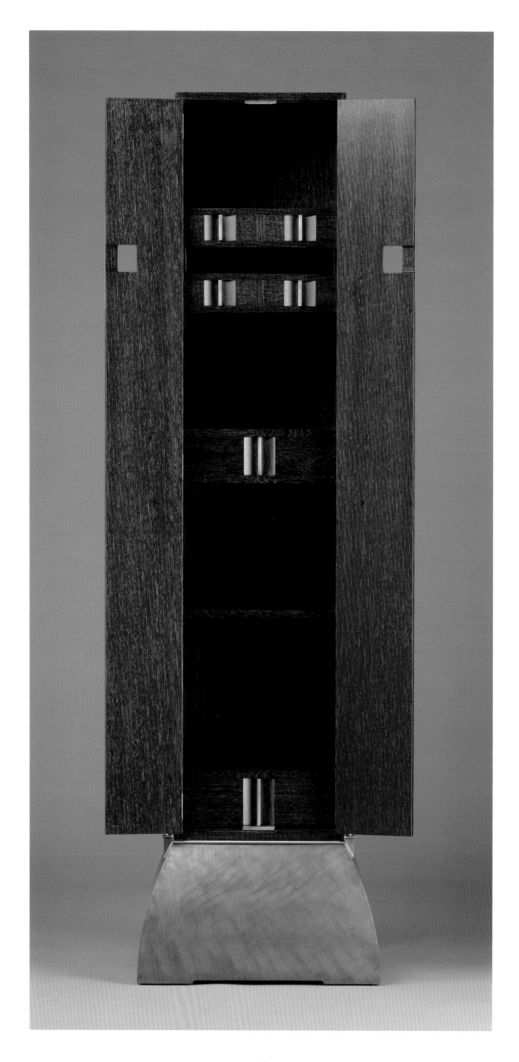

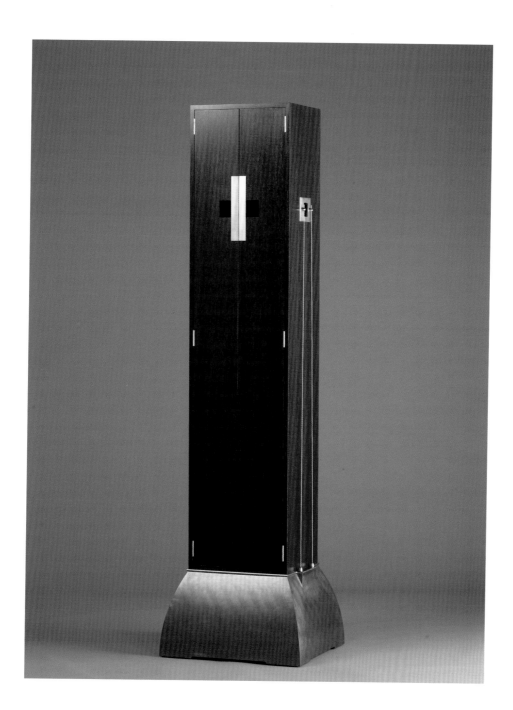

Richard Prisco

35. ***Untitled,*** 2006
Wenge, bamboo, nickel-plated steel, stainless steel, graphite
72 × 14 × 12 inches (182.9 × 35.6 × 30.5 cm)

Interested in combining wood with materials such as concrete and steel to create modern studio furni-ture, Prisco was drawn to the concept of portability when he examined a small Chinese apothecary chest or book cabinet. Since mobility is rarely a characteristic of Western case furniture, he combined a steel base, steel tension wires, and a steel carrying bar with a tightly constructed wooden carcass. ESC

My exploration is primarily focused on the book cabinet/apothecary chest. The resulting design will be a variation in proportion while working within the same volume. I plan to emphasize the method in which the cabinet was transported from place to place.

—Richard Prisco

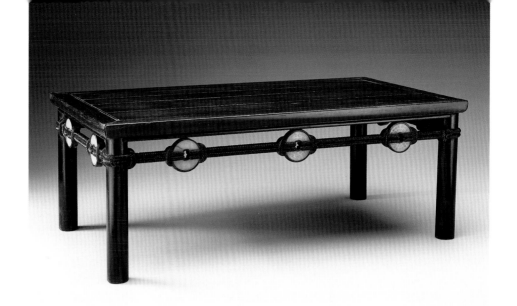

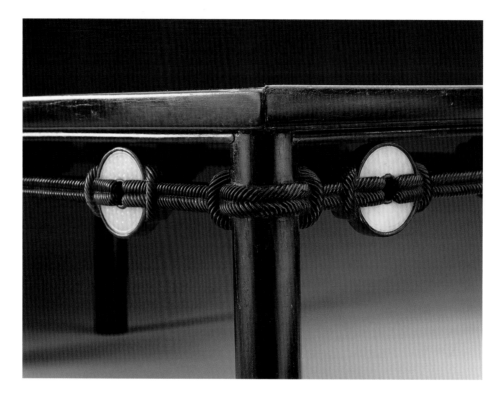

36. ***Kang* Table,** 18th century
Zitan, jade
11³/₁₆ × 31 × 17⁵/₈ inches (28.5 × 78.7 × 44.4 cm)

The finely incised carving on this *zitan* table, which was intended to be used on a *kang*, the raised and heated sitting and sleeping platform of northern-Chinese households, convincingly replicates the strands and knots of a thick rope. It was constructed during the eighteenth century, when the decorative arts were highly inspired by European trompe l'oeil techniques. But here the rope imagery—combined with the jade disks carved to look like ancient, ritual jade *bi* found in early tombs—additionally conjures up ancient Chinese decorative motifs of *bi* hanging on elegantly knotted silk cords. The juxtaposition of the dark, dense, and most desirable of Chinese hardwoods, *zitan*, with the hard and most revered of minerals, jade, creates a unique and dignified appearance for the elegant table. NB

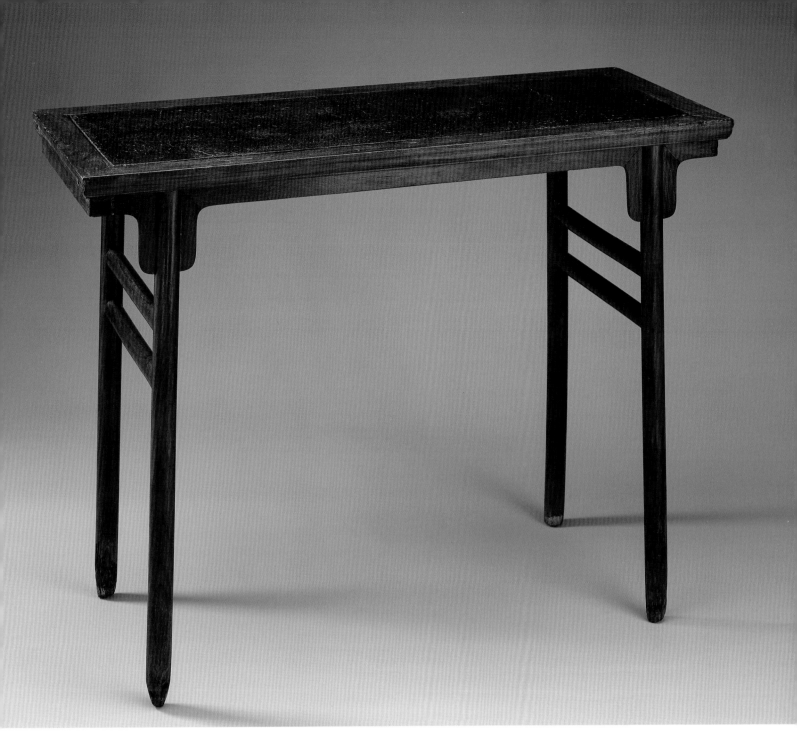

37. **Wine Table, waistless,** 17th century
Huanghuali, burl
29 × 38¼ × 15½ inches (73.7 × 97.1 × 39.4 cm)

This table, with its unadorned round members and rounded spandrels, is of a classical Chinese style that first appeared in the Song dynasty when chairs and chair-height tables first became popular. While fashions of many ornamental varieties have come and gone since that time, this proud but restrained manner has continued as a timeless emblem of the integrity and modesty of the scholar in Chinese society. During the first half of the twentieth century, Europeans and Americans in China conveyed the virtues of this style back to their compatriots who, with their form-follows-function approach, integrated its features into modern furnishings. NB

What immediately caught my eye is that little small table with the burl inlay. And I don't know exactly why that is, it might even be that it's kind of blandish, maybe that's what made it stand out. It looks like it has been faded, like it's been exposed to a lot of sunlight. But it's also quiet, it's a quiet piece, I guess that's a big part of it. I've characterized my work as being quiet, so that catches my eye.

—Michael Puryear

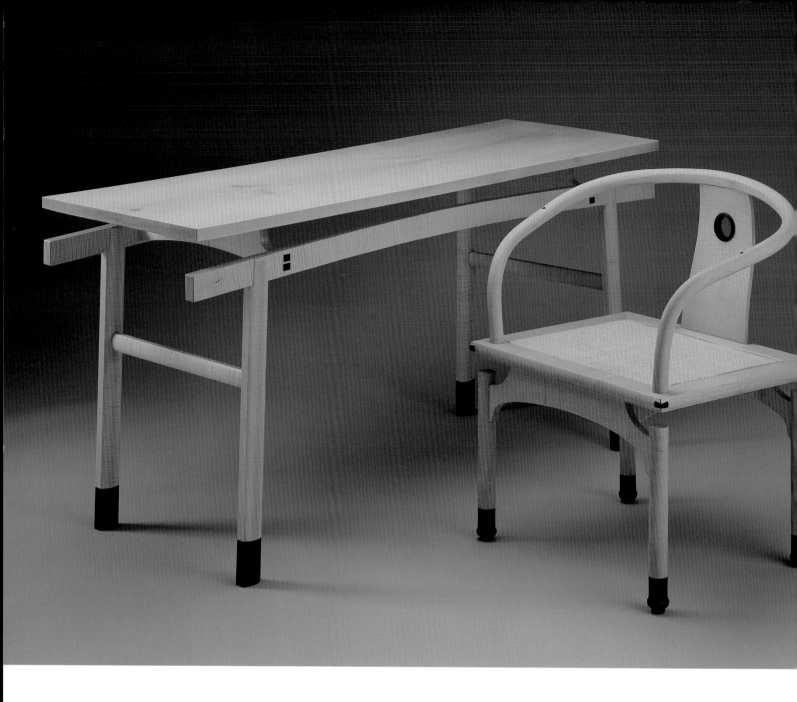

Michael Puryear

38. ***Wei Jinian Shifu (For the Master),*** 2006
Sycamore, wenge
Chair 48 × 30 × 24 inches (121.9 × 76.2 × 60.9 cm)
Table 30 × 48 × 24 inches (76.2 × 121.9 × 60.9 cm)

Puryear approached the inspiration process like an anthropologist. He was intrigued by the contrast between the quiet, reflective Taoism and dark woods of classical Ming-period furniture. As a result, he sought to make simple scholar's furniture in white woods. His stylized bleached-sycamore table and chair, with an occasional splash of dark wood, embody the fleeting spirit of Chinese ancestry. ESC

The general concept of my piece is to make a Taoist scholar's table and chair for the afterlife.... The light wood would not only contrast with traditional Chinese furniture, which is made with dark woods, but would also reference white, the color associated with death in China.... Both of these pieces, I hope, will have a "deconstructed quality" giving a further spiritual feeling.

—Michael Puryear

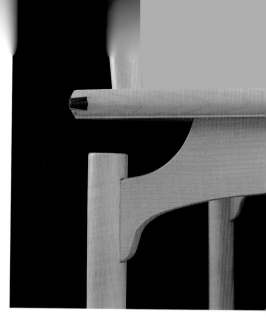

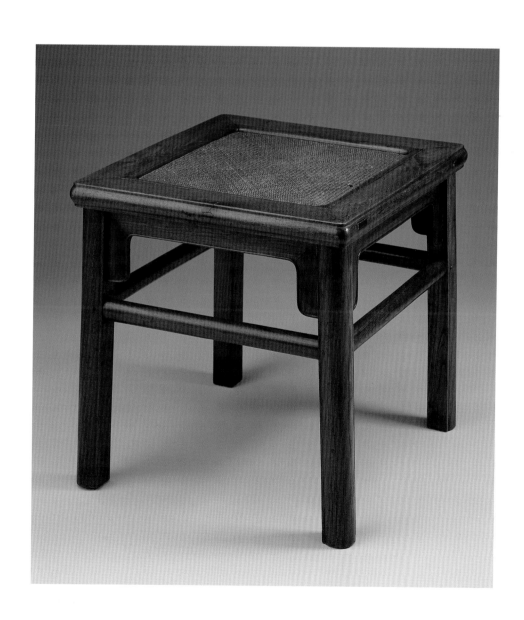

39. **Square Stool,** 17th–18th century
Jumu (zelkova)
19 × 19 × 19 inches (48.3 × 48.3 × 48.3 cm)

40. **Chair with engraved backsplat,**
16th–17th century
Huanghuali
45 × 18⅝ × 24 inches (114.3 × 47 × 61 cm);
seat height 18¹⁄₁₆ inches (46 cm)

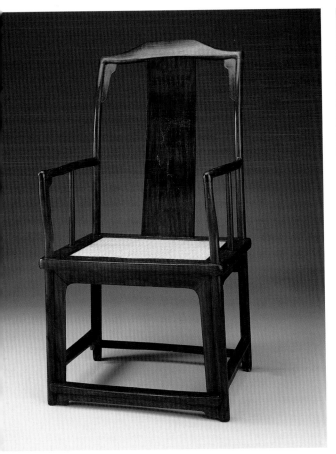

The concept of the chair, with its armrests and backrest, arrived in China during the fifth and sixth centuries from India, brought by Buddhist monks who called it a *shengchuang* (rope bed). The rope referred to the cords woven across the seat frame to make seating more comfortable, differentiating it from the low, solid platforms on which the elite Chinese kneeled in earlier eras. By the Song dynasty, the chair was the accepted and preferred manner for proper seating, and furnituremakers were devising a wide variety of chair shapes, designs, and ornamentation.

This restrained-style chair, with its round architectural members, expresses the dignity and earnestness that the seventeenth-century Chinese scholar strove for in all of his environments. Frills and ornamentation were considered frivolous and gaudy. The sole superfluous decoration on the chair is a branch of the plum blossom and a poem carved into the backsplat. Plum branches, which blossom during the chill of the very early spring, are a frequent motif in literati painting and poetry, conveying the stalwart righteousness of virtuous scholars and officials in difficult times. NB

Blustering, the north wind can blow a man down;
Everywhere there is sand and dust.
Only the solitary plum tree is pure and noble;
Reflected in the water, its opening blossoms are, each one, true.[1]

—Wang Mian (d. 1359)

Note

1. As translated in Maggie Bickford, ed., *Bones of Jade, Soul of Ice* (New Haven: Yale University Art Gallery, 1985), 79.

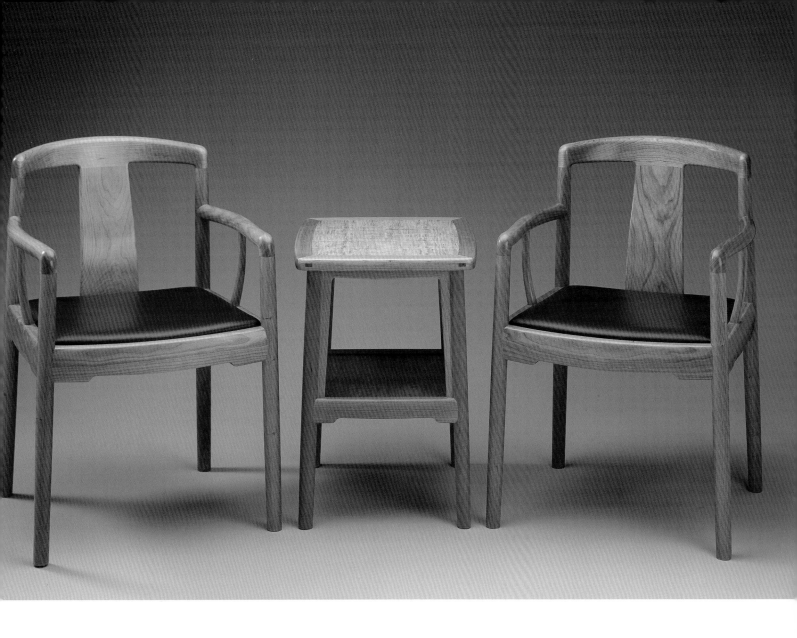

Yeung Chan

41. ***New Scholar's Chairs and Small Table,*** 2006
Cherry
Chairs, each 32 × 24 × 21 inches (81.3 × 61 × 53.3 cm)
Table 27 × 20 × 18 inches (68.6 × 50.8 × 45.7 cm)

Born and raised in China until after high school, Chan brings a deep knowledge of Chinese furniture and tradition to the exhibition. His chairs are an extremely subtle refinement of classical chairs, combining the sweep of crestrail and arm support with the scale of the low-back rose chairs. The real drama of this set is in the details of rounded elements such as the seat rails and the accentuated sweep of the chair back. His table also incorporates arched-shape aprons usually found on chairs and a richly figured panel set within a mortised frame. ESC

Nowadays I use mostly the Chinese joints in the pieces I make. They are very beautiful, very strong, and very unique. Joinery is not only for the structure itself, but also is a decorative detail in the furniture and that is what I appreciate.

—Yeung Chan

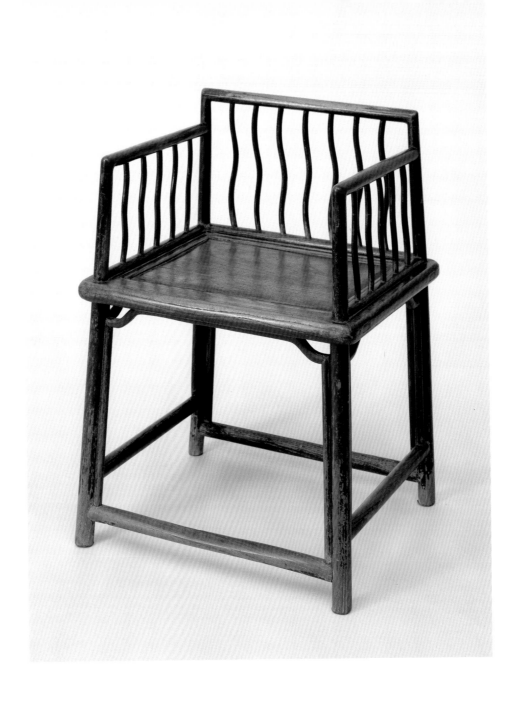

42. **Low-back Chair,** one of a pair, 18th century
 Jumu (zelkova)
 29 × 22 × 18 inches (73.6 × 58.9 × 45.7 cm);
 seat height 18½ inches (47 cm)

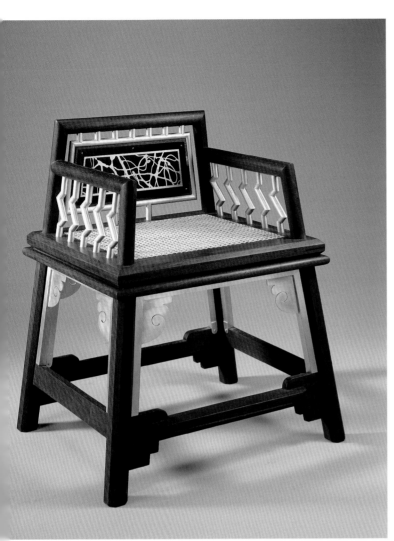
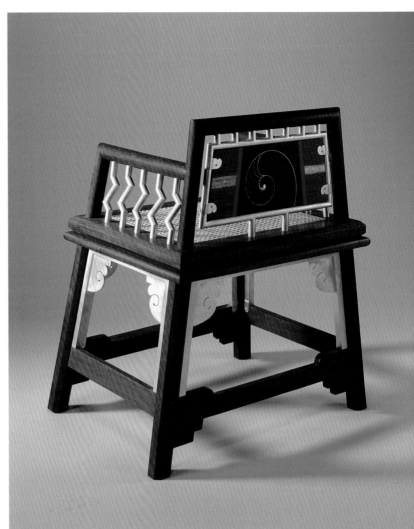

Garry Knox Bennett

43. ***Chair for a Small Important Person,*** 2005
Rosewood, matte 23kt gold-plated copper and brass, nautilus shell, epoxy, paint
28½ × 22½ × 19 inches (72.4 × 57.2 × 48.3 cm)

Bennett, a large man, chose a diminutive, low-back chair to produce his *Chair for a Small Important Person.* He tends to work in a series of a form. Since the mid-1980s, he has explored trestle tables, lamps, and clocks. At the time of the workshop he was in the midst of an enormous series of chairs that poked playful fun at famous designers and terms for chairs. He has made more than seventy within the past two years. After the workshop he took a brief hiatus to make the altar table, then returned to his chair project, making a quick series of six slightly different types of Chinese-inspired chairs. While the central material of this example was rosewood, a wood similar to Chinese *huanghuali,* he combines it with mixed media such as gold-plated copper and brass, epoxy, and paint. He uses this array of materials to move away from a singular devotion to wood. ESC

That chair really got intense. So much time went into that thing. I got a little fussier than I normally work, but I think it's got the spirit of a Chinese chair. . . . I didn't want to copy it exactly, so I put a lot of metal in it. There's quite a bit of gold-plated brass, etched steel, and on the backside there's epoxy work with a chambered nautilus shell. The materials, as you go along, they take off themselves. Very seldom do I really know what it's going to look like. I start with a chair, and I end with a chair but they change, the materials change it. It's unbelievably rigid and semi-uncomfortable for me. It hits you in the wrong place in the back; therefore we rationalized it and called it "Chair for a Small Important Person."

—Garry Knox Bennett

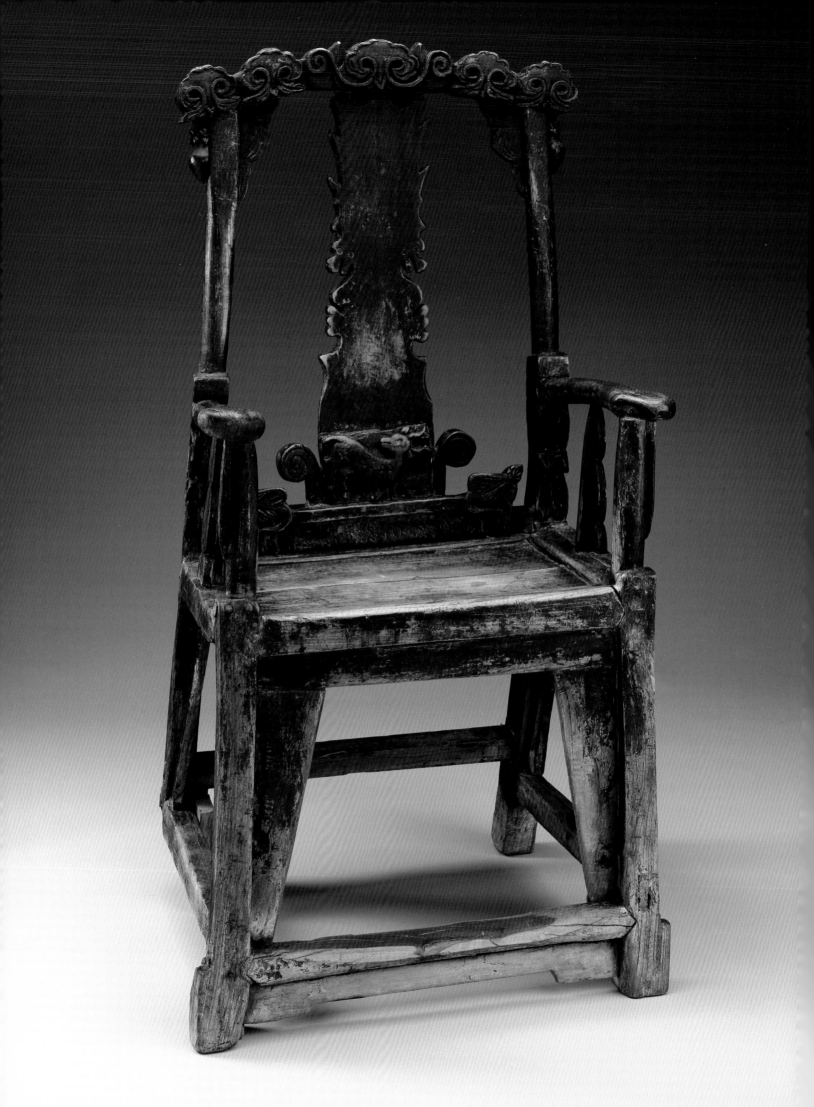

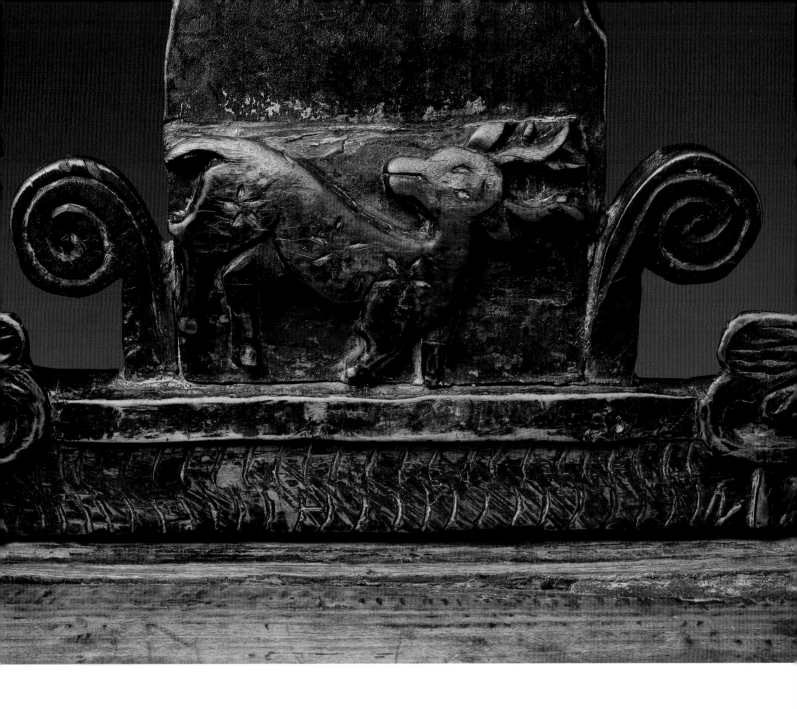

44. **Chair with protruding crestrail,** 19th century
Elm
46¾ × 22¾ × 21¼ inches (118.7 × 57.8 × 54 cm);
seat height 19½ inches (50 cm)

The exuberance of this chair, with its animated, upturned crestrail and animal imagery, demonstrates the range of tastes and variety of ornamentation in Chinese furniture. While seventeenth-century literati may have disdained such elaboration as vulgar, men of provincial positions may have delighted in the showy assertion of authority this chair proclaimed. The word for deer in Chinese, *lu*, is a homophone for the term denoting a high official's salary. Thus, this proud chair most likely was made for a man hoping to attain a high governmental position. NB

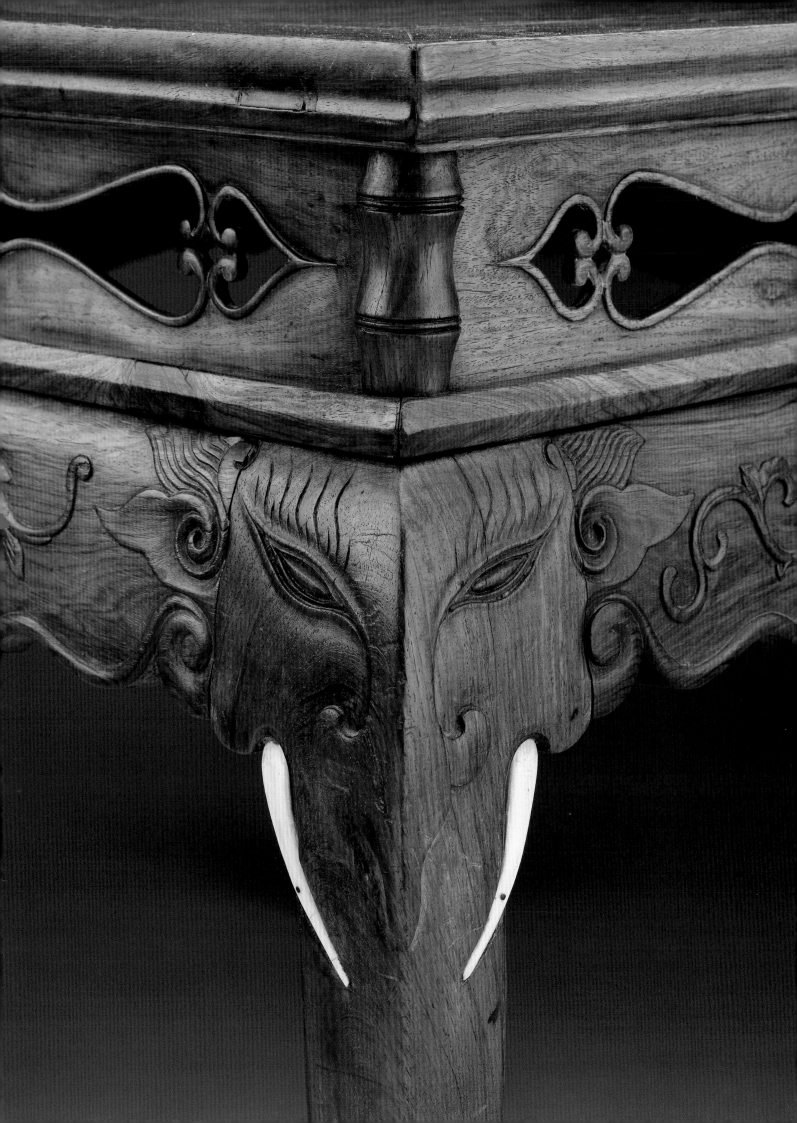

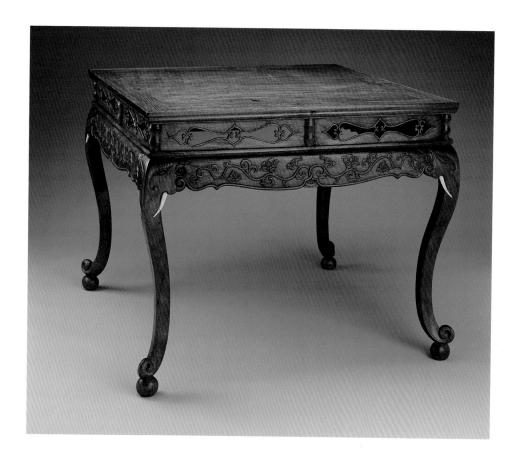

45. **Square Table,** 18th century
Huanghuali, ivory or bone
33½ × 42 × 42 inches (85 × 106.7 × 106.7 cm)

The large and lumbering elephant wandered central China during the ancient era of the Shang dynasty, 3,500 years ago. As the climate cooled over the centuries, these pachyderms, along with the rhinoceros, became extinct in the region. Buddhism's arrival in China from India during the Han dynasty, and tales that Buddha's mother was impregnated when a white elephant brushed her side, caused the image of the elephant to return to China. Centuries later, with increased trade and tribute gifts, domesticated elephants were imported and, during the Qing dynasty, the imperial court kept a retinue of elephants that paraded through the streets of Beijing on special occasions. The Chinese word for elephant, *xiang,* is a homophone with the word for *auspicious;* thus, by the Qing period the image of the enormous animal had become a popular symbol for decorating furniture, textiles, and ceramics, infusing their environs with good fortune. This table—with its cabriole legs, its elephant motif, and grand stature—was most likely part of an altar ensemble for a temple or shrine. NB

Garry Knox Bennett

46. *Chinese Platform Chair (Late Oaktown Dynasty, 1934–)*, 2005
Rosewood, aluminum, cushion, epoxy, paint, gold leaf
46½ × 22½ × 28½ inches (118.1 × 57.2 × 72.4 cm)

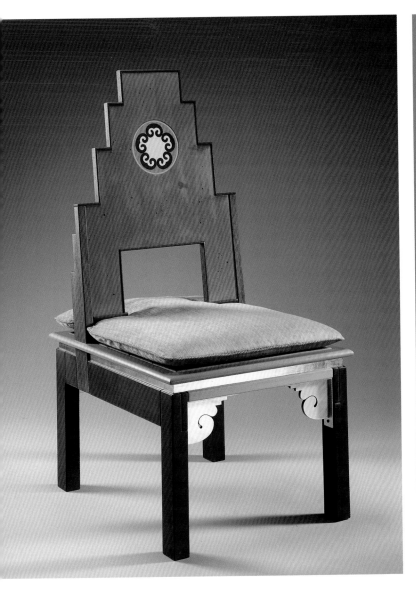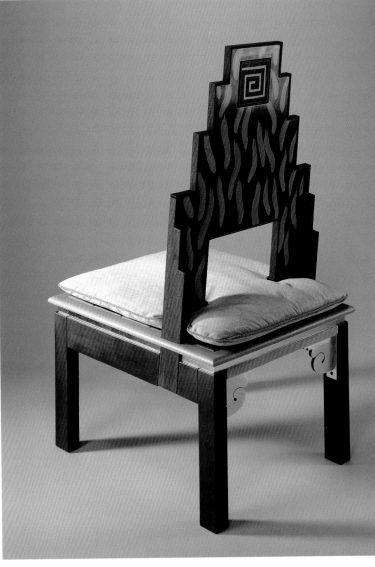

Unlike the low-back chair Bennett made in response to his participation in the workshop, this platform chair is scaled more to his own size. He drew inspiration from the stools and daybeds of the Chinese tradition, but translated such forms into his own version and incorporated more of his painterly approach. He restricted the display of wood to the seat and the legs and used paint, aluminum spandrels, and the upholstered cushion to provide a variety of textures and looks. The result is a surprisingly comfortable chair. He has gone on to make another four platform chairs that explore a range of variations in materials and imagery. ESC

That one is a total invention. I'm titling it "Chinese Platform Chair (Late Oaktown Dynasty, 1934–)."
I believe it's a unique chair proportionally and I do believe it has this strange aesthetic that I can't articulate, whatever the Chinese stuff is. It's such an odd duck. I've never seen anything with that proportion.
It's fairly comfortable. You could sit in that sucker for five or ten minutes. This Chinese platform chair,
I don't know how many I'll do. I'm up to five now. I just want to follow this format. This low seat, kind of straight-up back thing. They won't be something you'll sit in and tell stories to your grandchildren and fall asleep in, but to my eye they're visually exciting.

—Garry Knox Bennett

47. **Round-back Chair,** one of a pair, 19th century
Willow, lacquer
22½ × 19½ × 10½ inches (57.2 × 49.5 × 26.7 cm);
seat height 13½ inches (34.2 cm)

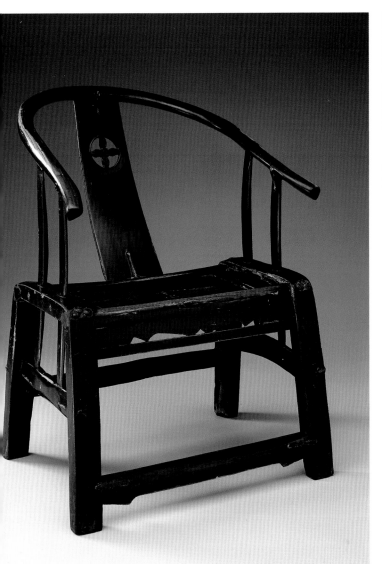 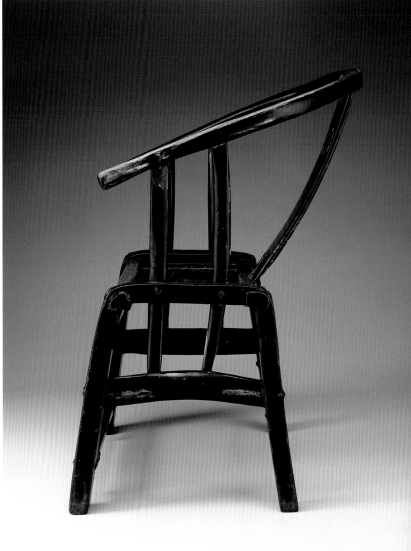

The form of the round-back chair, with a three-quarter, circular rail surround that envelops the sitter, providing a single support on which to rest the back and arms, has enchanted both furnituremakers and sitters since its naissance in China over one thousand years ago. Fine furnituremakers developed the intricate joinery to form the rounded rails out of three, or sometimes five, sections of hardwood. Furnituremakers working with less costly, more flexible woods such as willow could conveniently bend one supple length into the elegant shape. The two legs on each side of this chair are also conveniently created by bending one section of wood twice over. Metal nails and fasteners, rather than complex joinery that cannot be carved out of the extremely soft willow wood, reinforce this chair's components. N B

The round-back chairs—they've always been one of my favorite pieces for a variety of reasons. I just think the geometry of the object is amazing. And by that I mean on top view you have circle against square, side elevation you have triangle against square, front you have oval against square.

—Tom Hucker

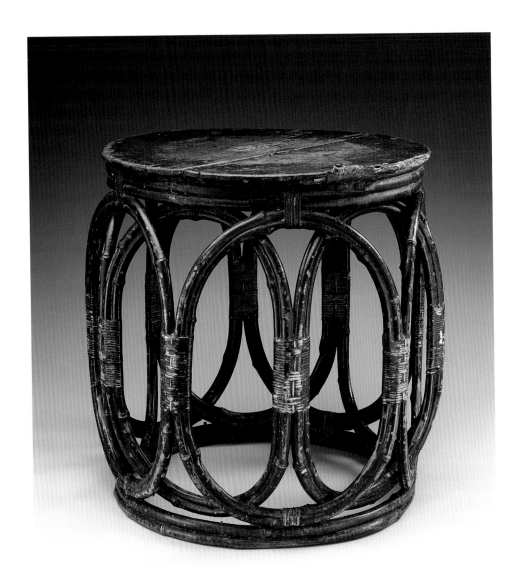

48. *Xiudun* **stool,** 19th century
Bamboo, wood
16 × 15⅛ inches dia. (40.6 × 38.4 cm)

Sitting on an elevated surface with legs hanging down—and the accoutrements permitting such posture—entered China from cultures to its west and south during the Han dynasty. Within six centuries, the stool had become a ubiquitous form of seating in China. During those years and the following millennia, furnituremakers in China created an array of forms to support this seating position, including square, round, drum-shaped, and folding stools made from stone, wood, and bamboo. Today, the stool—without a back or armrests—is still considered a comfortable seating option.

Many forms of the Chinese stool found favor among Europeans and Americans in the nineteenth and twentieth centuries. The function of the stool surprisingly transformed in these non-Chinese cultural contexts, however. In American and European homes, Chinese stools usually came to be used as side tables, telephone tables, or coffee tables in living rooms. NB

I love the rattan stool, the hoops that are bound together. I love how the material dictated that piece. I can see it as an Egyptian piece—that's where the same cane grows in the same condition—and the form evolves largely due to the materials available. And then I also love the abstraction of that, the evolution of taking that form and reinterpreting it in different materials. If I could get the structural clarity of the cane stool, if I could include that kind of thinking, that kind of structure in a piece, I'd love to.

—Michael Hurwitz

49. ***Xiudun* stool,** 17th–18th century
Cloisonné
17¾ × 10⅛ inches dia. (45.1 × 25.6 cm)

The designer of this stool has combined the visual metaphors of two distinct stools: rattan ring and drum. This sumptuously surfaced stool has borrowed the rings of the rattan stool and the round nail heads that would have held tight the animal skin on top of a drum. Neither of these elements serve any structural purpose here. They lend their visual forms and shapes, interacting with the colorful cloisonné surface, to create a pleasing and colorful piece of decorative furniture. A further ornamental feature on the stool is the lion's head–handle knobs. Similar to ancient Chinese tomb-door handles, the lion's head has replaced the Chinese mythological creatures. The lion was never native to China and the image of the lion only arrived with Buddhism from India during the Han dynasty. Once in China, where people had never been exposed to the actual animal, the lion image often transformed in the hands of artisans.

NB

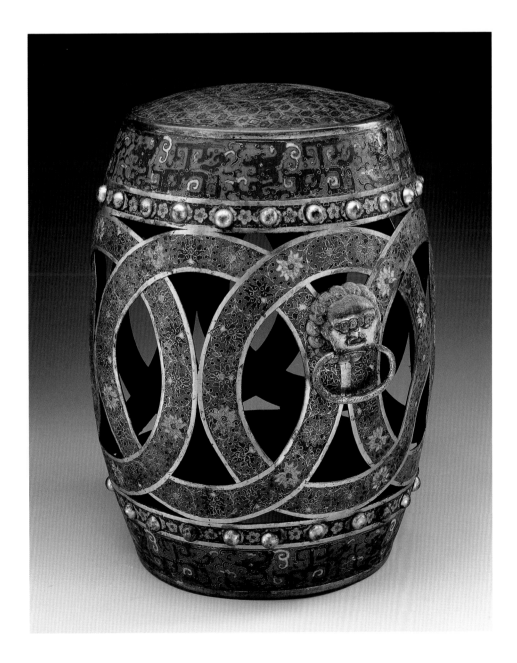

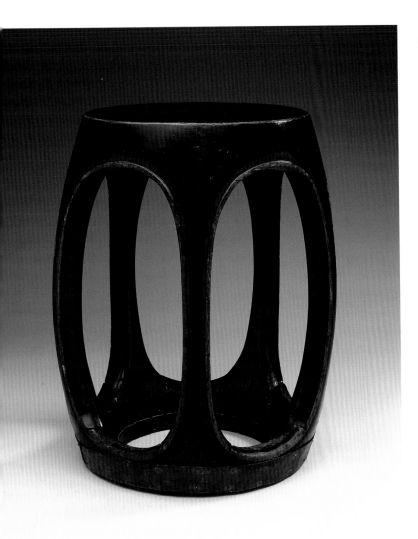

50. *Xiudun* stool, one of a pair, 18th century
 Softwood, lacquer
 19¼ × 12½ inches dia. (48.9 × 31.7 cm)

51. *Round Stool* drawing
 Pen and ink on paper

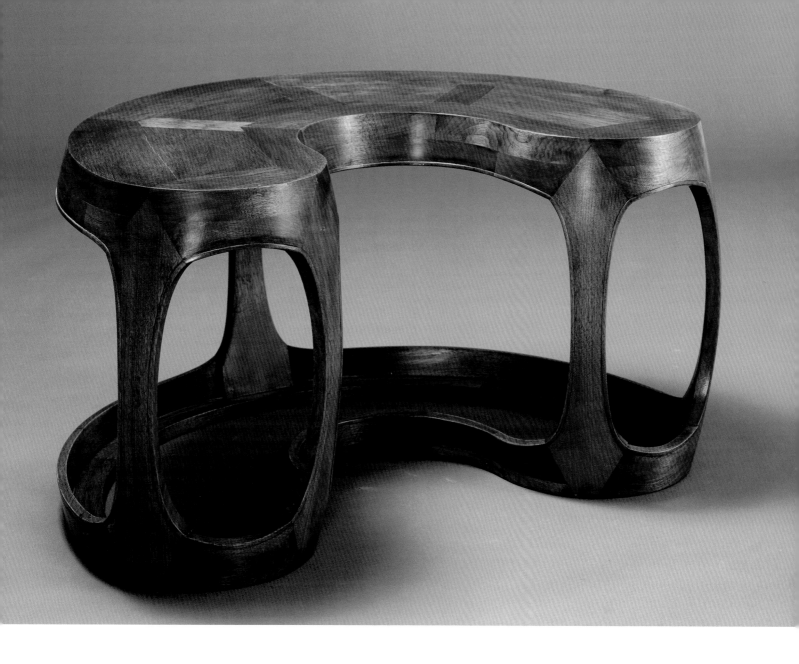

Shao Fan

52. ***Round Stool,*** 2005
 Elm
 20 × 38 × 26 inches (51 × 96.5 × 66 cm)

Following in the tradition of transforming prototypes, which has continued throughout the history of Chinese furniture, Shao Fan has taken the *xiudun* stool form into yet further reaches. Retaining the five open holes of the wooden *xiudun,* he stretched the entire piece and curved the form into a U-shaped seat. Three of the vertical ovals consequently become elongated horizontal ovals. The task of manipulating the wooden shape as if it were putty necessitated creating a series of intricate, hidden joints. In discussing his thoughts, Shao Fan displayed his awareness and interest in both Chinese and international philosophical traditions and noted Chinese and European sources including the fourth-century BCE Taoist philosopher Zhuangzi and the first-century BCE Roman poet Ovid. NB

Ovid once said in Metamorphoses: *"All can be transformed into new forms. To recognize the world is to disassemble it." Zhuangzi, in his work entitled* The Principle of Nurturing Life: Master Chef Dissecting an Ox *said: "An extremely thin blade can move between the bones with ease." Taking the circular seating surface of the original Ming stool, stretching horizontally, I have left two of the five original hollow circles at the side of the stool intact, while stretching and enlarging the other three, so that they become ovals. All elements of the stool have expanded simultaneously.*

—Shao Fan

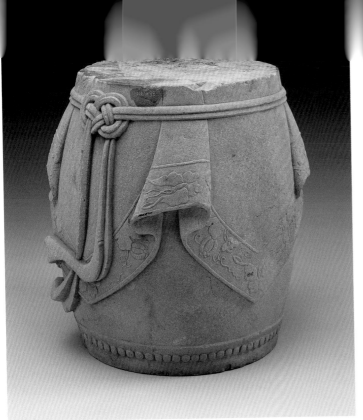

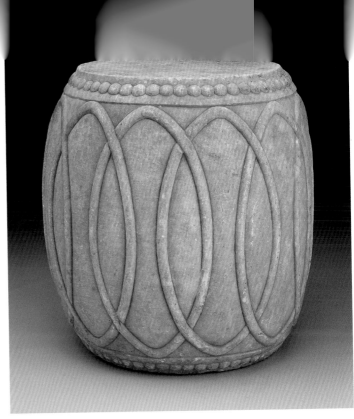

53. **Drum Stool, carved to imitate textile covering,**
17th–18th century
Stone
11⅝ × 21¹⁵⁄₁₆ inches dia. (29.2 × 55.6 cm)

54. **Drum Stool, carved to imitate bamboo rings,**
16th–17th century
Stone, marble
16¼ × 12¾ inches dia. (41.3 × 32.4 cm)

Gardens were an integral aspect of well-to-do Chinese households and decorated stone stools, which are indestructible outdoors, have been a basic feature for centuries, allowing garden visitors to relax and view the exquisite surroundings. Stone masons creating these garden stools delighted in producing surface imagery that negated the actual hardness of the stone. One stool's surface decoration depicts the structural elements of two different types of stools, combining the circular rings of the rattan stool and the nail heads of the drum stool while relying on neither of them to enhance the stool's stability. Another stool flaunts what tries to appear as a silken textile, complete with embroidered trim, draped over it and secured with an elegantly knotted cord.

NB

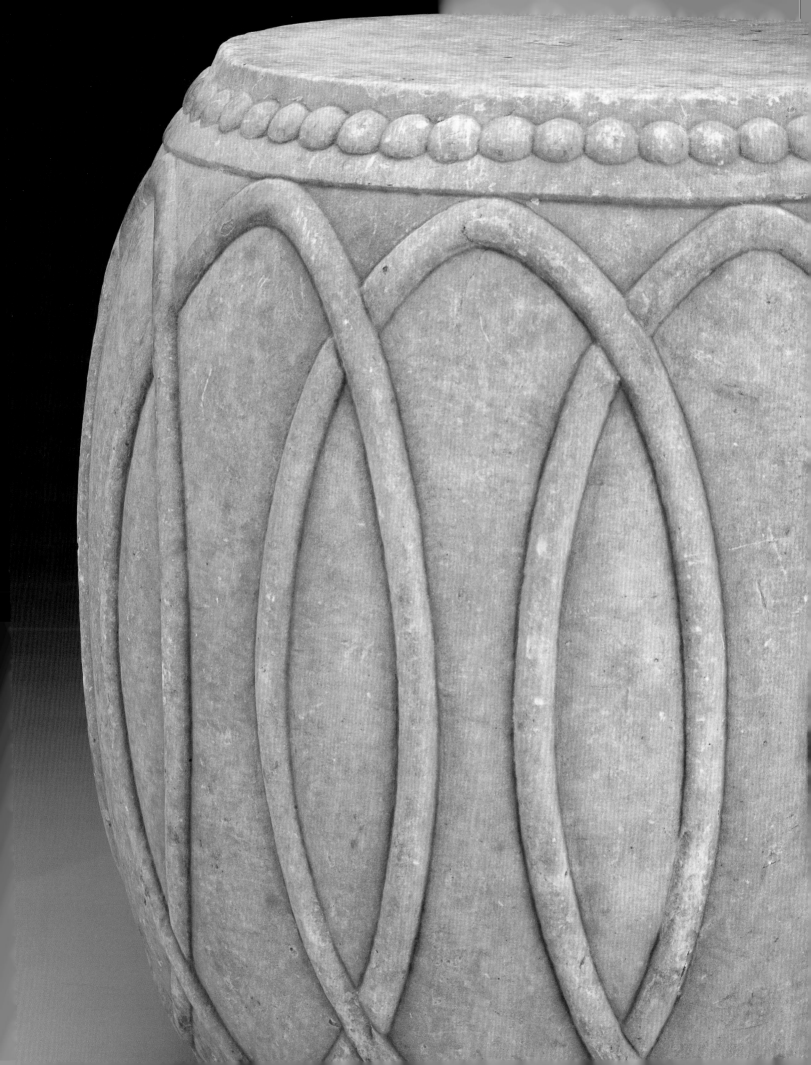

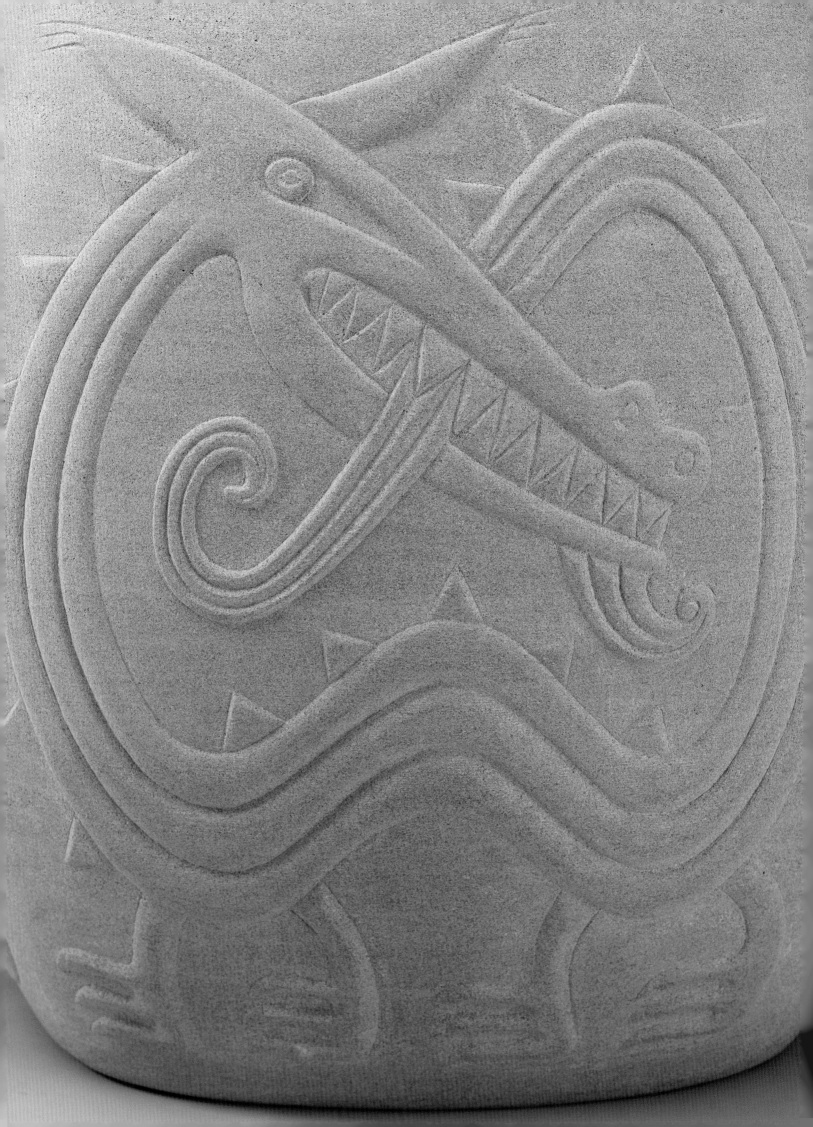

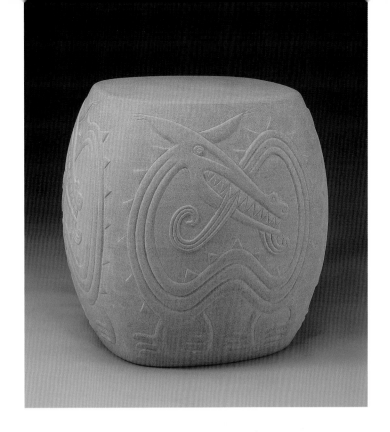

Judy Kensley McKie

55. ***Dragon Stool,*** 2006
Indiana limestone
19 × 20½ × 20½ inches (48.3 × 52 × 52 cm)

56. ***Dragon Stool*** **drawing**
Pen and ink on paper

McKie is best known for a menagerie of fanciful creatures that she has carved in the round or in relief. Initially she worked in wood, but has since gone on to have her designs cast in bronze or resin or executed in limestone. She responded to the carved stonework seen on drum stools as well as the architectural stonework in the Yin Yu Tang house, finding a similar approach to her own direct work. The variety of dragons depicted in the embroidered screens or carved furniture also influenced her choice of creature. To execute the stool, McKie carved a single side out of signboard then shipped this pattern off to the stone foundry where that side was scanned, enabling a digital lathe to cut that pattern on four sides of the limestone drum. ESC

I was most impressed by the complexity and intricacy of Chinese joinery and how beautifully it was concealed so as not to distract from the overall design and beauty of the curves and proportions of the furniture. The graceful, quiet nobility of many of the pieces was striking. I was also drawn to the complex patterns and imagery incorporated into screens and panels that were integrated into various furniture forms. In the end, however, it was the total simplicity and straightforwardness of the drum-shaped stools that sparked my interest. I loved those very simple barrel shapes made of stone because in some ways they had the simplicity of shape and form that appeals to me. And that was kind of a surprise to me that, to see those very simple forms, even though they have decoration on them, the decoration kind of blends into the form, and you see the form first, mixed in with much more complicated, complex things. My love of carving in relief and in the round influenced my decision to make a small "side table/stool" using a similar form. My interest in incorporating stylized animal forms was piqued by a variety of dragon images that appeared in various screens and panels. I decided to combine these two interests in the object I made for the show.

—Judy Kensley McKie

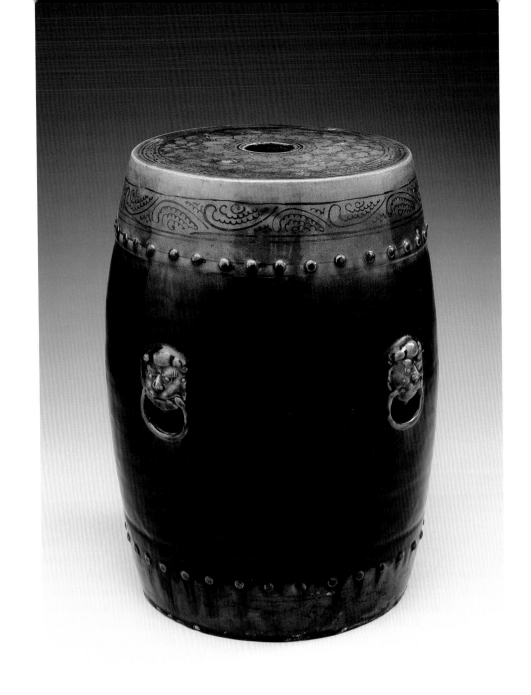

57. **Drum Stool,** 18th century
Glazed stoneware
14³⁄₄ × 11¹⁄₂ inches dia. (37.5 × 29.2 cm)

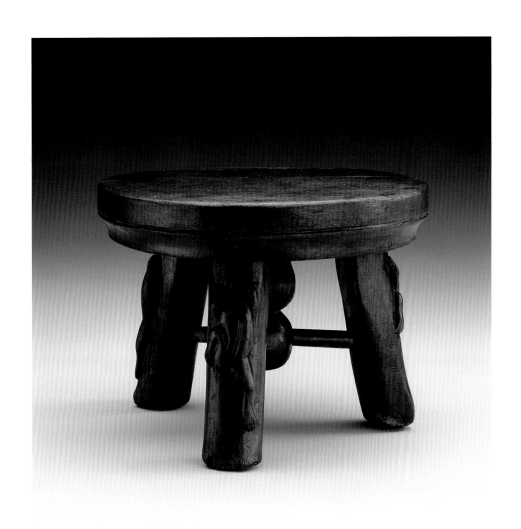

58. **Stool, round, three-legged,** 18th–19th century
 Elm
 4¾ × 6⅝ inches dia. (12.1 × 16.5 cm)

59. **Folding Stool,** 18th century
Jumu (zelkova)
21 × 13½ × 15 inches (53.3 × 34.3 × 38.1 cm)

The folding chair, folding stool, and drunken lord's chair all interested me not so much as impressive objects but because of the idea that they have connections to ancient European, Egyptian, and Roman folding stools. The folding stool is a good example of the shifting role of furniture politically, economically, and personally over time . . . a manifestation of the interdependent relationships among technology, style, culture, and identity. For thousands of years it was a special symbol of political authority and now it has become a common but successful product in a globalizing economy based on mass production and mass consumption. This really grabs me because it resonates with the kind of cultural context I like in my work.

—John Dunnigan

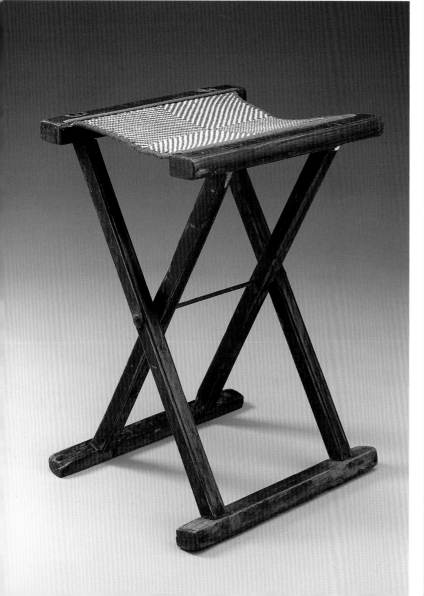

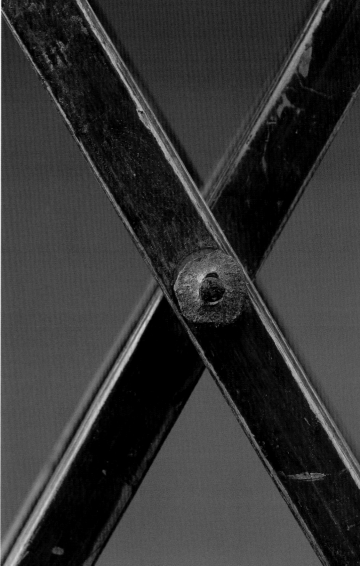

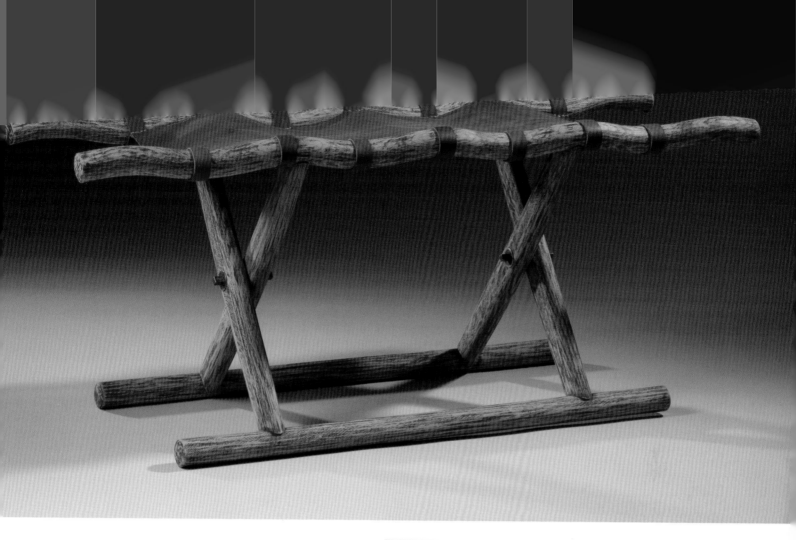

John Dunnigan

60. *Silk Route Stool,* 2006
White oak, brass, leather
15 × 37 × 11 inches (38.1 × 93.9 × 27.9 cm)

Dunnigan's attraction to the folding stool was predictable given his interest in furniture of the ancient world and his focus upon the cultural relationships embedded in furniture. Yet he was not content to make a stool in a standard historical size but lengthened it to become a folding bench suitable for two sitters. ESC

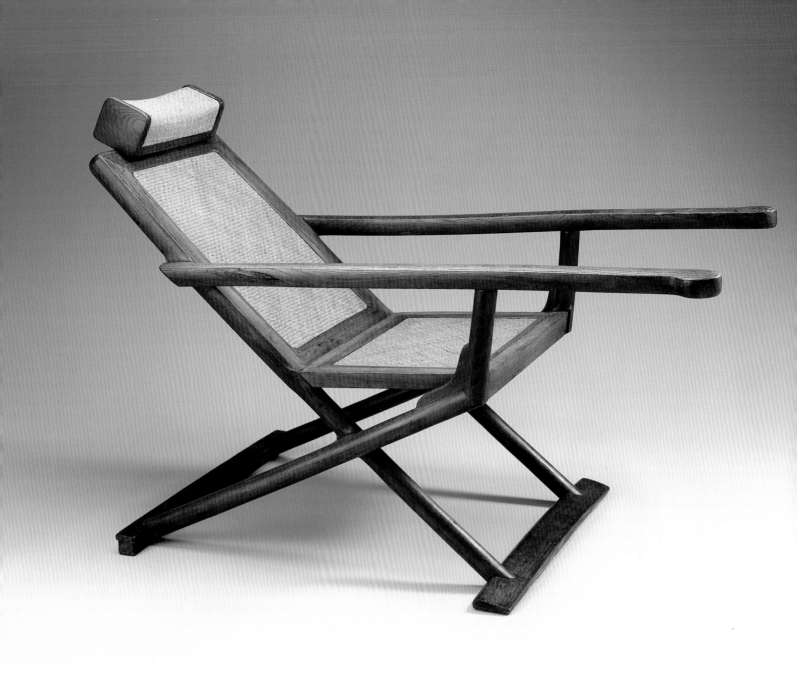

61. **Folding Chair ("drunken lord's chair"),** 18th–19th century
Jumu (zelkova)
35 × 56 × 29½ inches (88.9 × 142.2 × 74.9 cm)

Centuries after the Chinese adopted the folding stool from Central Asian cultures, native furniture design-ers and makers continued to devise more solutions for portable seating and lounging. An elegant elabo-ration of the folding stool was the *zuiweng yi* (drunken lord's chair), which offered the man of leisure support for a full and luxurious recline and the convenience of portability. The term *zuiweng* is usually a reference to the great Song calligrapher and writer Ouyang Xiu (1007–1072), who called himself the Drunken Lord. The standard pictured *zuiweng yi* traditionally has a backrest and elongated armrests. The extraordinary armrests allowed the sitter to, should he or she so desire, literally "put their feet up," and rest one or both legs on an armrest. Over time, because the lounge chair allowed for such positioning, this chair type also took on a reputation of one used for sexual dalliances and erotic Chinese paintings often feature it. NB

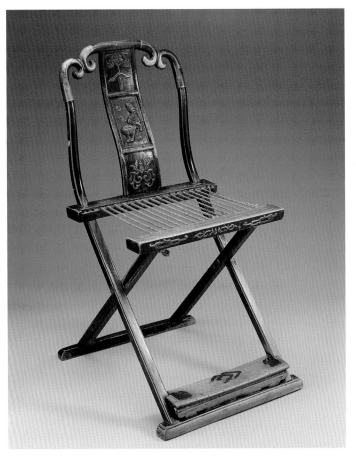

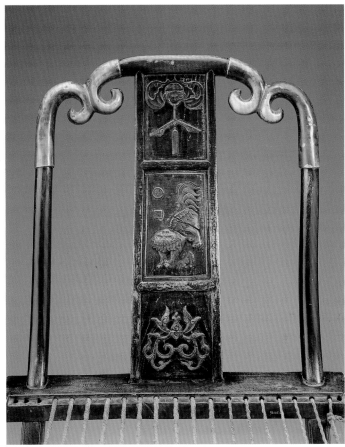

62. **Folding Chair,** 18th century
Jumu (zelkova), boxwood, *baitong*
41 × 21⅞ × 25½ inches
(104.1 × 55.3 × 64.8 cm)

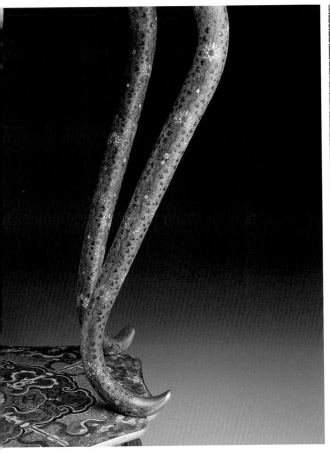

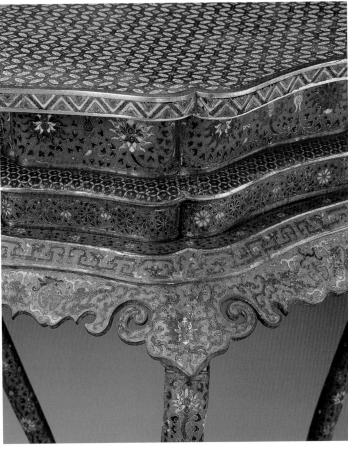

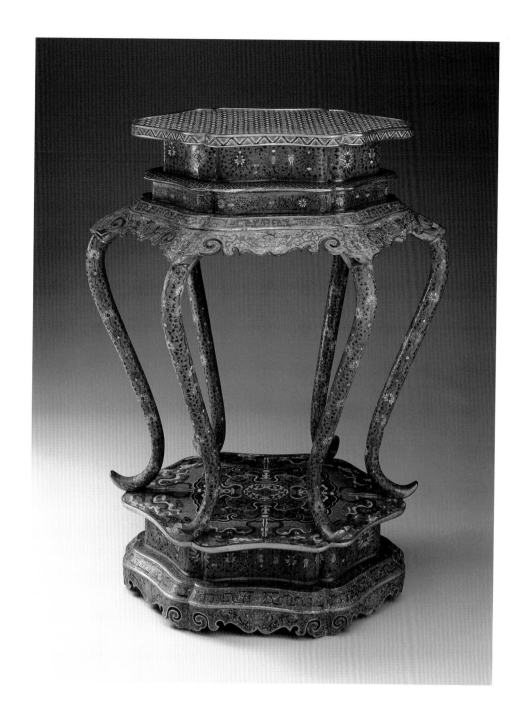

63. **Incense Stand with cabriole legs and foliated hexagonal outline,** 17th century
Cloisonné
33¼ × 26½ × 19 inches (84.4 × 67.3 × 48.3 cm)

The distinctive cabriole legs on this and many Song-dynasty and later incense stands, burners, tables, and even occasional stools developed from a leg shape that was first displayed in China on ancient Shang-dynasty bronzes. By the end of the seventeenth century, as trade between Europe and China increased, Europeans had become captivated by the sensual shape of these legs and adapted them to their tables and chairs. Just as the Chinese name for the imported cloisonné technique took on the Jingtai emperor's reign name, the appropriated cabriole leg became known in England as the Queen Anne leg, securing it as a seemingly English contrivance. NB

Gord Peteran

64. **_Inception Stand,_** 2006
Electrical wire
31 × 24 × 24 inches (78.7 × 60.9 × 60.9 cm)

65. **_Inception Stand_ drawing,** 2006
Pen and ink on paper and photocopy

Peteran, who is drawn to the deeper cultural meanings of furniture, has always balanced awareness of historical production with contemporary perspectives. During the workshop he marveled at the forms and cabinetmaking traditions, but after returning to his studio he found that this view of China as the wellspring for beautiful furniture was challenged by a contemporary view of China as the manufacturer of limitless plastic and metal objects. For him, _Inspired by China_ ran headfirst into "Made in China." His incense stand reveals how he approached a reconciliation of this tension by producing a three-dimensional, gestural work. ESC

At first glance, China is everywhere. Every conceivable object that surrounds me carries the label "Made in China." However, just as the quaint decorative motifs applied to early American-made and Chinese-export goods shed little light on the true ideals of Chinese culture, this present fantastic plastic production does even less toward furthering our understanding of this ancient people. My offering to this exhibition will be in the form of a question: What is the heart of China? What deep-rooted ancestral reverence do their people rigorously adhere to? How does a country remain so visible and yet so invisible? Is it magic? I will begin by duplicating a table within the museum's collection commonly used for holding incense burners. This type of ceremonial and ritualistic artifact can be very revealing. My form will be similarly symmetrical but rather than use wood I will weave together fine red electrical wire. This delicate object will trace the complicated arteries that lead to the fragile China we might not see. I was inspired . . . to look more closely.

—Gord Peteran

66. **Bed, with six posts and canopy,** 17th century
Huanghuali
90 × 89 × 62½ inches (228.6 × 226 × 158.7 cm)

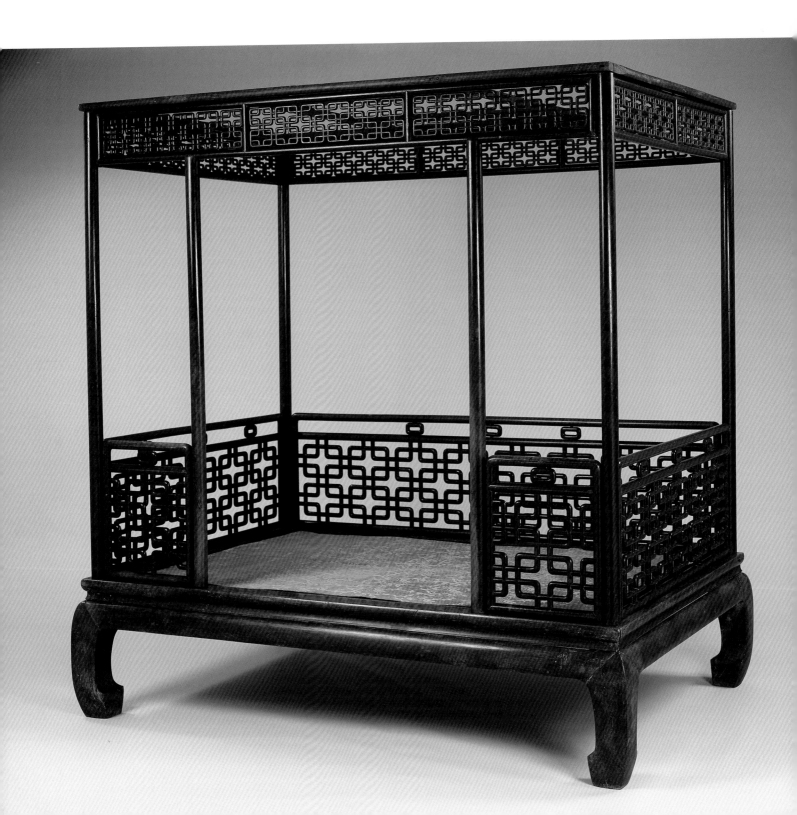

While the chair and stool were adoptions from non-Chinese cultures during the second, third, and fourth centuries, the concept of a bed—a platform raised off the ground—was already embedded in the native Chinese culture. When the folding stool first arrived in China, it was termed a *huchuang,* or "barbarian bed," and the chairs from India with their woven-rope seats were called *shengchuang,* "rope beds," as the word *chuang,* meaning bed, was already in the Chinese furniture vocabulary, while the words for chair or stool had yet to be determined. Excavated tombs have revealed that elevated wooden platforms, with lattice railing surrounds, supporting sleepers away from cold, moist floors and irritating insects and rodents, existed at least as early as the fourth century BCE.[1]

The intricate lattice on this grand *huanghuali* bed displays the remarkable skill of the master furnituremaker who created it. The lattice, carved to look like interlocking, round-cornered rectangles, is created with hundreds of fine joints fastening the scores of finely wrought lengths of wood. NB

Note

1. A tomb dated 316 BCE, excavated in Jingmen, Hubei Province, contained a large raised platform with railings, constructed from wood, lacquered wood, and bamboo. Sarah Handler, *Austere Luminosity of Chinese Classical Furniture* (Berkeley: University of California Press, 2001), 142.

Wendy Maruyama

67. **Vanity,** 2006
 Pau ferro, mixed media, video
 42 × 16 × 16 inches (106.7 × 40.6 × 40.6 cm)

Maruyama's recent work has demonstrated the maker's keen interest in her Japanese-American ancestry in combination with the exploration of new digital media. Drawn to the use of mirrors, mirror stands, and makeup in Chinese culture, she developed the idea of a cosmetic stand in which the mirror stand holds an LCD display that doubles as a mirror and screen on which a video shows a woman applying makeup either to accentuate the Asian upward slant of her eyes or to make her eyes appear rounder or more Western. To accomplish the integration of the technology she was fortunate to collaborate with the digital media lab during a fellowship at Anderson Ranch, a crafts school in Colorado. For the past two years she has been exploring the possible integration of new technology into furniture with the assistance of that institution. The stand and video directly address issues of identity and self-fashioning implicit within the larger endeavor of cultural exchange. ESC

My time in the media lab at Anderson Ranch was one of the most relaxing creative times I have had to myself in a long time and it was fun because it was something new: new studios, new applications, new tools. . . . I will be working on a cosmetic box which will house a small DVD player. The mirror will be propped up on top, as is shown in many other forms of the traditional examples. The mirror will be a two-way variety with a small LCD screen behind it. The video will show an Asian woman applying makeup but at some point she begins to either accentuate the slant of her eyes and in another version she tries to make her eyes look more Westernized, or rounder. The woman is my sister, Karen, who is an actor/comedian.
 —Wendy Maruyama

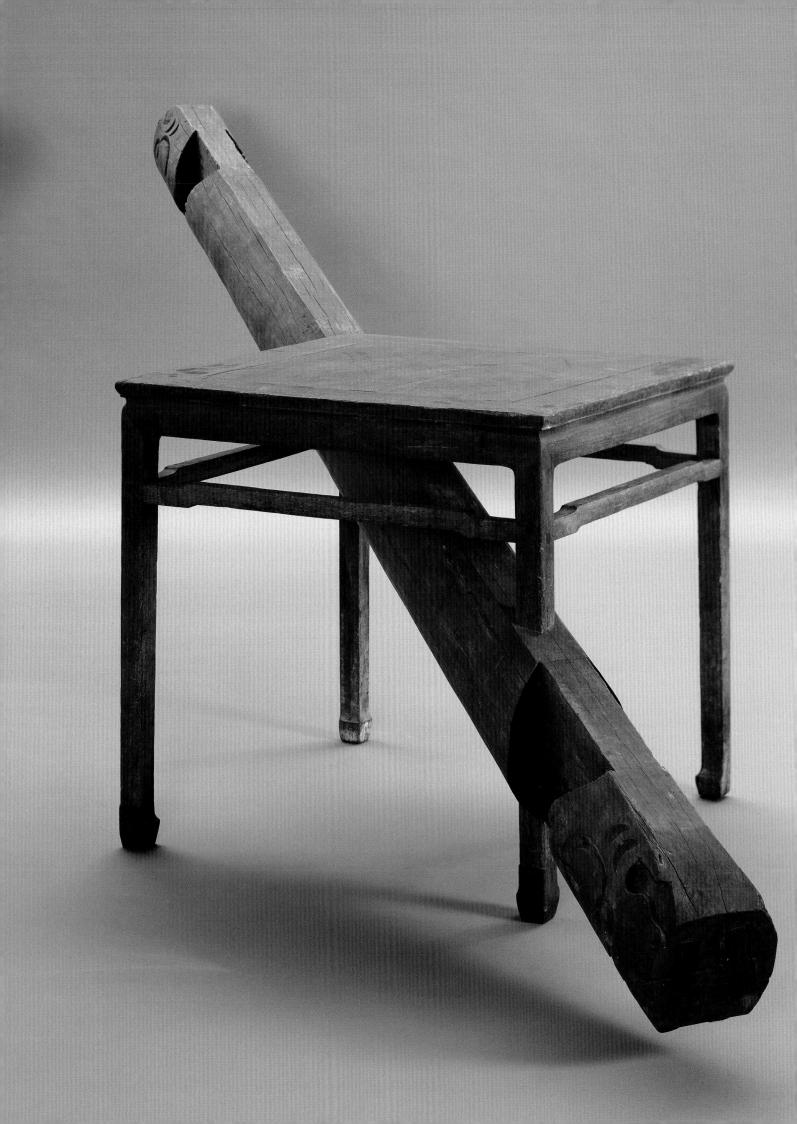

Ai Weiwei

68. **Table with Beam,** 2005
Tieli wood
49½ × 49½ × 151½ inches
(126 × 126 × 384 cm)

Table with Beam is both a work of conceptual art and the product of an architect and designer who creates spaces and objects for spaces. Conceptually, Ai Weiwei marries furniture to architecture and, at the same time, morphs two once very functional objects into a visually stimulating formal object. The piece evokes the traditional Chinese gentleman's virtue of modesty, which is also reflected in the Ming furniture aesthetic by which beautifully crafted joinery fastens together wooden components while being completely hidden to the viewer. Ai Weiwei, working with master woodworkers, made a soft-wood, life-sized model of the beam to ascertain the complex interior joinery that would allow the beam to appear to pass through the table. The table was dismantled for the fitting of the beam, but was never carved, nor was any nail or glue employed in the joining of the components. The power of the work derives both from its physicality and the extensive, meticulous mental configuring necessary to produce it. NB

I realized that furniture and architecture are all one piece for Chinese people. The universe is one piece. It's just everywhere, every part is supporting another to create total harmony of the universe. But furniture and building actually are separate always, even if they are in the same house. So I came up with the idea of why don't we try to see if they can have an interrelationship. By doing so, you really have to understand furniture, the nature of the furniture and how it's being built, how many parts and what is possible. I always use classic techniques—no nails or glue—to assemble it together. You have to make joints. Sometimes, it can get very complicated because measurement must be very precise. The beam is round and meeting the table at an angle can be very, very difficult. By making a precise careful study you can achieve a result that looks very simple and easy. The result looks to be a perfect wholeness. That impresses me a lot.

—Ai Weiwei

冰裂鼓桌之

打破無名之

The Artists and Their Biographies

Nancy Berliner and Edward S. Cooke, Jr.

Ai Weiwei (b. 1957)

Ai Weiwei stands at the forefront of the contemporary art and design world in China, his innovative and elegant designs ever probing new frontiers. A son of one of China's most celebrated twentieth-century poets, Ai Qing, Ai Weiwei was raised within the cultured milieus of postrevolution Beijing and was exposed early to the multiple opportunities of artistic realms. At the end of the Cultural Revolution, when colleges reopened, he enrolled at the Beijing Film Institute. Expressing his concern for alternative artistic directions, Ai Weiwei was one of the founding members of The Stars, one of the first groups of artists to display artworks after the Cultural Revolution in a nontraditional and nonsocialist-realist vein. Like many young artists in the early 1980s, Ai Weiwei moved to New York to further his understanding and to participate in the international art scene. There he studied at Parsons School of Design and the Art Students League. After eleven years in New York, he returned to China from where his works as a conceptual artist, designer, architect, writer, curator, and artist have been challenging and stimulating the world. He uses materials from ceramic to wood to video, often with reference to Chinese traditions and environs. Many of his works in wood have incorporated deconstructed and then reconstructed traditional Chinese furniture and architecture. He is presently collaborating with the Swiss firm Herzog de Meuron on the Beijing National Stadium project for the 2008 Olympics. His works have been seen at the Biennial at Sydney 2006; Museum für Moderne Kunst (MMK), Frankfurt, Germany; and the Second Guangzhou Triennial. NB

Select References Ai Weiwei, *Ai Weiwei: Works—Beijing, 1993–2003*, ed. Charles Merewether (Beijing: Timezone 8, 2004); Ai Weiwei, *Beijing 10 / 2003* (Beijing: Timezone 8, 2005).

Garry Knox Bennett (b. 1934)

After studying metal sculpture at the California College of Arts and Crafts in the late 1950s and early 1960s, Bennett first turned his creative energies to the production of counterculture paraphernalia such as roach clips and peace-sign pendants. As he achieved success in the commercial realm, he turned his attention to making clocks and lamps. Made in Oakland, California, this work began to attract the attention of galleries in the early 1970s, and he expanded his work into furniture, beginning to use wood in addition to metal. As he built more furniture, he began to get frustrated by the emphasis on technical virtuosity that characterized the field of studio furniture at that time. His nail cabinet of 1979, exquisitely constructed of padouk but with a bent silver nail driven into its perfect surface, signaled his challenge to the dominant approach of the field. Over the next quarter-century, he embarked on a body of work that combines wood, metal, and painted surfaces and highlights a specific working process. He rarely draws or plans his designs meticulously, but simply jumps right in with his materials and large machines. His dexterity comes from a deep knowledge of materials and techniques. He often focuses upon a specific form—benches, trestle tables, desks, clocks, lamps, and most recently chairs—to provide some parameters, then uses his large machines such as the band saw or drill press to begin making parts. This direct approach has enabled his rate of production to remain very high, and he has been a recognized leader in the creation of mixed-media furniture. ESC

Select References Ursula Ilse-Neuman, et al., *Made in Oakland: The Furniture of Garry Knox Bennett* (New York: American Craft Museum, 2000).

Yeung Chan (b. 1946)

Chan was born and raised in China. After high school he was sent to the country as a farm worker, as many were during the Cultural Revolution. After four years of agricultural labor, he escaped to Hong Kong in 1968 and got a job as a printing technician. He emigrated to New York in 1973 and then moved to California in 1977. Unconvinced by the prospect of a lifetime in commercial printing, he took a job in a furniture factory and over a twelve-year period became a patternmaker and then a production manager. His interest in the technical side of manufacturing, rather than design only, led him in 1991 to set up his own shop in Millbrae, California, preferring to work on his own and to make prototypes. Yet his technical skills seemed inadequate so in 1996 he enrolled in James Krenov's College of the Redwoods, a renowned program for fine furniture-making. After studying for one year with Krenov, Chen returned to his own shop and focused specifically on Chinese-influenced furniture. Rather than reproduce it, though, he has studied the older forms and traditions and then developed the means to make similar work with machines. It is part of his goal of bringing the style of Chinese furniture into modern life. ESC

Select References "Profile: Yeung Chan," *Woodworker West* (September–October 2000): 54–55; Yeung Chan, *Classic Joints with Power Tools* (Asheville, NC: Lark Books, 2002); and *Woodwork* 53 (October 1998): 48–54.

Michael Cullen (b. 1958)

With great-grandfather cabinetmakers on both sides of his family, Cullen seems destined to make furniture. Although he majored in mechanical engineering at the University of California, Santa Barbara, he also took sculpture classes, since he had enjoyed carving wood growing up and had been interested in carving musical instruments. After graduation in 1983, he stumbled onto the magazine *Fine Woodworking* and realized that he had found a pursuit that would combine his interest in hand skills, engineering, and sculpture. In 1986 he enrolled in Leeds Design Workshops in Easthampton, Massachusetts, a small school established by David Powell that focused upon the development of traditional cabinetmaking skills. After studying at Leeds for two years, he worked for another two years for Jamie Robertson in the Emily Street Workshops, an important cooperative workshop in Cambridge, Massachusetts, which was arguably the most important hothouse for the studio furniture field from the late 1970s through most of the 1980s. It was here that Judy McKie, Mitch Ryerson, and John Everdell had space and where others such as Michael Hurwitz, Wendy Maruyama, and Tom Loeser worked for short periods of time. In 1990, after the inspirational exposure at Emily Street, Cullen moved back to California and opened his own shop in Petaluma, where he has continued his interest in carving and texture but has also added color to his repertoire. ESC

Select References Tom McFadden, "Where Engineering, Art, and Woodworking Meet: Michael Cullen," *Woodwork* 35 (October 1995); and "Profile: Michael Cullen," *Woodworker West* (March–April 2003): 54–55.

John Dunnigan (b. 1950)

An English major at the University of Rhode Island, Dunnigan taught himself woodworking while in college and after graduation began to run his own shop in Rhode Island. In spite of some success, he felt he needed to study furnituremaking more formally in order to grow and so, in 1978, he enrolled in the MFA program at the Rhode Island School of Design (RISD), where he studied with the legendary teacher Tage Frid, eventually joining him as a faculty colleague in 1980. Dunnigan mastered the technical skills so valued in the 1970s but has since gone on to explore the cultural meanings of furniture through such concepts as classical proportion, the use of nontraditional materials such as plastic for contrasting details, and upholstery for its notion of physical and visual comfort. In work ranging from small objects to architectural interiors, he has developed an urbane style built upon a deep understanding of historical precedents. Throughout the last twenty years, his work in his West Kingston, Rhode Island, shop and his teaching at RISD have been intertwined, and he has affected the field through both. ESC

Select References Christine Temin, "Poet in Wood: John Dunnigan," *American Craft* 55, no. 6 (December 1995–January 1996): 50–53; and John Dunnigan, "Understanding Furniture," in *Furniture Studio: The Heart of the Functional Arts*, ed. John Kelsey and Rick Mastelli (Free Union, VA: Furniture Society, 1999), 12–23.

Hank Gilpin (b. 1946)

A 1973 MFA graduate of the Rhode Island School of Design (RISD), Gilpin heeded the advice of his teacher Tage Frid, who encouraged him to find a niche in the furniture world and stick with it. Armed with technical skills and a pragmatic design sense that relies on efficient commission work, Gilpin has operated his own shop in Lincoln, Rhode Island, for more than 32 years. Over the years he has built up a loyal base of clients who respond to his type of direct woodworking. His work tends to be historically informed but with a contemporary slant that emphasizes his respect for indigenous hardwoods and efficient, expressive joinery. He is recognized as the consummate master-cabinetmaker, who knows so much about wood and woodworking tools.

ESC

Select References Jonathan Binzen, "Talking Shop with Hank Gilpin," *Fine Woodworking* 171 (August 2004): 80–83; and Hank Gilpin, "Raising the Lot of the Lowly Bench: A Designer Explains Why He Builds Benches," *Home Furniture* 9 (January 1997): 22–25.

Tom Hucker (b. 1955)

Hucker discovered the world of studio furniture when the seminal exhibition "Objects: USA" traveled to Philadelphia in 1973. After seeing the possibilities of sculptural furniture in that show, he worked briefly with Dan Jackson before entering into a two-year apprenticeship with Leonard Hilgner, a skilled, German-trained craftsman. From this solid technical training he went on to earn a Certificate of Mastery from the Program in Artisanry at Boston University in 1980. While in Boston he studied at the Urasenke School of Tea Ceremony and began to explore Japanese aesthetics and ritual. In 1982, he was an artist-in-residence at Tokyo National University of Fine Arts. In the late 1980s, he shifted gears and began to study industrial design at the Domus Academy in Milan. This awakened an interest in the ambient meaning of furniture within a specific architectural space. Since returning to the United States and setting up a shop in Hoboken, New Jersey, in 1991, he has begun to integrate his Asian sensibility with his architectural interests to create a new body of work. ESC

Select References Rose Slivka, "Thomas Hucker: Counting Angels," *American Craft* 52, no. 3 (June–July 1992): 46–49; and Amy Forsythe, "Jere Osgood and Thomas Hucker: A Tale of Shared Inspiration and a Study in Opposites," *Woodwork* 69 (June 2001): 24–33.

Michael Hurwitz (b. 1955)

Initially drawn to making fine musical instruments, Hurwitz turned to furnituremaking while a student at Boston University's Program in Artisanry in the late 1970s. His teachers Dan Jackson, Jere Osgood, and Alphonse Mattia provided him with a good technical sense of furniture and encouraged him to follow his instincts. In the mid-1980s his pioneering exploration of texture and paint to provide patina and a sense of history established Hurwitz as one of the leaders in the studio furniture field. After teaching for a few years at the University of the Arts in Philadelphia, he received a fellowship to study woodworking in Japan for six months. This experience was transformative, and Hurwitz decided to stop teaching and focus upon his own work, blending an Asian structural-design sensibility, texture, unusual materials (such as marble mosaics, stone, Damascus steel, and silk in addition to unusual woods), and rubbed, painted surfaces.

ESC

Select References Michael Rush, "Michael Hurwitz," *American Craft* 57, no. 2 (April–May 1997): 62–66; and Jonathan Binzen, "Michael Hurwitz: Furnituremaker's Gift," *Woodwork* 97 (February 2006): 24–31.

Silas Kopf (b. 1949)

A graduate of Princeton University, where he studied architecture, Kopf turned to furnituremaking because he had grown to like wood carving and sculpture while an undergraduate. He was drawn to the idea of designing and creating his own object without having to rely on a team of workmen. After seeing the work of the studio furnituremaker Richard Scott Newman and talking with him, Kopf moved to Rochester, New York, to work, and then began to apprentice for Wendell Castle in 1974. After two years Kopf went out on his own, contemplating how he would develop a signature look in his work. While helping Castle build stack-laminated work, he noted the great waste of wood and began to develop an interest in taking scraps of veneers and making marquetry pictures. Initially he made cabinets and small marquetry jewelry boxes, the latter being his bread-and-butter work that he sold at craft shops and fairs. He moved to Easthampton, Massachusetts, in 1976 and continued this line of work, but in 1983 he took a ten-day trip to Italy with scholars of Italian intarsia work and discovered the European tradition of wood pictures. This experience, and a 1988 National Endowment for the Arts Craftsman's Fellowship that allowed him to study marquetry at the Ecole Boulle in Paris, dramatically raised the level of his pictorial work. At present, he is the preeminent marquetry specialist in America and has recently completed a DVD on marquetry. ESC

Select References Silas Kopf, "Marquetry on Furniture," *Fine Woodworking* 38 (1983): 61–65; *Silas Kopf: Marquetry Furniture* (New York: Gallery Henoch, 2003); and Interview with Silas Kopf, October 1, 2004 (Nanette L. Laitman Documentation Project for Craft and Decorative Arts in America, Smithsonian Archives of American Art).

Wendy Maruyama (b. 1952)

Maruyama has been one of the pioneering women in the field of studio furniture. First attracted to making furniture in junior college, she enrolled at San Diego State University to pursue it more fully. Recognizing the artistic possibilities of furniture, she realized she had to broaden her horizons and enrolled in Boston University's Program in Artisanry to study with Jere Osgood and Alphonse Mattia. Following this solid foundation, she went on in 1980 to become one of the first two female MFA graduates of the Rochester Institute of Technology's School for American Crafts. Since then, she has been an inspiring teacher at the California College of Arts and Crafts and, since 1989, at San Diego State University. Throughout her academic career she has also exhibited her work extensively. That work has shown a consistent interest in pushing the boundaries of furniture through the incorporation of painted surface colors in combination with angular forms as well as neon and glass, combining organic shapes with textured surfaces and paint, and most recently exploring notions of gender, biography, and ethnic identity. ESC

Select References Nina Stritzler, "Wendy Maruyama," in John Perreault, et al., *Explorations II: The New Furniture* (New York: American Craft Museum, 1991), 38–41; and D Wood, "Pause for Reflection: Looking Back at Wendy Maruyama," *Woodwork* 92 (April 2005): 26–32.

Judy Kensley McKie (b. 1944)

Although trained as a painter at the Rhode Island School of Design (RISD), McKie initially turned to furnituremaking simply to furnish her house. Intrigued by the process, in 1971 she joined New Hamburger Cabinetworks, a cooperative workshop that was established in 1970 in Roxbury, Massachusetts, and then moved in 1973 to Emily Street in Cambridge. Gaining considerable experience in all manner of woodworking over four years, she then decided to pursue her own sort of sculptural furniture in which she carved in low relief on boxes and chests. For inspiration she turned to Native American, pre-Columbian, African, Greek, and Egyptian art and began to draw stylized, fanciful creatures. By the late 1970s, she had also begun to shape structural elements of tables and benches into animal forms and began to add color. Best known for her carved wood, she began in the late 1980s to carve work to be cast in bronze or cut out of stone. Her work remains singular in its simple but beguiling animation, which reaches out and touches the viewer. ESC

Select References Joy Cattanach Smith, "Judy Kensley McKie," *American Craft* 43, no. 1 (December 1983–January 1984): 2–6; Akiko Busch, "Judy McKie: Connecting to the World," *American Craft* 54, no. 6 (December 1994–January 1995): 32–35; and Jonathan Binzen, "A Conversation with Judy Kensley McKie," *Woodwork* 95 (October 2005): 24–31.

Clifton Monteith (b. 1944)

Trained as a painter at Michigan State University, Monteith taught art and practiced as a graphic illustrator in New York for a number of years. In 1985 he decided to leave his New York career and return to Michigan in order to begin a new career as a furnituremaker. He was especially interested in working with natural, rustic materials in a contemporary fashion and felt that living and working in Lake Ann, Michigan, would foster such work. His keen interest in form has enabled him to update the willow furniture of the Adirondack rustic style of the early twentieth century. In contrast to the Adirondack furniture made a century ago, Monteith's work has considerably more volume and asymmetry to it, and he has introduced color as well. In 1994 and 1998 he received fellowships to travel to Japan to study *washi* (traditional handmade paper) and *kakishibu* (a waterproofing material made from the fermentation of persimmons) as well as *urushi* lacquering. He has incorporated these natural materials into his own work, combining *washi* and *kakishibu* to make colorful lampshades and using *urushi* to add both strength and interesting finish looks to his willow structures. Monteith uses willow—a readily available and easily replenished material—in a way that respects its natural state. By working with natural finishes that require time and patience to prepare, Monteith has developed his own sort of environmental, organic approach to studio furniture. This niche is well marked by his extensive lectures and workshops throughout the United States and Japan. ESC

Select References Artist's Statement, which can be consulted in the *Inspired by China* files, Peabody Essex Museum; and http://homepage.mac.com/cliftonmonteith/Menu6.html.

Brian Newell (b. 1966)

While studying language at the University of Michigan, Newell discovered James Krenov's *A Cabinet-maker's Notebook*. The extraordinary quality of the work prompted Newell to leave Michigan in 1989 and go to study at Krenov's College of the Redwoods in Fort Bragg, California. After two years there he moved to Chicago to work as a patternmaker for a toy company for three years before setting up his own furniture shop. After a short time on his own, he moved to Japan in 1997 and has worked just outside Tokyo ever since. He has developed a very personal style that is distinct from most of Krenov's students. While his work shares the consummate technical joinery and reverence for wood of those fellow graduates, his gift of animating his case furniture in a Kafkaesque fashion sets him apart. Within the beauty of his cabinets lurks an uneasy, insectlike feeling, a darker version of the creatures that animate Judy McKie's work. ESC

Select References Masanori Moroyama, *Brian Newell* (Tokyo: Exhibition Space, 2001); and *Brian Newell* (Easthampton, NY: Pritam & Eames, 2004).

Gord Peteran (b. 1956)

A 1979 graduate of the Ontario College of Art and Design, Peteran has built a reputation for site-specific and situation-specific commissions that draw on his extensive woodworking skills, extraordinary draftsmanship, and interest in a wide variety of materials. In combining concept and technique, he consistently uses the fundamental nature of materials and processes to explore vital or universal issues, whether sheathing a turned phallic object in leather or making a side table out of off-cuts glued together. His is a thoughtfully irreverent approach that complements Garry Knox Bennett's more explicit challenge of materials. For Peteran, the contemporary maker should be blending elements from what are traditionally distinguished as fine art, design, and craft. Although he continues to teach at the Ontario College of Art and Design, he has lectured and taught throughout Canada and the United States and received numerous honors for his furniture and sculptural work. In 2001 he received the prestigious Jean A. Chalmers Award and was inducted into the Royal Canadian Academy of Arts, and in 2004 he received the competitive Ontario Arts Council Chalmers Fellowship. ESC

Select References Glenn Adamson and Edward S. Cooke, Jr., *Wood Turning in North America since 1930* (New Haven and Philadelphia: Yale University Art Gallery and Wood Turning Center, 2001), 148 and 174; and Tom Loeser, et al., *Contemporary Studio Case Furniture: The Inside Story* (Madison, WI: Elvehjem Museum of Art, 2002), 26, 60, and 85–86.

Richard Prisco (b. 1962)

Initially an industrial designer with extensive experience in exhibition, packaging, and furniture design, Prisco sought more personal rewards in his design work and headed back to school to immerse himself in furnituremaking techniques. He earned an MFA from the Rochester Institute of Technology's School for American Crafts and has taught at the Savannah College of Art and Design since 1994. The hybrid curriculum there, one that blends product design and one-off studio work as well as industrial materials and figured woods, is consistent with Prisco's own work. In his designs, he is most drawn to engineering issues such as tension, compression, shear, and torsion, but to realize these concepts in an expressive manner he uses traditional furniture joinery in conjunction with metal components, steel cables, and concrete. The result is a distinctive industrialized studio furniture.

ESC

Select References http://www.guild.com/artist/3603.html; and http://www.penland.org/news/wood-auction/CATALOG/prisco.html.

Michael Puryear (b. 1944)

After studying anthropology in college and working as a reference librarian, Puryear began to develop an interest in furnituremaking and taught himself by reading, asking questions, and gaining experience while working as a contractor. The physicality of a creative pursuit and a connection to past makers drew him especially to working in wood. Eventually he evolved into a furnituremaker and has been active for over twenty years. He has taught part-time for the State University of New York at Purchase, but he has mainly made furniture for clients and exhibition. A serious student of Eastern philosophy, he draws particularly on Chinese, Japanese, and African cultural traditions to build understated and graceful furniture. A philosophical approach, grounded in his thoughtful interest in cultural context and made possible by his physical dexterity with tools, distinguishes his work.

ESC

Select References D Wood, "Body Language: Translating the Furniture of Michael Puryear," *Woodwork* 83 (October 2003): 22–29.

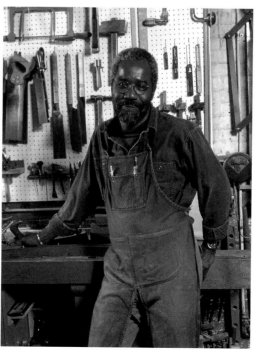

Shao Fan (b. 1964)

Shao Fan first learned to paint as a child, and in 1984 graduated from the Beijing School of Arts and Crafts, one of Beijing's elite academies. He did further studies in woodworking and porcelain at the Institute for Research in Arts and Crafts. Shao Fan was one of the first artists of the post-Cultural Revolution era to consider and incorporate Chinese traditional furniture in his work. "Chairs about Chairs," his 1996 solo exhibition at the Gallery of the Central Academy of Fine Arts, Beijing, was a sensational debut of his unique fabrications. The works presented were configurations and variations of deconstructed chairs often conjoined with modern-style chairs. In later years he continued to make furniture-related work. A set of chairs, also created in the later 1990s, is intended to reference Chinese written characters. His work reflects the deep pride and identity that many designers, artists, and connoisseurs in the 1990s and early twenty-first century find in the restrained and unadorned lines of Ming furniture, which resonates so well with modern sensibilities. Shao Fan's interest lies both in physically deconstructing the profound classicism of this furniture and conceptually deconstructing its meaning in the present time. His works have been included in numerous exhibitions in China, Europe, and the United States, among them the 2004 "Chinese Imagination" (Chinese Contemporary Sculpture Exhibition, Tuileries Garden, Paris) and "New Phenomenon in Contemporary Chinese Art" (Picardi National Museum, Amiens, France). His works are represented in the collection of the Victoria and Albert Museum, London, and are the first pieces of contemporary art and design by a Chinese artist to be collected by that museum.　　　NB

Select References　Susan Dewar, "Beijing Report" (review of "1st Academic Exhibition of Chinese Contemporary Art 95–96"; and "Chair about a Chair: Shao Fan," Red Gate, Courtyard, Marlborough Galleries); *ART AsiaPacific* no. 15 (1997): 39–41; Shao Fan, *Shao Fan* (Beijing: the artist/CIFA Gallery, 1996); and Zeng Xiaojun and Ai Weiwei, eds. *Hui pi shu* (The Grey Cover Book) (Beijing: self-published, 1997).

Shi Jianmin (b. 1962)

Born and raised in the ancient capital city of Xi'an, in the western province of Shaanxi, Shi Jianmin had a greater exposure to regional Chinese culture than most urban Beijing artists. He spent many years in rural Shaanxi Province documenting village culture and customs on film and through photography before settling in Beijing to focus on his furniture, design, and sculptural work. At the Central Academy of Arts and Crafts in Beijing, where he majored in interior design, he was in the first class in which it was possible to have furniture design as a primary focus. After a number of successful years in the interior design business, he was able to turn his attention back to fabricating unique pieces of furniture with stainless steel. Working with steelworkers and powerful heat sources, he is able to form the hard metal into dynamic shapes that function both as furniture and as powerful, sculptural presences. Both Shao Fan and Shi Jianmin were trained to become contemporary international designers. After some years working in the professional, urbanized world, each became captivated in his own way by the Chinese traditions that had almost faded from their immediate surroundings. Shi Jianmin often notes that he strives to create forms that reflect his deep dedication to Chinese calligraphy, painting, and aesthetics. His chairs express the energy and force apparent in the brushstrokes of calligraphy and the forms of organic rocks and wood appreciated by Chinese connoisseurs for centuries. In 2004, his work was included in the tenth annual "All-China Exhibition of Award-winning Artworks" and the China National Art Gallery as well as in the "Awakening: La France Mandarine" exhibition displayed in Shanghai, Paris, Hong Kong, and Beijing (2004–2005).

　　　NB

Select References　Ma Kejia, "*Linggan Yishu Jia*" (Inspiration, Art, Home), *Jia Shi* (May 2005): 45–50; Meredith Etherington Smith, *Awakening, La France Mandarine* (Hong Kong: Contrasts Gallery, 2004).

J.M. Syron (b. 1960) and Bonnie Bishoff (b. 1963)

Syron and Bishoff have been making furniture together since 1987, first setting up a shop in Philadelphia and then moving to Rockport, Massachusetts. While Syron has focused predominantly upon joinery and carcass work and Bishoff on carving and polymer clay veneers, their work is integrated throughout the design and construction process. Initially, much of their work combined simple forms with carved work that introduced texture and lines to engage the eye. In the early 1990s Bishoff began to experiment with the use of polymer clays to introduce a different sort of color to their work. While the typical use of polymer clay has been in jewelry, Bishoff pioneered its application to furniture and remains the innovator in combining clay with wood. Her exploration of color and pattern in sheets of clay has allowed the partnership to develop and use their own sort of Formica veneer. Sometimes they use the clay veneer in rather traditional panel sheets set within a wooden frame, but in some of their most recent work they are creating clay lampshades or boxes that have very little wood. Throughout their sensuous work, clay provides color and the suggestion of natural elements in a flat plane, thereby setting off the rounded or carved wooden framing members. ESC

Select References Tom Loeser, et al., *Contemporary Studio Case Furniture: The Inside Story* (Madison, WI: Elvehjem Museum of Art, 2002), 68 and 89; and www.syronbishoff.com.

Tian Jiaqing (b. 1953)

For the past ten years, Tian Jiaqing has been creating Chinese furniture in a Beijing workshop, working with fine master woodworkers. He has garnered a reputation for superb Ming-quality craftsmanship and unique designs that develop out of classic Ming-furniture traditions. First intrigued by wood as a young man, he soon gravitated to the academic study of Chinese furniture. He has authored numerous articles in Chinese and English on Ming and Qing furniture as well as the most authoritative text on the history of Qing-dynasty furniture. His research into Ming and Qing furniture led to dismantling many pieces to examine the complex joints that were created to fasten together the wooden members. Soon he was reproducing the joints to better understand them, then working with fine craftsmen to repair deteriorated Ming masterpieces. By 1996, he felt sufficiently confident to begin designing his own furniture based on his years of research into Ming and Qing furniture. During the next five years he created twenty pieces—including chairs, tables, a bookshelf, and daybed—in a series he calls *Ming Yun* (Charms of the Ming Dynasty). His subsequent series is called *Jiaqing Zhi Qi* (Objects Produced by Jiaqing). While the second series, by his own description, is more innovative, he continues to strive to achieve Ming-style furniture standards, which he feels can reflect the virtues of the maker. Two guiding principles by which he perseveres in his quest to realize these high benchmarks are: "(1) No decoration for decoration's sake; and (2) If it doesn't have a use, it's useless."

NB

Select References Tian Jiaqing, *Enduring Resonance: 50 Works by Tian Jiaqing* (Beijing: Wenwu Chubanshe, 2006); Tian Jiaqing, *Classic Chinese Furniture of the Qing Dynasty* (Hong Kong: Joint Publishing, 1995); and Shannon Roy, "Fully Furnished Life," *Beijing This Month* (May 1, 2004).

Joe Tracy (b. 1946)

While working in a naval weapons laboratory, Tracy visited "Objects: USA" at the Renwick Gallery of the Smithsonian American Art Museum in 1969 and marveled at the possibilities of expressive furniture. He read about Wendell Castle teaching at the School of American Crafts in Rochester and applied to that program. He ended up studying and working in Rochester for six years, with a brief stay with James Krenov in Stockholm, before moving to Mt. Desert, Maine, in 1976, while finishing up his MFA. He soon found commission work there for the Wendell Gilley Museum of Bird Carving and the Jordan Pond House. Taking advantage of local materials, he incorporated popple stones (beach-washed granite) into his work, often building light, expressively joined wooden frames to showcase the natural stone. The results can be characterized as quietly crafted for livable interiors. ESC

Select References *Bangor Metro* (March 2006): 34–35.

Checklist of the Exhibition

Chinese Furniture

Altar Table, waisted with cusped legs,
16th–17th century
Huanghuali, oak
29½ × 40¼ × 25½ inches (74.9 × 102.2 × 64.7 cm)
Photograph by Dean Powell
Plate 5

Altar Table with everted flanges, 17th–18th century
Softwood, lacquer
33 × 49 × 17½ inches (83.8 × 124.5 × 44.4 cm)
Photograph by Dean Powell
Plate 3

Altar Table with everted flanges, 17th–18th century
Walnut
36¾ × 95½ × 19⅜ inches (93.3 × 242.6 × 49.5 cm)
Photograph by Dean Powell
Plate 1

Bed, with six posts and canopy, 17th century
Huanghuali
90 × 89 × 62½ inches (228.6 × 226 × 158.7 cm)
Photograph by Dean Powell
Plate 66

Cabinet, square-cornered, with lattice windows,
17th–18th century
Tieli wood
74¾ × 46⅝ × 25¹⁄₁₆ inches (189.8 × 118.1 × 63.7 cm)
Photograph by Dean Powell
Plate 30

Chair with engraved backsplat, 16th–17th century
Huanghuali
45 × 18⅝ × 24 inches (114.3 × 47 × 61 cm);
seat height 18¹⁄₁₆ inches (46 cm)
Photograph by Dean Powell
Plate 40

Chair with protruding crestrail, 19th century
Elm
46¾ × 22¾ × 21¼ inches (118.7 × 57.8 × 54 cm);
seat height 19½ inches (50 cm)
Photograph by Dean Powell
Plate 44

Drum Stool, 18th century
Glazed stoneware
14¾ × 11½ inches dia. (37.5 × 29.2 cm)
Photograph by Dean Powell
Plate 57

Drum Stool, carved to imitate bamboo rings,
16th–17th century
Stone, marble
16¼ × 12¾ inches dia. (41.3 × 32.4 cm)
Photograph by Dean Powell
Plate 54

Drum Stool, carved to imitate textile covering,
17th–18th century
Stone
11⅝ × 21¹⁵⁄₁₆ inches dia. (29.2 × 55.6 cm)
Photograph by Dean Powell
Plate 53

Folding Chair, 18th century
Jumu (zelkova), boxwood, *baitong*
41 × 21⅞ × 25½ inches (104.1 × 55.3 × 64.8 cm)
Photograph by Dean Powell
Plate 62

Folding Chair ("drunken lord's chair"),
18th–19th century
Jumu (zelkova)
35 × 56 × 29½ inches (88.9 × 142.2 × 74.9 cm)
Photograph by Dean Powell
Plate 61

Folding Stool, 18th century
Jumu (zelkova)
21 × 13½ × 15 inches (53.3 × 34.3 × 38.1 cm)
Photograph by Dean Powell
Plate 59

**Incense Stand with cabriole legs and foliated
hexagonal outline,** 17th century
Cloisonné
33¼ × 26½ × 19 inches (84.4 × 67.3 × 48.3 cm)
Photograph by Dean Powell
Plate 63

Kang Table, 18th century
Zitan, jade
11³⁄₁₆ × 31 × 17⅝ inches (28.5 × 78.7 × 44.4 cm)
Photograph by Dean Powell
Plate 36

Low-back Chair, one of a pair, 18th century
Jumu (zelkova)
29 × 22 × 18 inches (73.6 × 58.9 × 45.7 cm);
seat height 18½ inches (47 cm)
Photograph by Jeffrey Dykes and Mark Sexton
Plate 42

Round-back Chair, one of a pair, 19th century
Willow, lacquer
22½ × 19½ × 10½ inches (57.2 × 49.5 × 26.7 cm);
seat height 13½ inches (34.2 cm)
Photograph by Dean Powell
Plate 47

Screen, 18th century
Wood
68½ × 46 × 15 inches (173.99 × 116.84 × 38.1 cm)
Photograph by Dan Gair
Plate 10

Square Stool, 17th–18th century
Jumu (zelkova)
19 × 19 × 19 inches (48.3 × 48.3 × 48.3 cm)
Photograph by Dean Powell
Plate 39

Square Table, 18th century
Huanghuali, ivory or bone
33½ × 42 × 42 inches (85 × 106.7 × 106.7 cm)
Photograph by Dean Powell
Plate 45

Stool, round, three-legged, 18th–19th century
Elm
4¾ × 6⅝ inches dia. (12.1 × 16.5 cm)
Photograph by Dean Powell
Plate 58

Stool with storage cavity and cover, 19th century
Tree trunk
21 × 26 × 23 inches (53.3 × 66 × 58.4 cm)
Photograph by Dean Powell
Plate 11

Stool, *xiudun*, 17th–18th century
Cloisonné
17¾ × 10⅛ inches dia. (45.1 × 25.6 cm)
Photograph by Dean Powell
Plate 49

Stool, *xiudun*, one of a pair, 18th century
Softwood, lacquer
19¼ × 12½ inches dia. (48.9 × 31.7 cm)
Photograph by Dean Powell
Plate 50

Stool, *xiudun*, 19th century
Bamboo, wood
16 × 15⅛ inches dia. (40.6 × 38.4 cm)
Photograph by Dean Powell
Plate 48

Table with cracked-ice pattern marquetry,
17th–18th century
Huanghuali, nanmu
31⅛ × 44¼ × 33³⁄₁₆ inches (78.9 × 112.4 × 84 cm)
Photograph by Dean Powell
Plate 24

**Tangram Puzzle Tables with Cracked-ice Floor
Rest Designs,** 18th century
Hongmu, burl
Seven-piece set
Square table 31¾ × 15 × 15 inches
(80.6 × 38.1 × 38.1 cm)
2 large triangles 31¾ × 42 × 21 inches
(80.6 × 106.7 × 53.3 cm)
2 small triangles 31¾ × 21 × 10½ inches
(80.6 × 53.3 × 26.7 cm)
Medium triangle 31¾ × 30 × 15 inches
(80.6 × 76.2 × 38.1 cm)
Parallelogram 31¾ × 21¼ × 15 inches
(80.6 × 54 × 38.1 cm)
Photograph by Dean Powell
Plate 23

Textile Screen, 18th century
Silk, linen
144 × 288 inches (365.7 × 731.5 cm)
Collection of the Peabody Essex Museum
Gift of William F. Spinney, 1933 E21773
Photograph by Dennis Helmar
Plate 17

Wine Table, waistless, 17th century
Huanghuali, burl
29 × 38¼ × 15½ inches (73.7 × 97.1 × 39.4 cm)
Photograph by Dean Powell
Plate 37

Contemporary Studio Furniture

Ai Weiwei
(b. 1957)
Table with Beam, 2005
Tieli wood
49½ × 49½ × 151½ inches (126 × 126 × 384 cm)
Photograph by Ma Xiaochun
Plate 68

Garry Knox Bennett
(b. 1934)
Altar Table, 2005
Honduran rosewood, California walnut, timber
bamboo, aluminum, copper, paint
40 × 96 × 16 inches (101.6 × 244 × 40.6 cm)
Photograph by Dean Powell
Plate 2

Garry Knox Bennett
(b. 1934)
Chair for a Small Important Person, 2005
Rosewood, 23kt gold-plated copper and brass, nautilus
shell, epoxy, paint
28½ × 22½ × 19 inches (72.4 × 57.2 × 48.3 cm)
Photograph by Dean Powell
Plate 43

Garry Knox Bennett
(b. 1934)
*Chinese Platform Chair (Late Oaktown Dynasty,
1934–),* 2005
Rosewood, aluminum, cushion, epoxy, paint, gold leaf
46½ × 22½ × 28½ inches (118.1 × 57.2 × 72.4 cm)
Photograph by Dean Powell
Plate 46

Yeung Chan
(b. 1946)
New Scholar's Chairs and Small Table, 2006
Cherry
Chairs, each 32 × 24 × 21 inches (81.3 × 61 × 53.3 cm)
Table 27 × 20 × 18 inches (68.6 × 50.8 × 45.7 cm)
Photograph by Dean Powell
Plate 41

Michael Cullen
(b. 1958)
Quintet with Cracked Ice, 2006
Mahogany, paint
Square configuration 20 × 38 × 38 inches
(50.8 × 96.5 × 96.5 cm)
Rectangular configuration 20 × 72 × 18 inches
(50.8 × 182.9 × 45.7 cm)
Photograph by Dennis Helmar
Plate 26

Michael Cullen
(b. 1958)
Star Table, 2005
Red eucalyptus
Height 18 × width variable 35 to 68¼ inches
(45.5 × 88.9 to 172.7 cm)
Photograph by Dean Powell
Plate 15

John Dunnigan
(b. 1950)
Silk Route Stool, 2006
White oak, brass, leather
15 × 37 × 11 inches (38.1 × 93.9 × 27.9 cm)
Photograph by Mark Johnston
Plate 60

John Dunnigan
(b. 1950)
Standing Desk, 2005
Padouk, brass
48 × 66 × 20 inches (121.9 × 167.6 × 50.8 cm)
Photograph by Dean Powell
Plate 34

Hank Gilpin
(b. 1946)
Curiously Red . . . , 2006
Elm, pigment, magnets
36 × 76 × 18 inches (91.4 × 193 × 45.7 cm)
Photograph by Dean Powell
Plate 7

Tom Hucker
(b. 1955)
Screen #1, 2006
Swiss pearwood, English yew, bronze
69 × 111 × 1½ inches (175.2 × 281.9 × 3.8 cm)
Photograph by Dean Powell
Plate 16

Michael Hurwitz
(b. 1955)
The Chinese Piece, 2006
Bamboo, zelkova, elm, Damascus iron, bronze
78 × 36 × 24 inches (198.1 × 91.4 × 61 cm)
Photograph by Dean Powell
Plate 31

Silas Kopf
(b. 1949)
Cracked-ice Puzzle Tables, 2005
White oak, East Indian rosewood, various woods
2 squares, each 34 × 15 × 15 inches
(86.4 × 38.1 × 38.1 cm)
2 triangles, each 34 × 15 × 15 inches
(86.4 × 38.1 × 38.1 cm)
1 parallelogram 34 × 20 × 15 inches
(86.4 × 50.8 × 38.1 cm)
1 rectangle 34 × 30 × 15 inches
(86.4 × 76.2 × 38.1 cm)
Photograph by Dean Powell
Plate 25

Wendy Maruyama
(b. 1952)
Vanity, 2006
Pau ferro, mixed media, video
42 × 16 × 16 inches (106.7 × 40.6 × 40.6 cm)
Photograph by Dean Powell
Plate 67

Judy Kensley McKie
(b. 1944)
Dragon Stool, 2006
Indiana limestone
19 × 20½ × 20½ inches (48.3 × 52 × 52 cm)
Photograph by Dean Powell
Plate 55

Clifton Monteith
(b. 1944)
Alter Altar Table, 2006
Oak, willow twigs, aspen, black and cinnabar *urushi*
lacquer
35 × 36 × 22 inches (88.9 × 91.4 × 55.9 cm)
Photograph by Dean Powell
Plate 18

Brian Newell
(b. 1966)
Cicada Cabinet, 2006
Zitan, boxwood, brass
37½ × 42 × 12 inches (95.3 × 106.7 × 30.5 cm)
Photograph by Dean Powell
Plate 33

Gordon Peteran
(b. 1956)
Inception Stand, 2006
Electrical wire
31 × 24 × 24 inches (78.7 × 60.9 × 60.9 cm)
Photograph by Dean Powell
Plate 64

Richard Prisco
(b. 1962)
Untitled, 2006
Wenge, bamboo, nickel-plated steel, stainless steel,
graphite
72 × 14 × 12 inches (182.9 × 35.6 × 30.5 cm)
Photograph by Joseph Byrd
Plate 35

Michael Puryear
(b. 1944)
Wei Jinian Shifu (For the Master), 2006
Sycamore, wenge
Chair 48 × 30 × 24 inches (121.9 × 76.2 × 60.9 cm)
Table 30 × 48 × 24 inches (76.2 × 121.9 × 60.9 cm)
Photograph by Dean Powell
Plate 38

Shao Fan
(b. 1964)
Round Stool, 2005
Elm
20 × 38 × 26 inches (51 × 96.5 × 66 cm)
Photograph by Ma Xiaochun
Plate 52

Shao Fan
(b. 1964)
U-shaped Altar Table, 2005
Elm
36½ × 69⅝ × 45 inches (92.5 × 177 × 114 cm)
Photograph by Ma Xiaochun
Plate 4

Shi Jianmin
(b. 1962)
Chair, 2005
Stainless steel
84 × 36 × 36 inches (213 × 91.5 × 91.5 cm)
Photograph by Ma Xiaochun
Plate 13

Shi Jianmin
(b. 1962)
Stool, 2005
Stainless steel
20½ × 59 × 55 inches (51.8 × 150 × 140 cm)
Photograph by Ma Xiaochun
Plate 12

J. M. Syron
(b. 1960)
Bonnie Bishoff
(b. 1963)
Sea and Sky Altar Coffer, 2006
Mahogany, polymer clay
26 × 32 × 18 inches (66 × 81.3 × 45.7 cm)
Photograph by Dean Powell
Plate 27

Tian Jiaqing
(b. 1953)
Reclining Dragon, 2005
Huanghuali
32⅞ × 34 × 174 inches (83 × 86.3 × 442 cm)
Photograph by Yiyan Nanjin
Plate 6

Joe Tracy
(b. 1946)
Split Personalities in Sequoia semper virens:
Three Case Studies, 2006
Wenge, split sequoia redwood, Indonesian red palm,
Lebanon cedar, walnut, Damascus steel, silver leaf
72 × 20 × 16 inches (183 × 50.8 × 40.6 cm)
Photograph by Dean Powell
Plate 19

Inspired by China
FURNITURE – 2 – China
IN-80